MINNESOTA
CHASING THE SEASONS
FROM THE NORTH SHORE
TO THE MISSISSIPPI

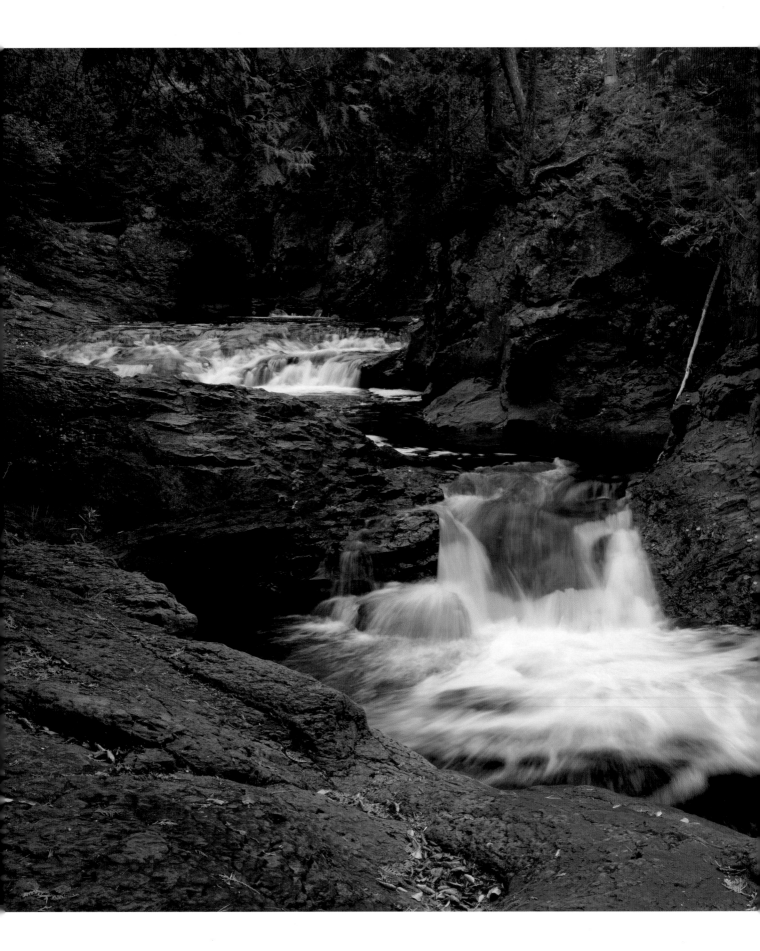

Minnesota
Chasing the Seasons
from the North Shore
to the Mississippi

Jim Jamieson

IMAGESTREAM PRESS
SAVAGE, MINNESOTA

Typeset in Adobe Garamond

First published in 2008 by ImageStream Press
8339 Carriage Hill Alcove
Savage, MN 55378
jjamieson@compuserve.com

For extra copies of this book please check with your preferred bookseller, or contact ImageStream Press.

Printed in China
by C & C Offset Printing Co., LTD.

Illustrations
Cover: Tettegouche State Park
Page 1: Sugar Maple, North Shore
Page 2-3: Cascade River State Park
Page 6-7: Birch, Split Rock Lighthouse State Park

This book is dedicated to my wife Julie, and sons Ian and Wesley whose endless patience and understanding helped to make this work become a reality. Special thanks to those who conserve and preserve our Minnesota wilderness areas, state parks and National Wildlife Refuge System.

Publisher's Cataloging-in-Publication
(Provided by Quality Books, Inc.)

 Jamieson, Jim, 1965-
 Minnesota : chasing the seasons from the North Shore to the Mississippi / Jim Jamieson.
 p. cm.
 Includes bibliographical references.
 LCCN 2007930160
 ISBN-13: 978-0-9729126-3-1
 ISBN-10: 0-9729126-3-0

 1. Minnesota--Pictorial works. 2. Seasons--Minnesota --Pictorial works. 3. Natural history--Minnesota-- Pictorial works. 4. Landscape--Minnesota--Pictorial works. 5. Nature photography--Minnesota. 6. Photography--Digital techniques. I. Title.

F607.J36 2008 917.76'022'2
 QBI07-1621

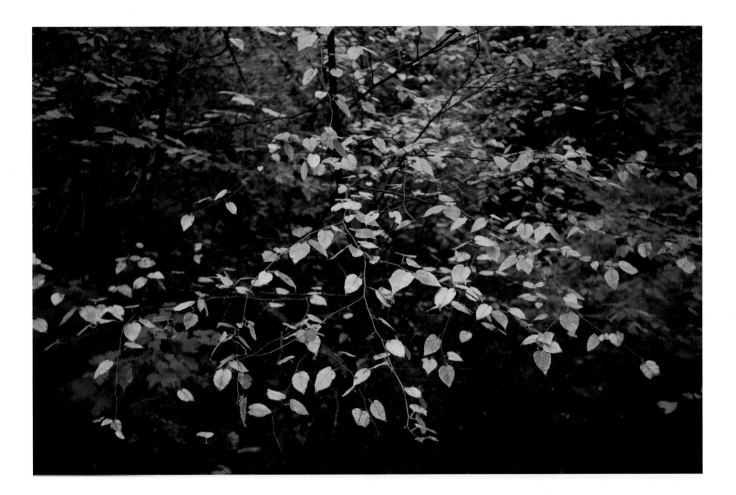

Cascade River State Park, Minnesota

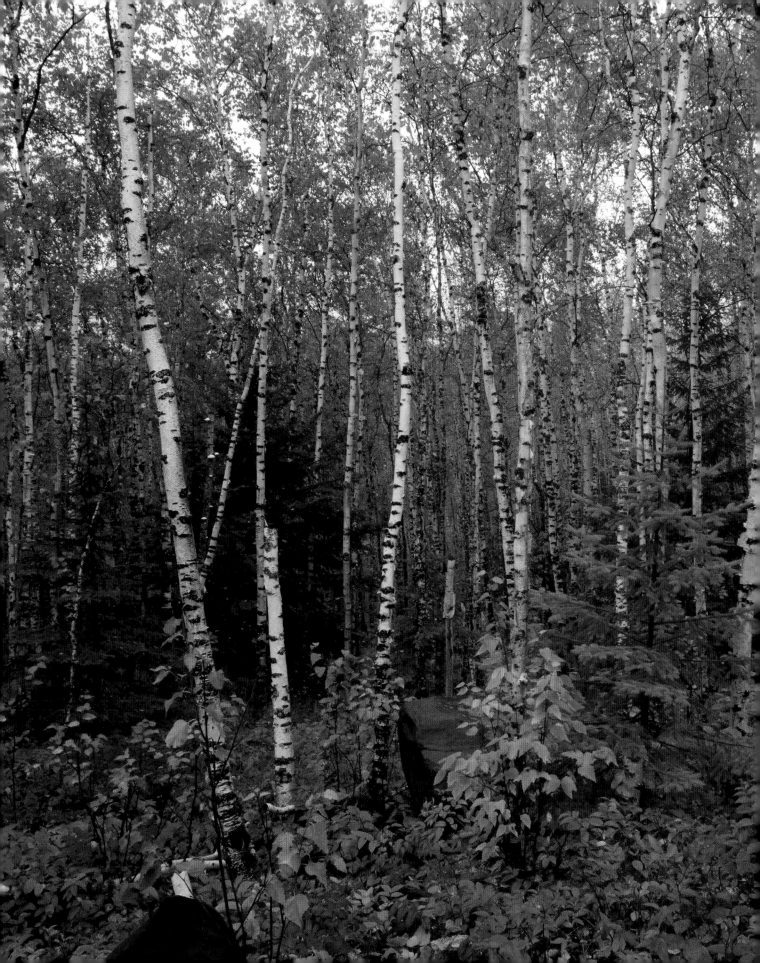

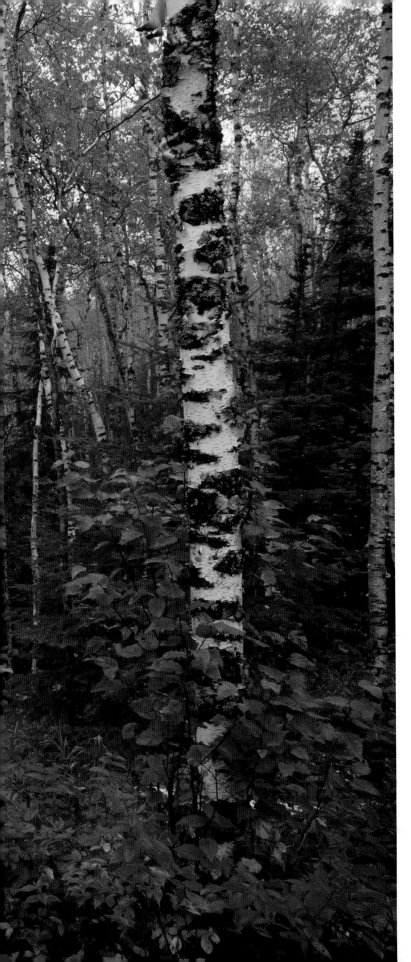

Contents

Intro

Introduction

When viewed from space the earth appears as a brilliant spinning jewel in the otherwise cold, ink black void of imperceptible infinity. Indigo blues, wisping white clouds, and swirling storms wrap around this magnificent marble of the universe every day. From space the human presence on earth is virtually undetectable - at least until nightfall. Against the darkness of space subtle outlines, boundaries, and concentrations of city lights can be seen as this intriguing planet quietly slips in and out of shadow.

How unique it must be that this planet, like no other in this solar system and perhaps many millions of others in the universe, supports such diverse life forms. It's hard to imagine only this planet in the infinity of space could support the biodiversity we observe every day. From the simplest single cell life form to the reasoning ability of the human species, nowhere have we found life outside of the thin atmosphere covering our planet. What an incredible accomplishment.

Despite these unbelievable odds and achievements, civilization today often is not bound together through worship of a common Holy Creator; unfortunately it's often religions and philosophies that divide us. Rather than a focus on conserving this fragile environment, today we are more likely bound together through our insatiable dependency on hydrocarbon fuels, consumption of natural resources, economic trade, and the latest technology trends such as the Internet or iPod. Like no time before, conflict can quickly escalate and be played out to hundreds of millions of people live on the Internet or cable TV. Like no time before, the vitality of humankind hangs in the balance against an exponential rate of change and new challenges.

With this ever present backdrop of development, commercialization, conflict, and advancement of our society, work also remains to protect and conserve our fragile environment. Within the continental United States and across the globe there still are significant areas of unspoiled lands ranging from intricate marine ecosystems to rugged expanses supporting an entire biosphere of interdependent life. Independent of our presence in these biospheres, the natural forces of earth continue unimpeded, shaping these lands over millions of years. In a blink of an eye, earthquakes, forest fires, volcanoes, and landslides dramatically transform the land. Over the millenniums surpassing the lifespan of any species on earth, entire continents have been set in motion, seas retreated and advanced, and massive glaciers have given way to lakes and rivers carving the land.

Geologists have been able to reconstruct some of these events through the fossil and flora records to unravel a violent past of continental forces, ancient seas, uplift, volcanism, fires, glaciation, floods, meteor impacts, and erosion. These forces not only created the very visible landmarks we see and interact with today from remote wilderness areas to national parks, they also created things not so abundantly visible such as our finite energy natural resources or unique minerals enabling everything from manned flight to advanced medicines and materials. In fact, it is this living earth of global forces with ebbs and flows, and rich resources guided by the hand of God that has created this highly interdependent world that continues to enable life as we know it. With remarkable resilience, the species on earth continue to adapt to change and survive. In this process, thousands of species however have not been so fortunate and either through circumstance, disease, or an inability to adapt to rapidly changing conditions, have ceased to exist. In biological ecosystems as in business, the ability to adapt is the single most critical element of survival.

▶ Earth. *NASA Goddard Space Flight Center Image, Visible Earth http://visibleearth.nasa.gov/*

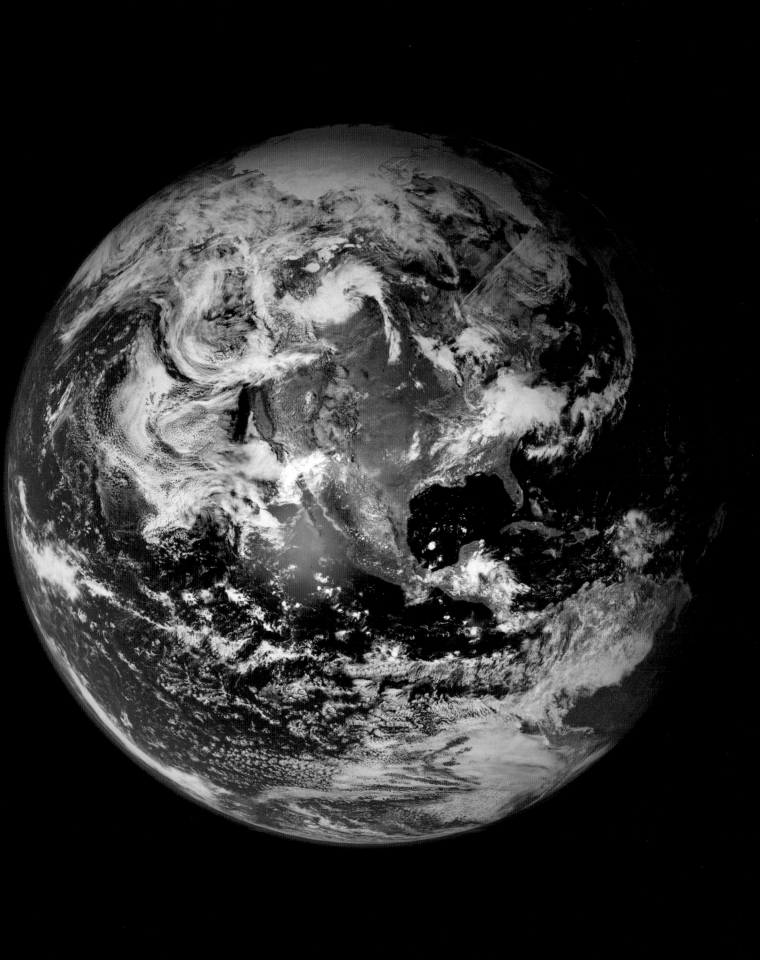

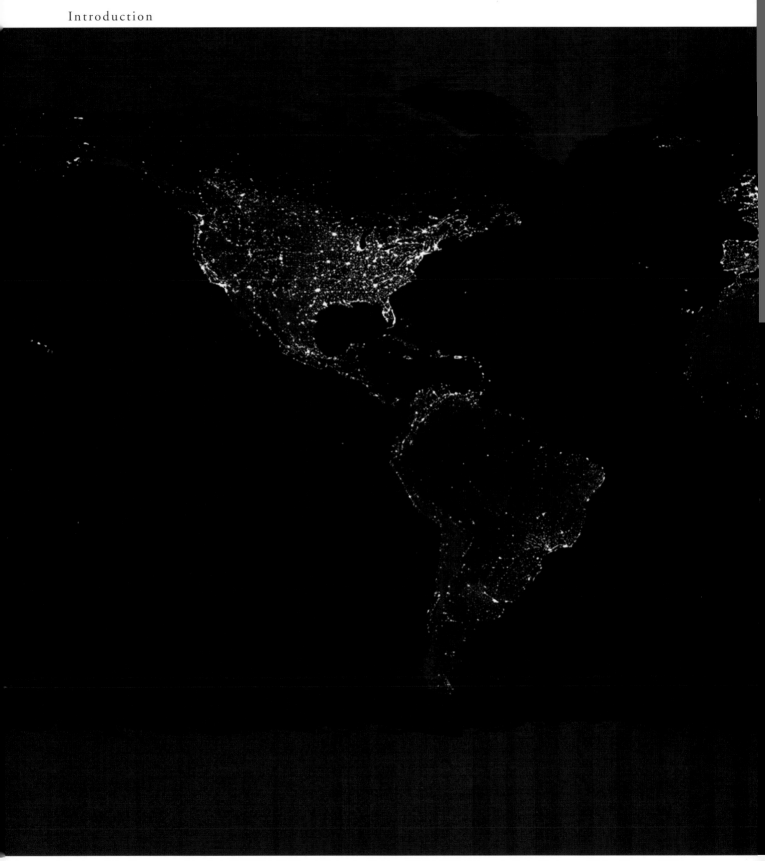

▲ Earth at night. *Data courtesy Marc Imhoff of NASA GSFC and Christopher Elvidge of NOAA NGDC. Image by Craig Mayhew and Robert Simmon, NASA GSFC, Visible Earth http://visibleearth.nasa.gov/*

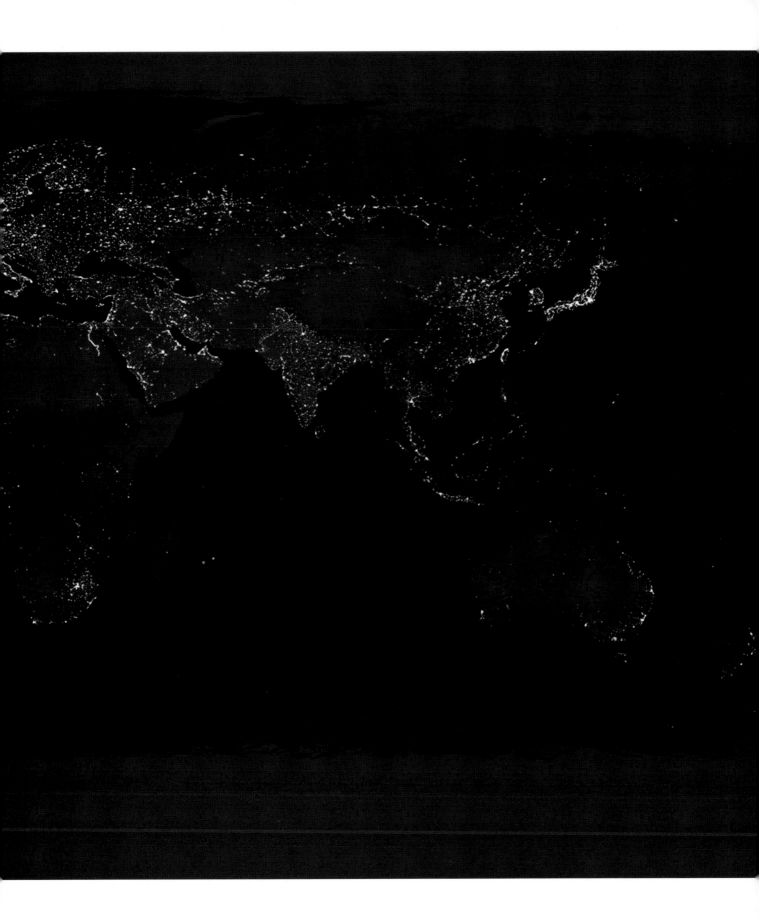

In the book entitled *The Journey of Man, A Genetic Odyssey*, renowned geneticists Dr. Spencer Wells traces modern day male Y- chromosomes across the planet back to a point of origin near Kenya 60,000 years ago. Over thousands of years, migration routes have been shown through genetic sampling to identify prominent paths heading east into India and along the Pacific Rim, north into the Middle East, west into Europe, and finally northeast into central Asia and the Arctic Circle. The trail is picked up again in modern-day Alaska and terminates in North and South America. But what made this passage possible thousands of years ago when humans were not capable of maritime travel?

The answer most likely lies in periods of climatic change where global water levels could have been much lower or significant ice formed a natural land bridge across the unforgiving northern Bering sea connecting North America to Asia. In the midst of the Ice Age, mankind most likely entered into North America through the Bering Strait more than 15,000 years ago and established sustainable populations. The interdependence of climate and human survival it seems were inseparable and helped to accelerate the dispersion of the human race worldwide. Without these probable events, sustainable populations in North and South America could have been delayed by many thousands of years.

Surely enabling this continental migration was the utility and abundance of the forest and natural resources in North America. Not only home to wildlife, the forest hosts materials for shelter, hunting, and ability to sustain fire. In fact, some of the world's oldest growth forests today lie on the climatic boundary located between the Arctic Circle and the Plains, in the very region where crossing the Bering Sea may have been possible. In this climatic zone, human life can be sustained along with a supporting ecosystem. Evergreens and conifers find an abundance of cool temperatures, ample water sources, rich soil conditions, sunlight, and wildly varying seasonal weather. In a circumpolar band surrounding the globe, temperatures can vary wildly, reminiscent of hot summer days in the Plains to fridged temperatures of the Arctic. Sweeping across northern Europe, Asia, and into Alaska and Canada, this halo of forest today covers millions of acres and is known as the Boreal Forest.

As glacial periods came and went, this band of green traveled south and then retreated north, staying near to the icy tundra below the surface. Comprising substantial areas of Canada, Alaska, Russia, and northern Europe, the Boreal Forest totals an amazing one-third of the available forests on earth. In North America it extends from Alaska, sweeping south momentarily into northern Minnesota and terminating in Nova Scotia. Comprised mainly of spruces, firs, and conifers the Boreal Forest is located between the summer and winter positions of arctic fronts arriving from Canada. In this zone, sufficient temperature and moisture can sustain life in the summer and throughout the long winter periods. Considering the complexities of such diverse weather, wildlife, and soil conditions, it's a major accomplishment only achieved through a delicate balance established over millions of years of environmental and global factors. (Interestingly, this circumpolar forest in the northern hemisphere would not be possible at the South Pole due to the lack of adjoining land features.)

While Minnesota is often associated with brutal winters and summer mosquitoes, the reality is the climate and natural resources can be as varied as the terrain. From the prairies of the southwest, to a transitional zone of deciduous trees and conifers, the state supports four major ecosystems: Prairie Parkland, Eastern Broadleaf Forest, Tallgrass Aspen Parklands, and Laurentian Mixed Forest. These four regions not only support widely varying ecology but also can undergo dramatically different weather conditions.

Using enhanced satellite imagery, the extent of tree cover in North America can be seen from space along with the Boreal

The Boreal Forest

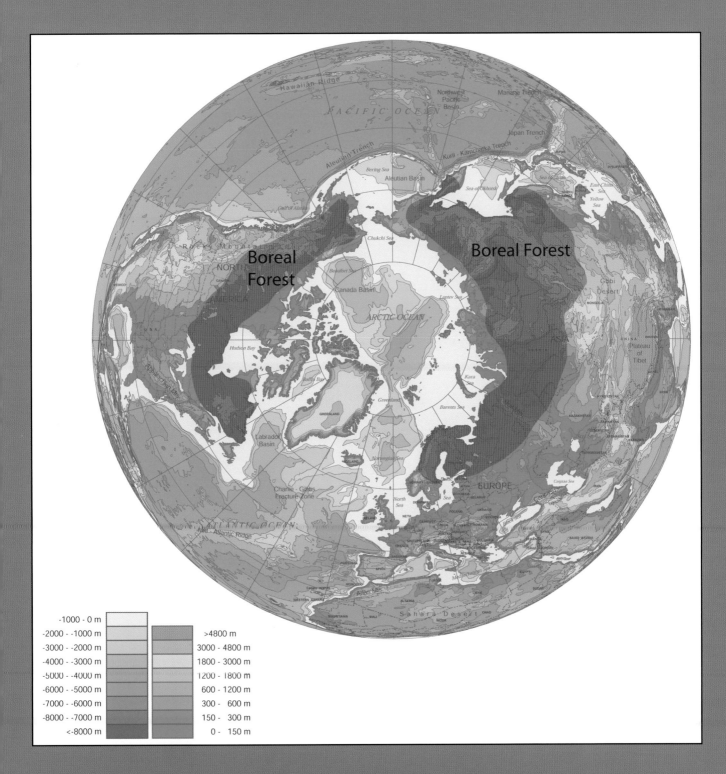

Boreal Forest

Boreal Forest

-1000 - 0 m	>4800 m
-2000 - -1000 m	3000 - 4800 m
-3000 - -2000 m	1800 - 3000 m
-4000 - -3000 m	1200 - 1800 m
-5000 - -4000 m	600 - 1200 m
-6000 - -5000 m	300 - 600 m
-7000 - -6000 m	150 - 300 m
-8000 - -7000 m	0 - 150 m
<-8000 m	

▲ Covering roughly 6.5 million square miles, the Boreal Forest blankets the earth in a halo of green.

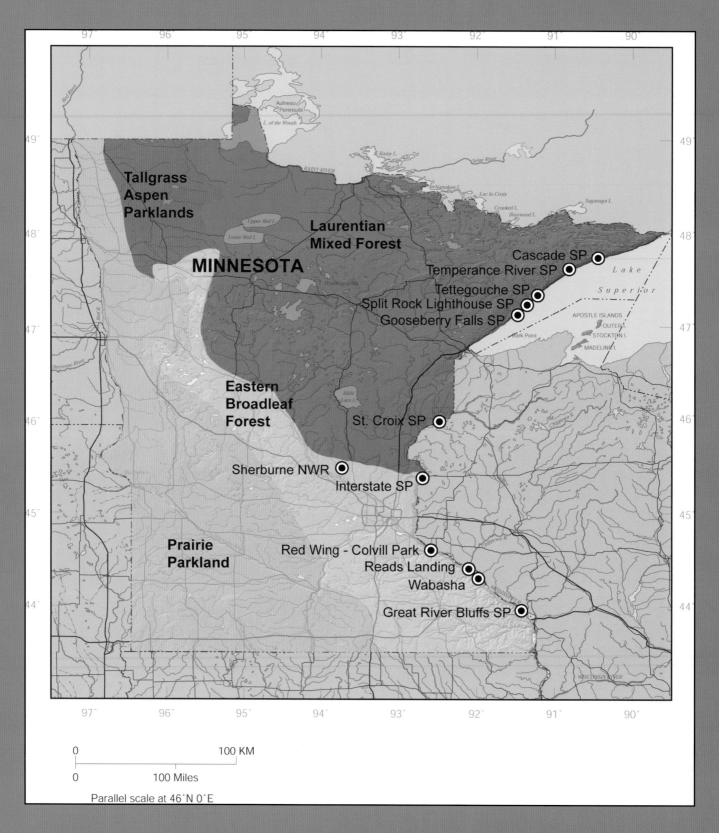

▲ Ecological Provinces. *Courtesy of the State of Minnesota, Department of Natural Resources.* ▶ Minnesota Satellite Image, *Landsat 7 and National Elevation Dataset. U.S. Geological Survey Department of the Interior / U.S. Geological Survey, http://eros.usgs.gov/*

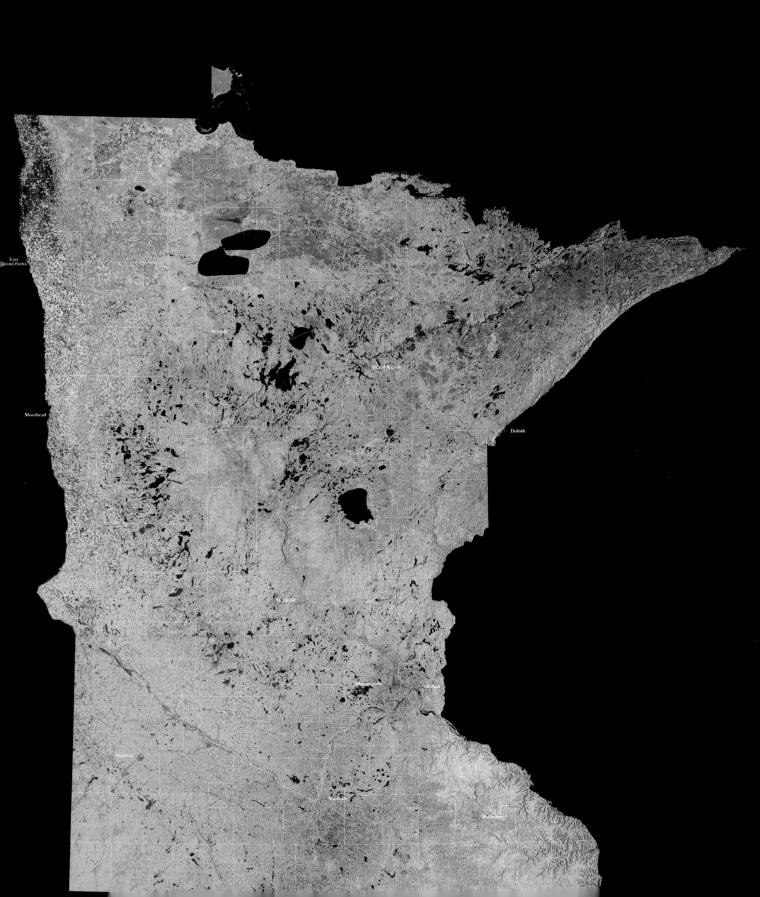

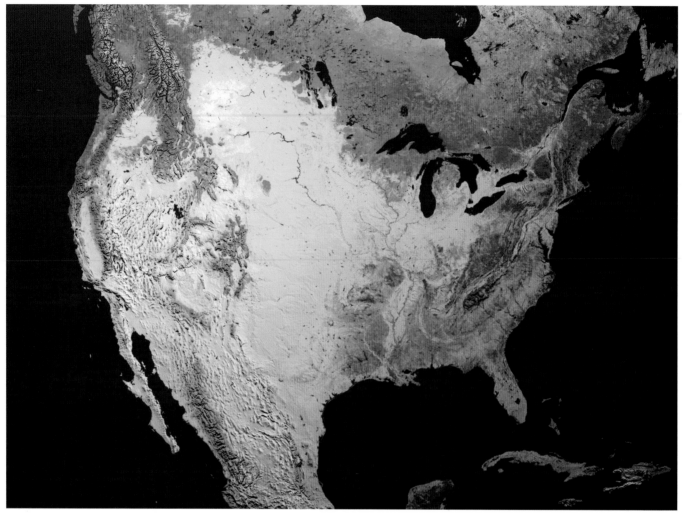

▲ Enhanced Satellite Imagery, North American Tree Cover. *Image by Robert Simmon, based on data provided by Matt Hansen, University of Maryland Global Land Cover Facility , NASA GSFC, Visible Earth http://visibleearth.nasa.gov/*

Forest that sweeps briefly into northern Minnesota, Wisconsin, and the Upper Peninsula of Michigan. In shades of white (no tree cover) to deep green indicating 100% tree coverage, the influences of urban cities, farming, terrain and unspoiled land are visible. On the east coast, major clearing and arteries can be seen in New York, New Jersey, and Maryland. Along the Mississippi, trees have been cleared to make way for farming and development. In the central Midwest, a mixture of prairie and farmland dramatically divides the United States creating a vast area of land void of significant forestation. Interestingly, this bread basket of agriculture has also contributed significantly to migratory waterfowl populations. Finally, lining the west coast, Washington, Oregon, and Northern California, continue to host heavily forested areas in the Pacific Northwest.

While the climatology, geology, and ecology of Minnesota today can be quite varied across the state, that has not always been the case as much of North America, including Minnesota, was buried under an immense ice sheet 15,000 years ago during the Ice Age. As glaciers advanced and receded, major land features were abraded and eroded leaving behind unique geologic features, thousands of smaller lakes, and the Great Lakes that includes Lake Superior. Today, the seasonal cycles of bitter winters, renewal in the spring, summer heat, and vivid colors of fall are repeated year after year. Gone are the very dramatic changes the landscape once stood witness to in the past such as ancient seas, geologic change, lava outflows, and glaciation.

One of the more interesting areas of Minnesota is along its eastern boundary with Wisconsin. Here, the states are divided by Lake Superior, national scenic rivers, great bluffs, and a major waterfowl and avian flyway. Along this boundary with Wisconsin, Minnesota transitions quickly from the rugged, remote landscapes and dense Boreal Forest of the north to deciduous forests, plains, and waterways of the St. Croix and the headwaters of the Mississippi. Nowhere in the state is such a dramatic transition visible.

Using the latest in digital photography equipment and techniques, the seasonal rhythms across this transition of Boreal Forest to Plains are explored through a number of state, regional parks, and national wildlife refuges in Minnesota along and near this border. I've hiked and photographed these areas for years and finally undertook a project to better see the changes that occur within these ecosystems over a year that to many of us can go unseen for a lifetime. Through photographic technique and experience, the subtle patterns of change in wildlife, vivid colors, and sweeping landscapes through the seasons come to life as a living planet.

This book is broken into four major sections representing the winter, spring, summer and fall seasons within this portion of the state. Returning to these areas each season not only revealed the major changes of climate, but the interdependency of wildlife and ecology on the land. The Common Loon for example relies heavily on the water resources within the State of Minnesota. Studying and photographing these birds feeding their young year after year at Sherburne National Wildlife Refuge can only continue if sufficient habitat is available, free from shoreline development, pollution and boaters. Our refuge system offers this protection that in many areas around the state continues to be threatened by development. As fall approaches and immature loons take to flight for the first time, it is critical they develop the skills not only to fly but to hunt and sustain life during migration. If these basic elements are disrupted, a successful migration may not be possible and the likelihood of returning for another season is doubtful.

A very similar pattern is seen with Bald Eagles within the state. In the winter, hundreds of Bald Eagles camp-out along open stretches of water on the St. Croix and Mississippi, invading small towns such as Red Wing or Wabasha. When spring comes they move back to inland areas very often returning to previous nesting sites. For the last six years at Sherburne National Wildlife Refuge nesting Bald Eagles have produced on average two offspring each year and can be easily observed right off the road.

These interdependencies of wildlife, seasonal changes, vivid colors, and the rugged landscape are the focus of this book. To capture these images not only takes a passion for the subject, but also the equipment and perseverance to uncover the story. Over the years I've deepened my reliance on Canon equipment. All of the images within this book were shot with either the 16 mega-pixel Canon 1Ds Mark II or the 8 mega-pixel Canon 1D Mark II. I will touch briefly on the advantages of both pieces of equipment and the various techniques used to capture these images with numerous tips along the way.

Finally, it should be noted that none of the images within this work would have been possible without the thousands of hours of effort and financial commitment by state and industry leaders over the years to conserve and preserve our great Minnesota environment.

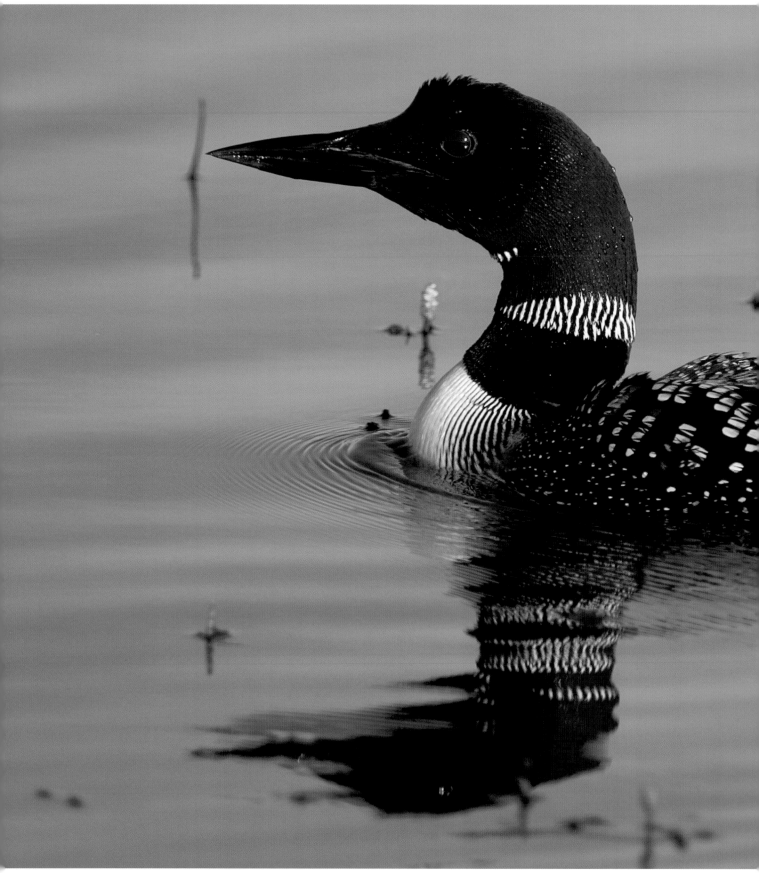

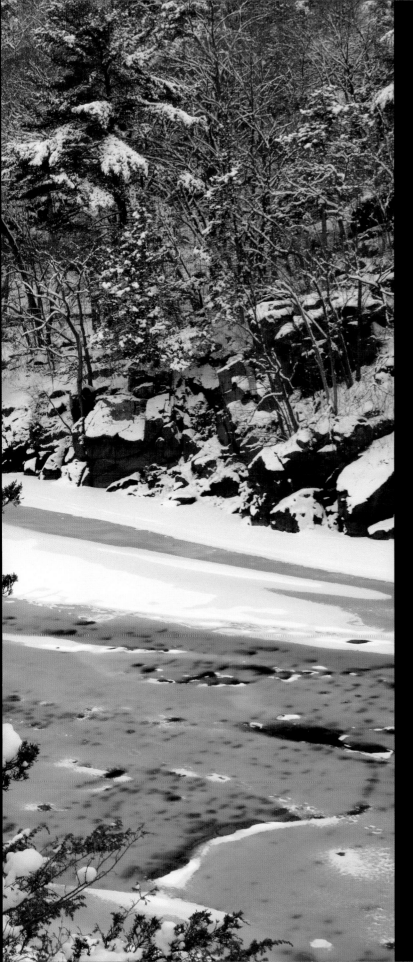

Winte

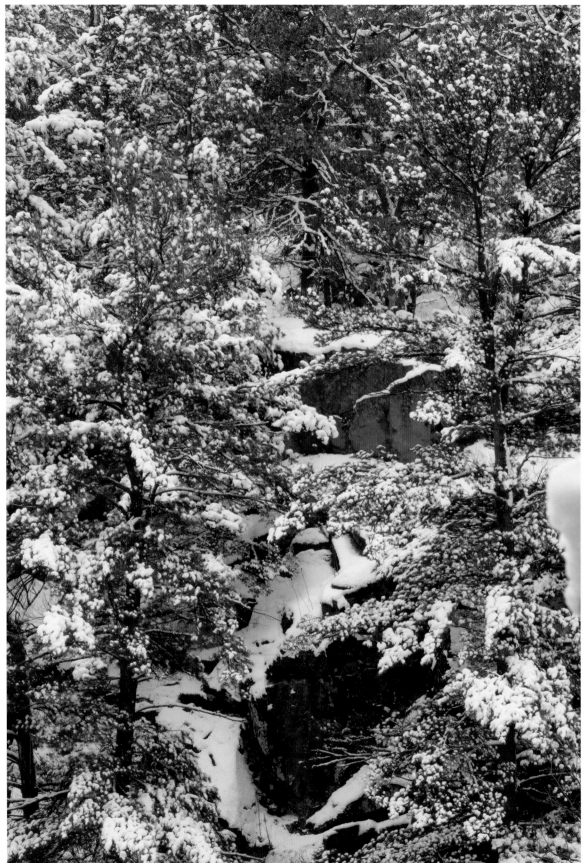

Interstate Park

Hiking along a snow and ice covered ridgeline high above the St. Croix River in Wisconsin, massive basalt blocks nested between pine trees are briefly revealed during a strong winter storm. Across the canyon lies Minnesota, while down below the St. Croix River quietly slips through the canyon known as the Dalles of the St. Croix.

There are few places I have found within Minnesota that best exemplify the remnants of the Ice Age as here. Rugged landscapes, lakes, erosion, exposed geology, fossils, rivers, and of course - no shortage of brutal winters. Established in 1895 in Minnesota, and then five years later in Wisconsin, Interstate Park was the first park in the Nation to span state boundaries. This insightful conservation was an important step that preserved a critical geologic record from mining and development that helped to unravel millions of years of glacial and geologic activity in the region.

Roughly a billion years ago, this area was very active with lava flows stretching from northern Minnesota to Iowa. Covered by advancing and retreating seas, sedimentary rock was compacted down over millions of years only to be eroded by glacial outflows that formed Lake Superior and carved the St. Croix and Mississippi Rivers. Today a heavy, wet snow has blanketed the icy trail. With large snowflakes coating my clothes and equipment, I made my way to a ledge overlooking the St. Croix.

◀ Winter storm blankets Interstate Park with heavy wet snow. *Canon 1d Mark II Camera, 100-400mm f/4 lens, 235mm, ISO 100, 1/8 second at f/22.*

Hiking Tips

• *Avoid hiking alone.* It seems obvious, but winter hiking can be especially dangerous due to the icy paths, hidden terrain, and cold temperatures. If you must hike alone, always let someone know where you will be and your expected return.

• *Dress appropriately.* Plan for the worst, expect the best. Waterproof boots, pants, and breathable insulating layers will facilitate your safe return in comfort for a long, strenuous hike.

• *NEXRAD Radar.* I always check the outside temperature for the area I plan to hike along with looping radar from www.noaa.gov for the likelihood of precipitation. This allows me to better position for rapidly changing conditions and time my visit for optimal conditions.

Weather

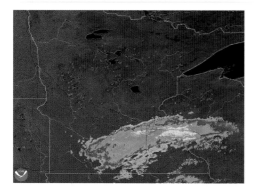

Digital Equipment

• *Know your equipment.* It's cold, a heavy wet snow is falling, and ice has formed - no time to be fumbling for a manual. Minutes spent stationary with gloves off can dramatically reduce your sustainability in cold temperatures.

• *Lens Hood.* Adding a lens hood not only reduces lens flare and increases contrast, it can limit pelting rain, ice, or snow from reaching the front lens element.

• *Extra Batteries.* Today's high speed digital cameras require power that can be diminished in cold temperatures. Adding a spare battery to your camera backpack is well worth the extra weight.

• *Minimize changing lenses in the field.* Inevitably when you want to change lenses, high winds or blowing snow can create a real problem by accumulating ice particles on your sensitive CCD or CMOS sensor, or front lens element. Select a zoom or fixed focal length in advance with the hiking area in mind for the desired coverage.

While winter storms are not uncommon in Minnesota, catching them at just the right time and place for photography can be a challenge. In early January a strong winter storm developed over the lower Central Plains pulling warm, moist air up from the Gulf of Mexico spawning numerous tornados in Kentucky and Georgia overnight. NEXRAD radar from www.noaa.gov showed the tight counter-clockwise rotation with heavy precipitation bands approaching from the south-southeast. A handy tool used by meteorologists and savvy photographers to estimate the type and likelihood of precipitation is the Skew-T/Log-P plot shown below and is available at www.spc.noaa.gov/exper. Based on instrumented radio balloons released twice a day, this plot examines air temperature (red line on the right below) and dewpoint (middle line) from the surface to 40,000ft. At 9,000 ft the dewpoint approached the air temperature at 7 deg C forming precipitation. As it descended, the temperature cooled to -3 deg C allowing sufficient time for large snowflakes of heavy, wet snow to form.

In these conditions, time is of the essence as wind can quickly disturb the accumulated snow on the branches. Often following a heavy, wet snow, ideal conditions can last as few as thirty minutes, so it's important to be in the right place at the right time by knowing the area in advance and allowing time for travel. Returning to hiking areas regularly throughout the season allows you to anticipate conditions and ideal shooting locations when adverse weather strikes.

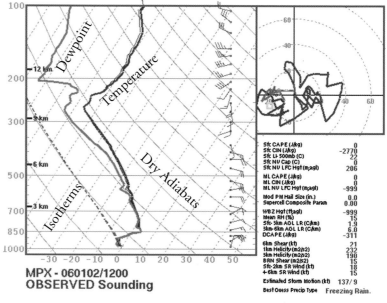

Skew-T / Log-P January 2, 2006
NOAA / National Weather Service Storm Prediction Center

▶ Warm upper atmosphere and dewpoint temperatures combine with cool surface temperature to form heavy, wet snow. *Canon 1d Mark II Camera, 100-400mm f/4 lens, 180mm, ISO 100, 1/13 second at f/22.*

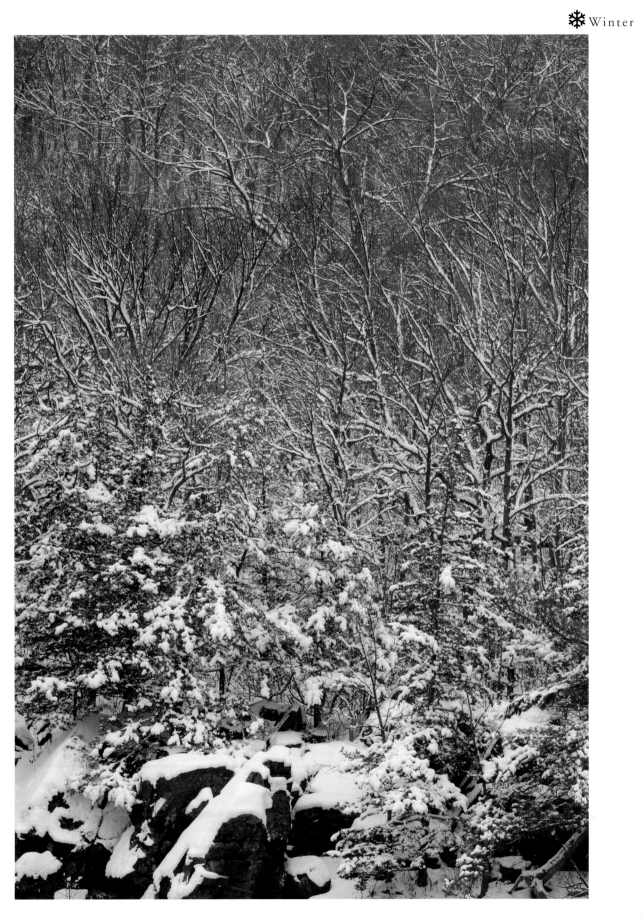

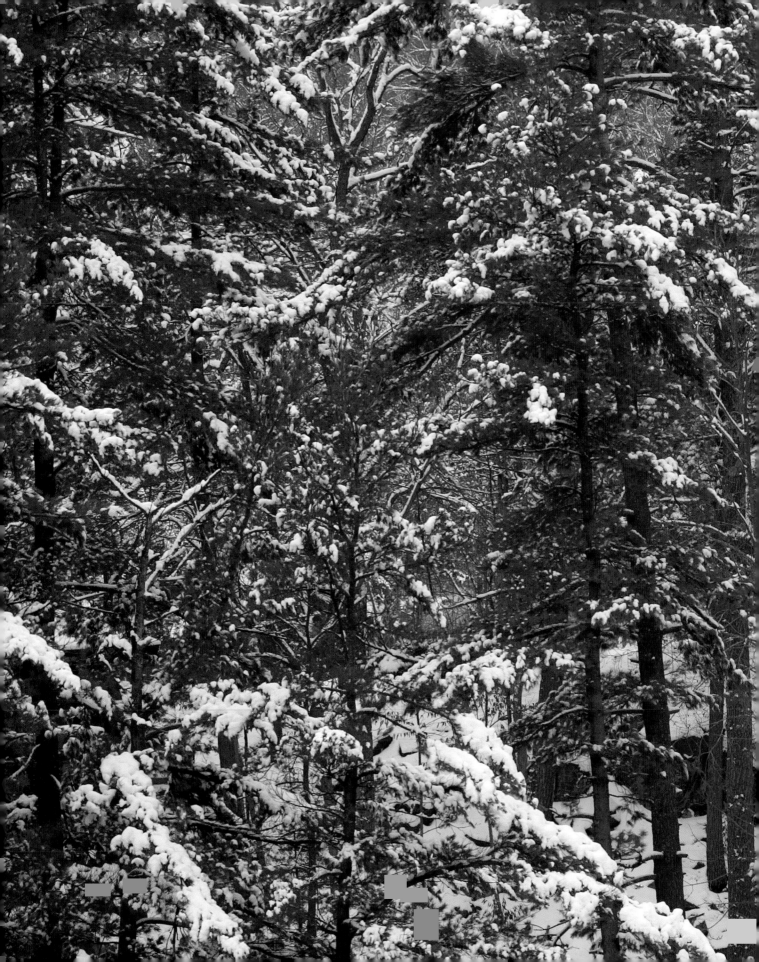

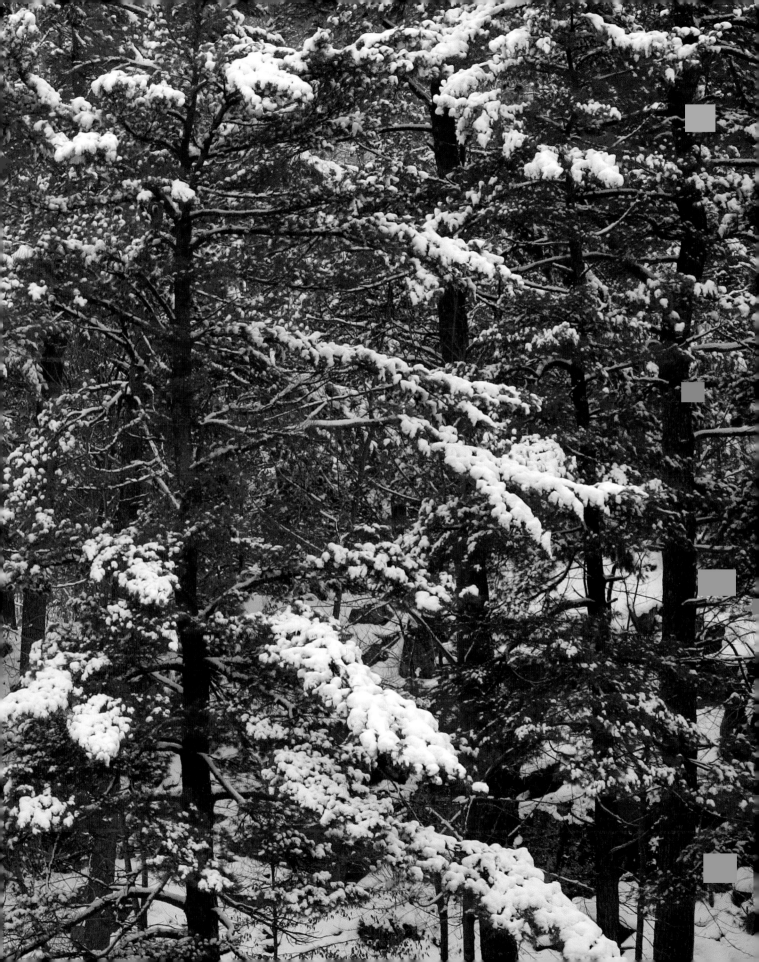

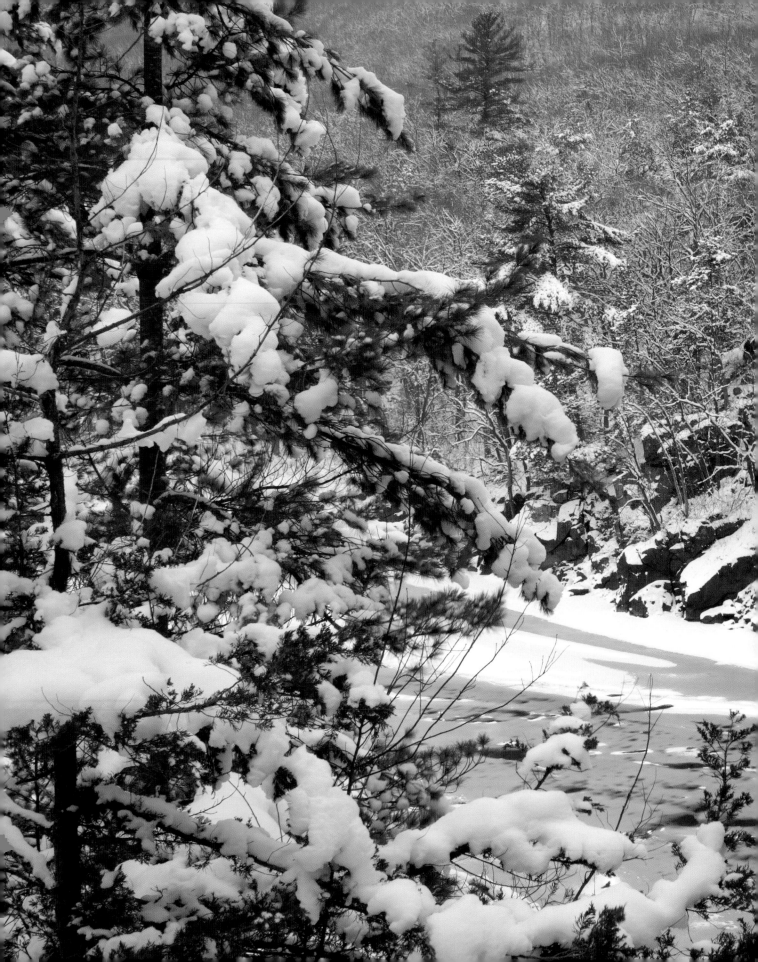

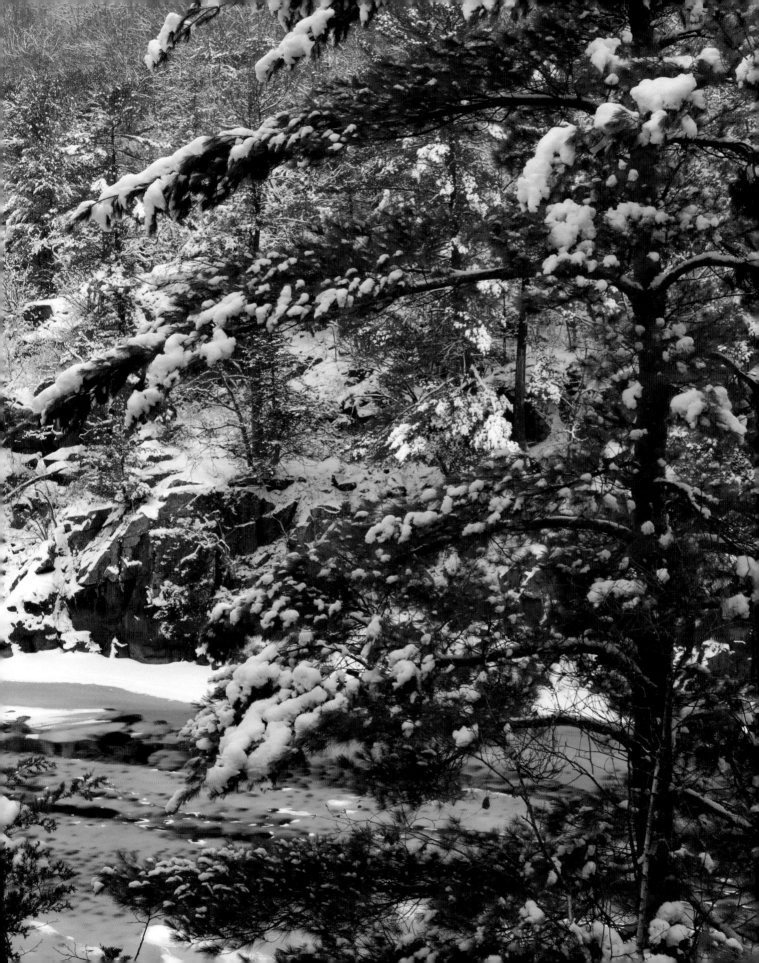

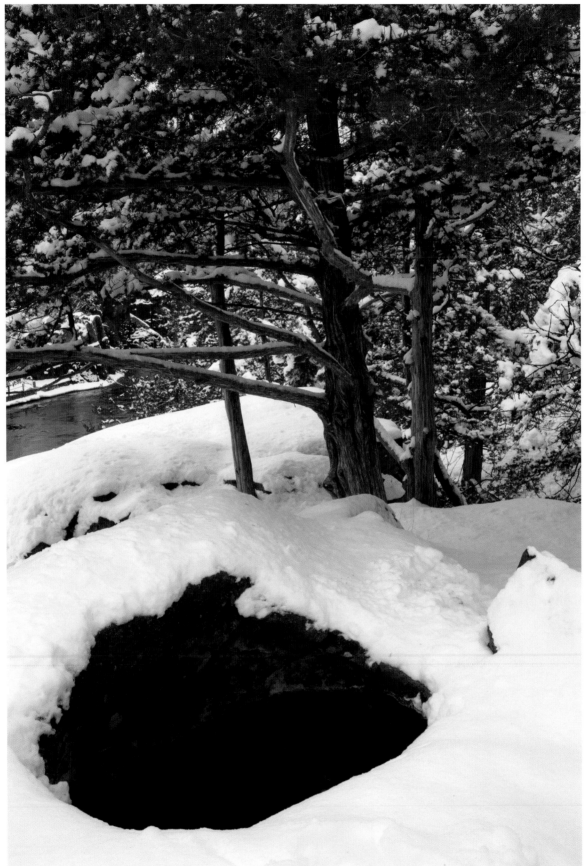

Perspective, Shifts and Hazards

Just as important as the design content of an image, controlling the perspective and depth of field are essential elements of landscape photography. To keep from distorting the landscape unnaturally, very often I reach for the Canon 45mm f/2.8 or 90mm f/2.8 Tilt-Shift Lenses to increase the range of focus between foreground and background objects within an image also referred to as depth of field. Similar to a view camera, these perspective control lenses tilt the optical axis to increase the depth of field resulting in an extreme range of focus within an image at larger apertures and faster shutter speeds, critical for low-light landscape photography where windy conditions can blur branches. Exceedingly sharp and fast, these lenses can also shift to the left and right to form stunning post-processed panoramic images in Adobe Photoshop by simply stitching together multiple images.

When working in the field on winter days with lenses like these, it's easy to get distracted. Take great care on the trail to avoid hazards such as ice, potholes, and steep sandstone cliffs. Formed thousands of years ago by swirling sand and rocks from glacial run-off, potholes can be 10 feet deep, difficult to see, and unexpected. Unseen ice under a fresh layer of snow can also be a real hazard to hikers with heavy backpacks.

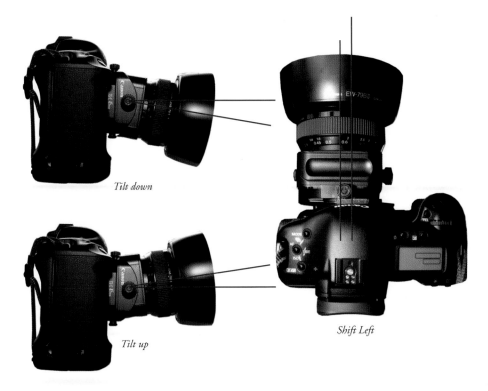

Tilt down

Tilt up

Shift Left

▲ Lens shifts and tilts of the 45mm f/2.8 TS-E lens on the Canon 1D Mark II Camera.

◄ Pothole high above the St. Croix River. *Canon 1ds Mark II Camera, 45mm f/2.8 TS-E lens, ISO 100, 1/13 second at f/22.*

Photography / Hiking Tips

• *GPS/Cellphone.* Always hike with a cellphone. While coverage can be limited, in an emergency it can be a lifesaver.

• *Know your limits.* Hiking in the winter can be especially dangerous due to icy paths, hidden terrain, cliffs, supercooled streams, and extreme temperatures. Know the area you are hiking in and your physical limits. For longer hikes, bring ample food and water to remain hydrated.

• *Emergency Personal Locator Beacon.* While carrying a PLB may seem extreme, if you need the cavalry and cellphone coverage is not available, this can summon them anywhere in the world. Particularly when hiking in the Boundary Waters Canoe Area Wilderness, cellphone coverage can be spotty at best. In these areas a PLB is highly recommended.

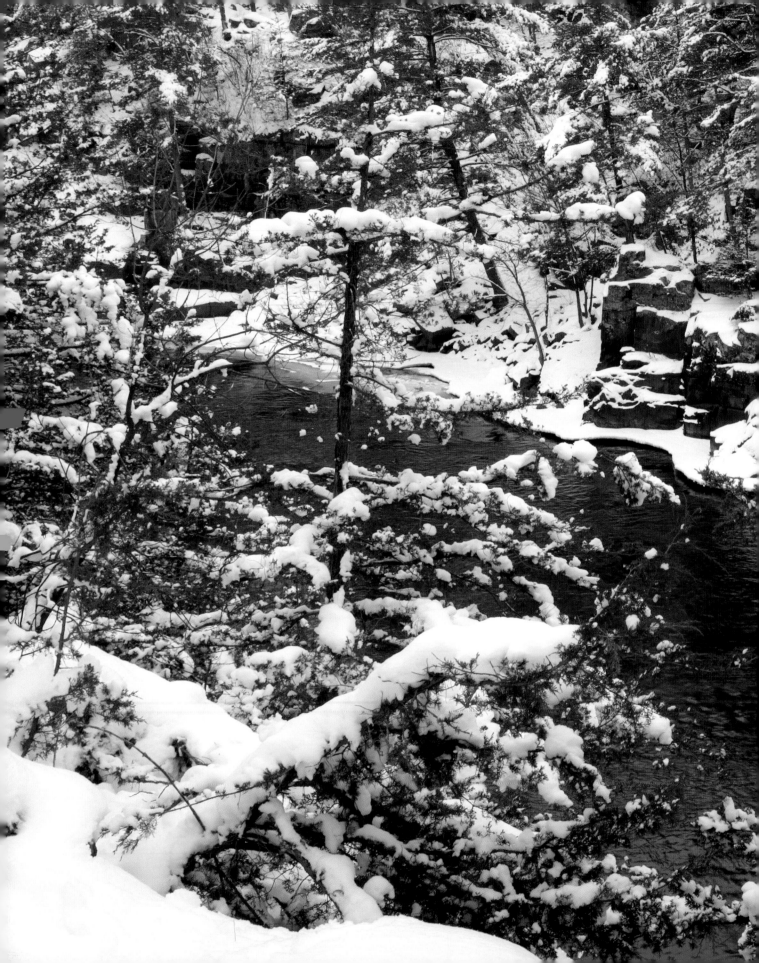

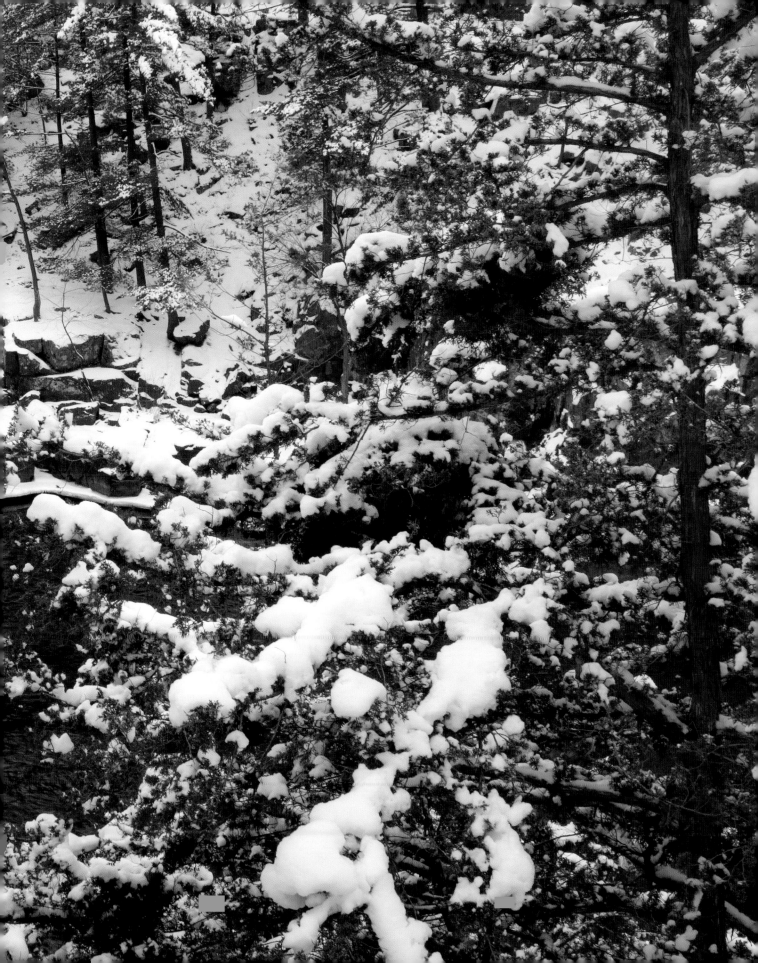

▲ A winter storm creates a winter wonderland along the Minnesota shore of the St. Croix. *Canon 1ds Mark II Camera, two images stitched together, 45mm f/2.8 TS-E lens, ISO 100, 1/10 second at f/22.*

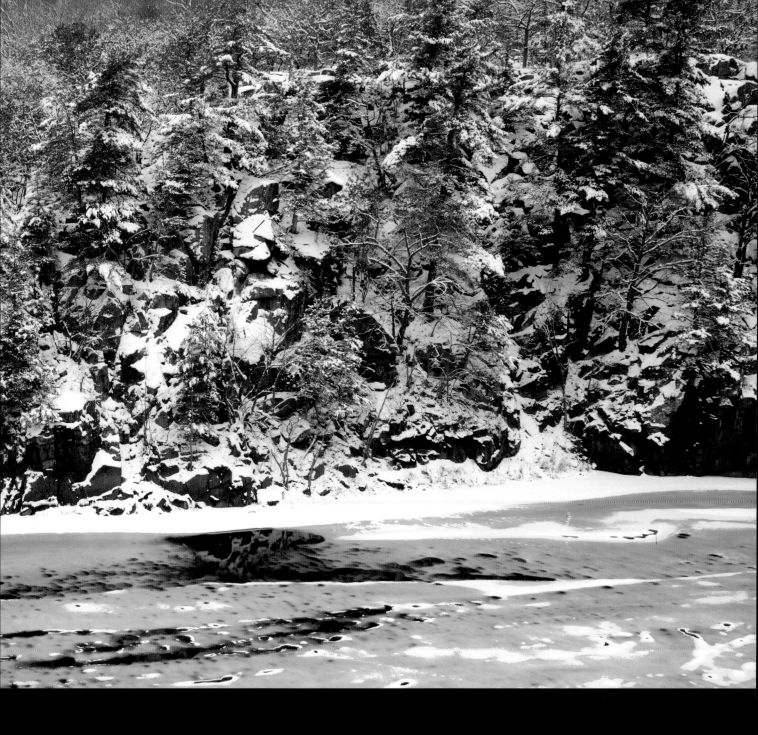

Perspective

▲ Conifers and White Birch line the St. Croix. *Canon 1ds Mark II Camera, two images stitched together, 45mm f/2.8 TS-E lens, ISO 100, 1/8 second at f/22.*

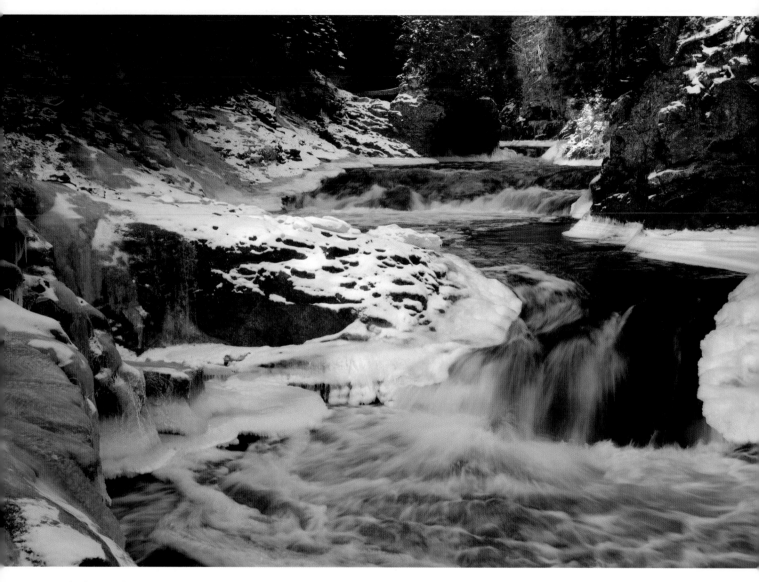

▲ The Cascade River powers its way to Lake Superior through The Cascades in early December. *Canon 1ds Mark II Camera, 45mm f/2.8 TS-E lens, ISO 100, 1/8 second at f/20.*

The North Shore

In northern Minnesota, rugged igneous rock stands firm against the relentless waves of Lake Superior. Extending from Duluth to Grand Portage near the Canadian border, numerous state parks, streams, and cliffs line the lake in mile after mile of amazing landscapes. In the winter the land is transformed into a magical array of ice sculptures, stained from the leaves of autumn as the water races its way down to Lake Superior.

▶ Cascade Falls shrouded in ice. *Canon 1d Mark II Camera, 100-400mm f/4 lens, 100mm, ISO 100, 1/25 second at f/9.*

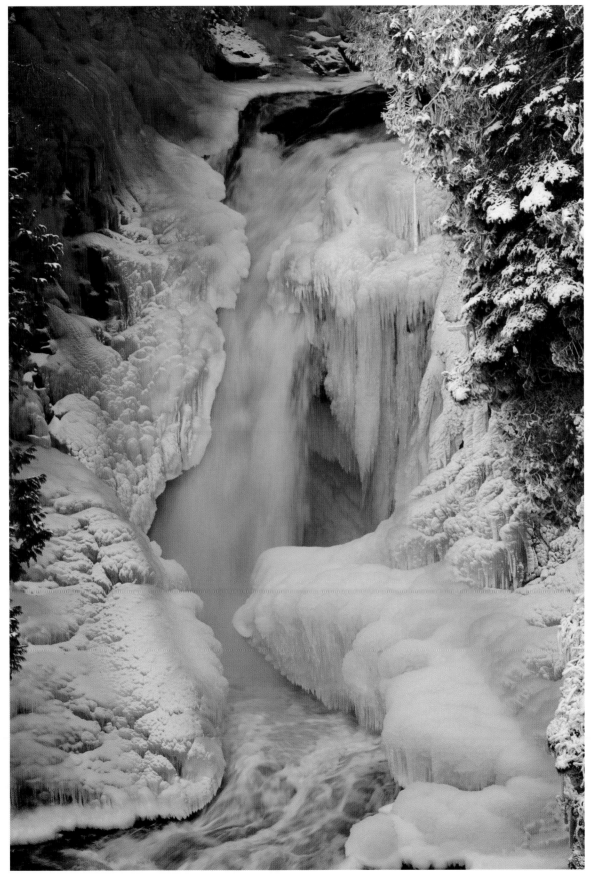

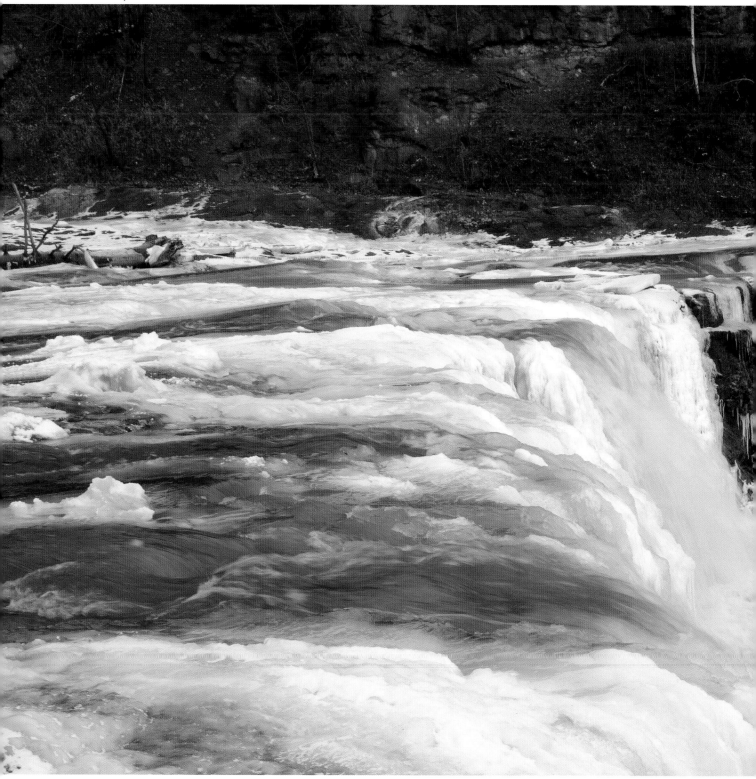

▲ As winter progresses, the Upper Falls of Gooseberry State Park continues to flow while building up significant ice structures. *Canon 1ds Mark II Camera, 45mm f/2.8 TS-E lens, ISO 100, 1/30 second at f/20.*

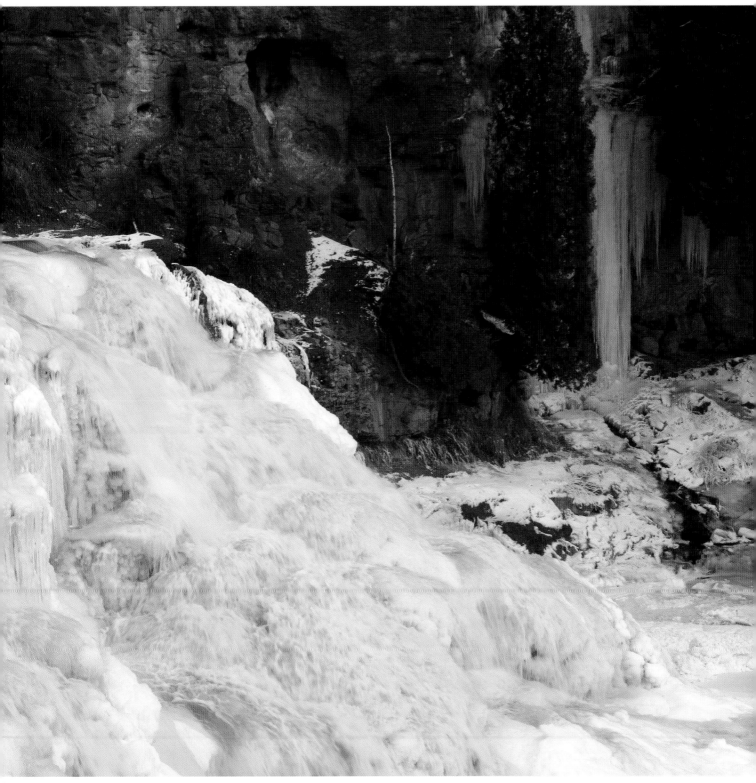

Winter Waterfalls

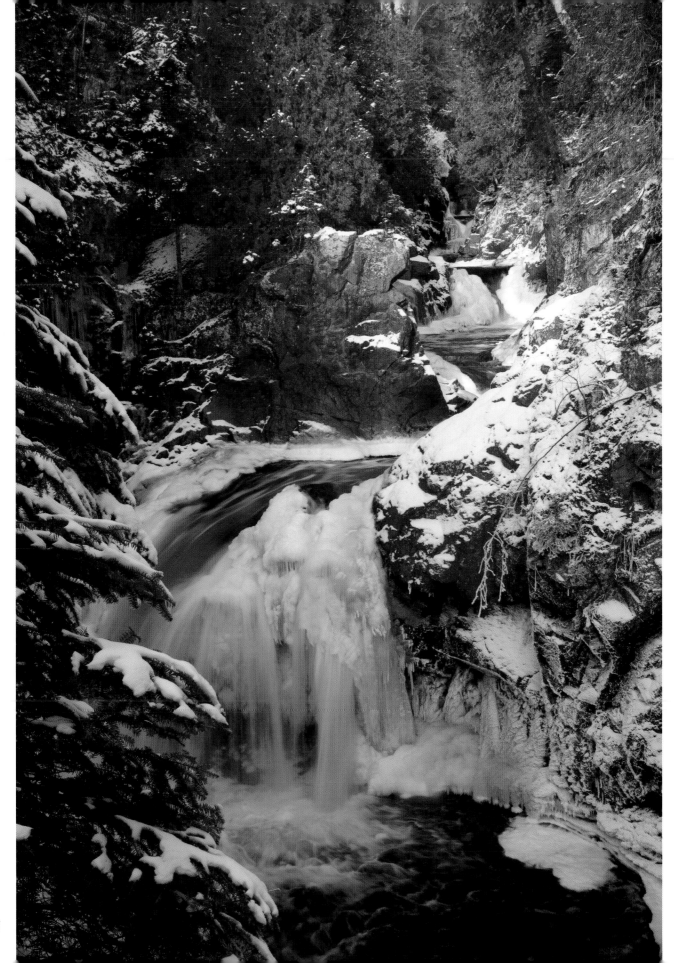

Managing Exposure

Icy temperatures come quickly in the north country. The long sunlit summer evenings part ways and plunge the North Shore into cold days and long nights. Soon, arctic fronts collide with warm, moist air from the south dumping snow on the ice-lined streams. Depending on the time of day and weather, controlling digital photography exposures can be a challenge as strong sunlight and deep shadows can easily exceed the dynamic range of the CMOS or CCD detector on your camera. Using a Split Graduated Neutral Density filter is generally not a good choice due to the deep canyons and irregular landscape. In these cases, I will expose to maintain definition in the brightest whites and take multiple images varying the exposure to maintain contrast in dark areas. Then in Adobe Photoshop, I'll merge and make selective adjustments of dark and highlight regions to return them to a natural balance of light.

◀ Cascade River State Park. *Canon 1ds Mark II Camera, 45mm f/2.8 TS-E lens, ISO 100, 1/8 second at f/22.*

▼ St. Croix State Park, *Canon 1d Mark II Camera, 100-400mm f/4 lens, 160mm, ISO 1250, 1/160 second at f/5.*

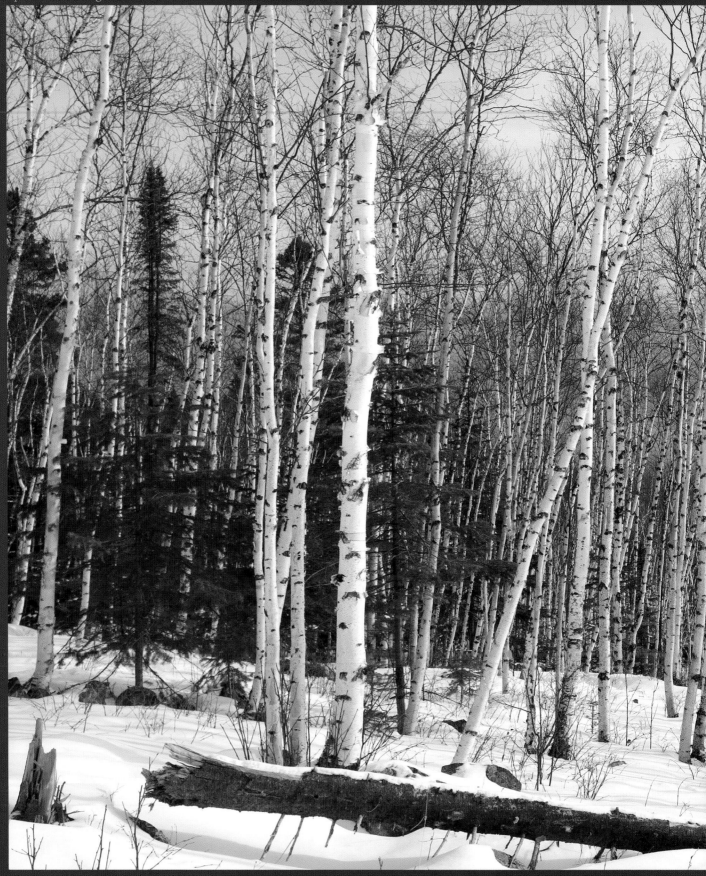

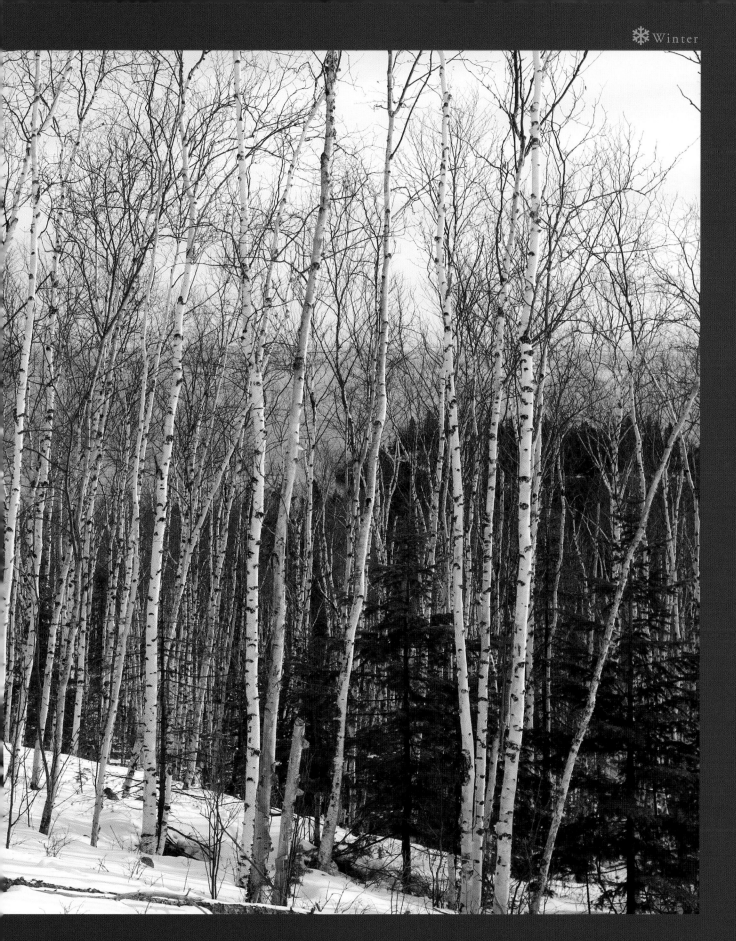

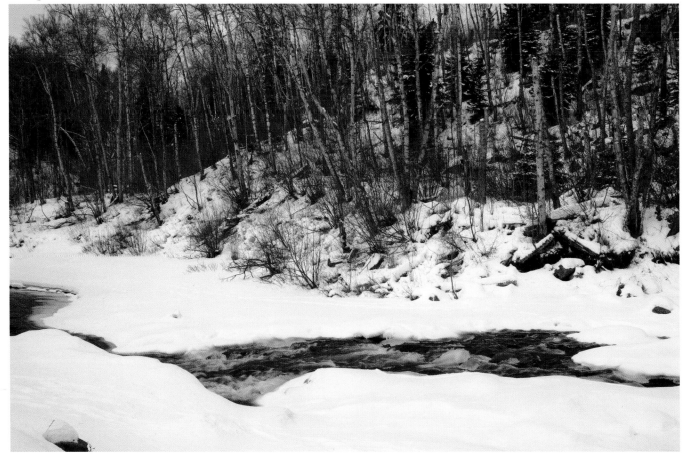

▲ Supercooled water flows on the Temperance River at the height of winter. *Canon 1ds Mark II Camera, 45mm f/2.8 TS-E lens, ISO 100, 1/30 second at f/22.*

Winter Streams

By mid-January, the North Shore is blanketed with thick snow. Bitter temperatures regularly plunge below 10F with extremes well into -30F. Strong northerly winds can be accelerated down the narrow canyons of the Temperance River State Park driving wind chills below -20F in local microclimates. Despite the cold temperatures, the Temperance River continues to flow with super-cooled water draining into Lake Superior. With more than half of the river now covered with ice and snow, navigating hiking trials is all but impossible for the inexperienced hiker. Snowshoes with ice-gripping cleats are highly recommended along with an intimate knowledge of the trail locations in less severe conditions.

▶ Temperance River. *Canon 1ds Mark II Camera, 45mm f/2.8 TS-E lens, ISO 100, 1/13 second at f/22.*

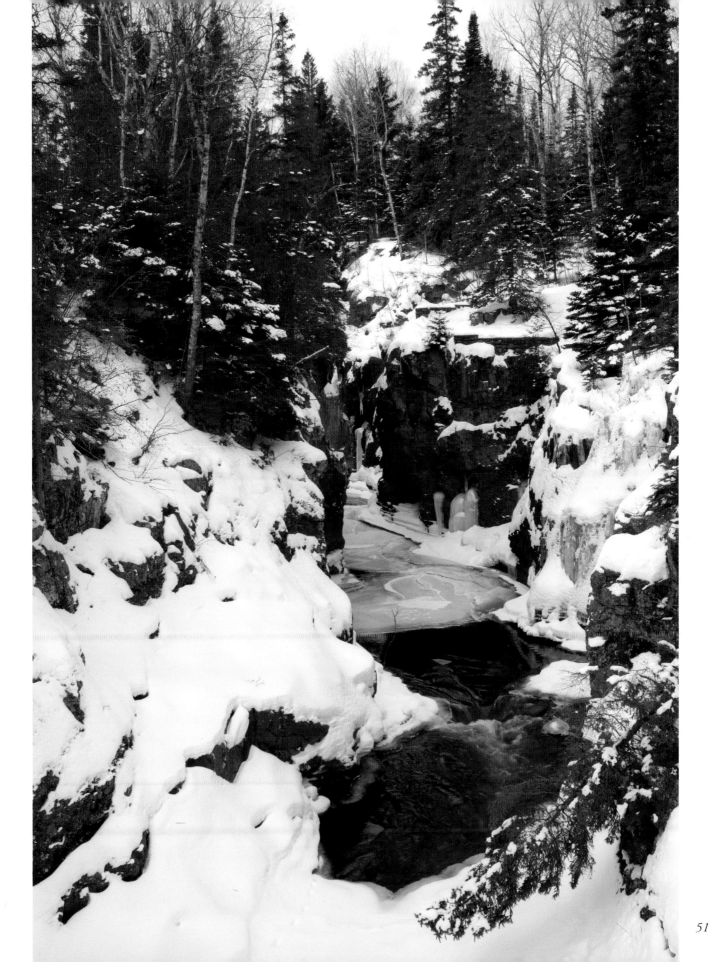

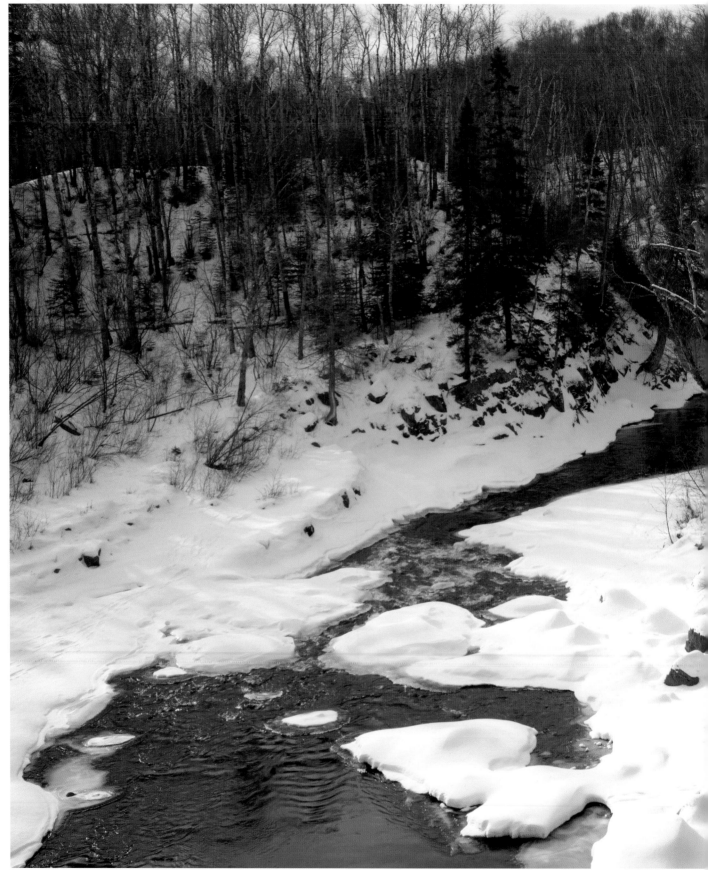

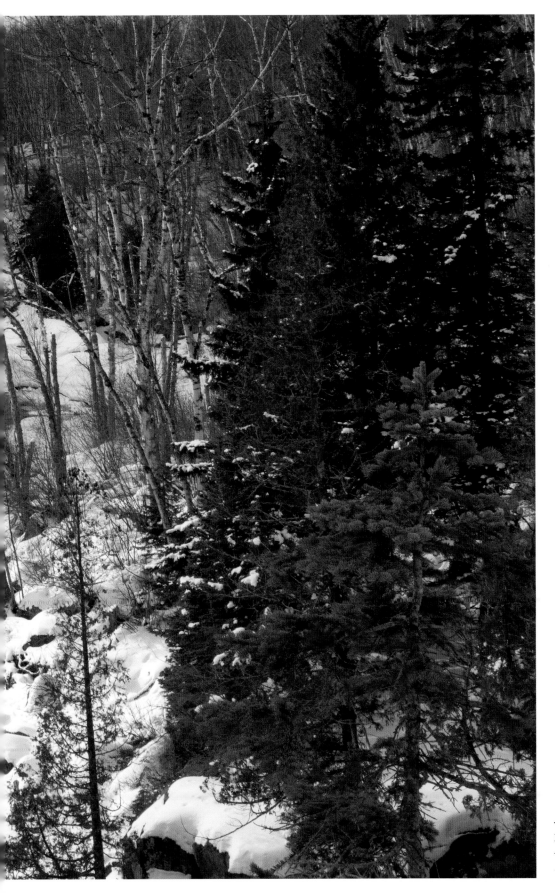

◄ High above the Temperance River. *Canon 1ds Mark II Camera, 45mm f/2.8 TS-E lens, ISO 100, 1/30 second at f/22.*

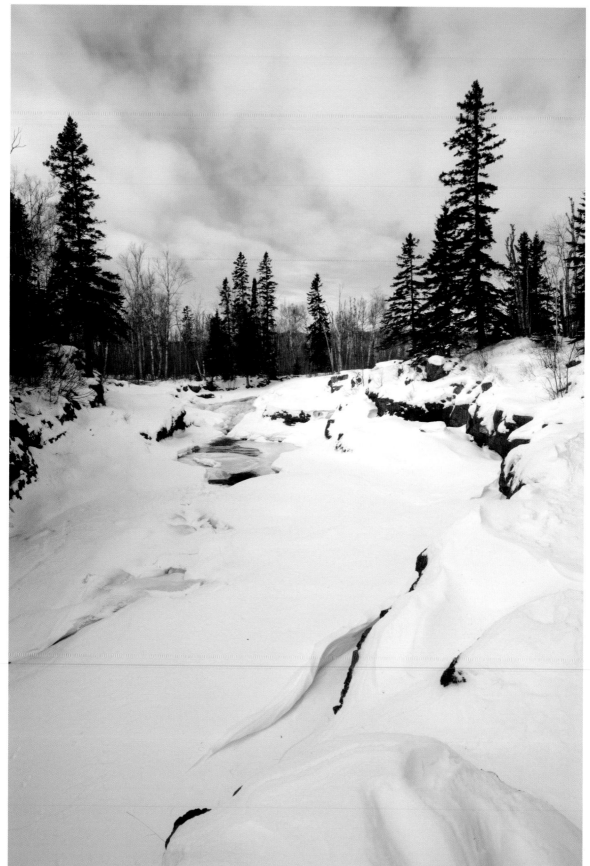

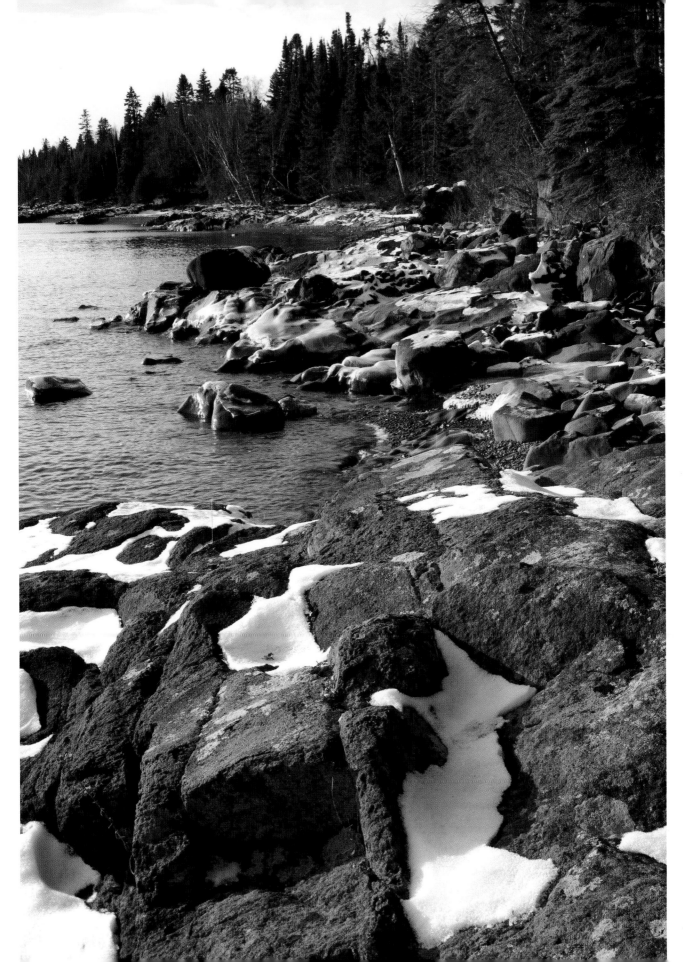

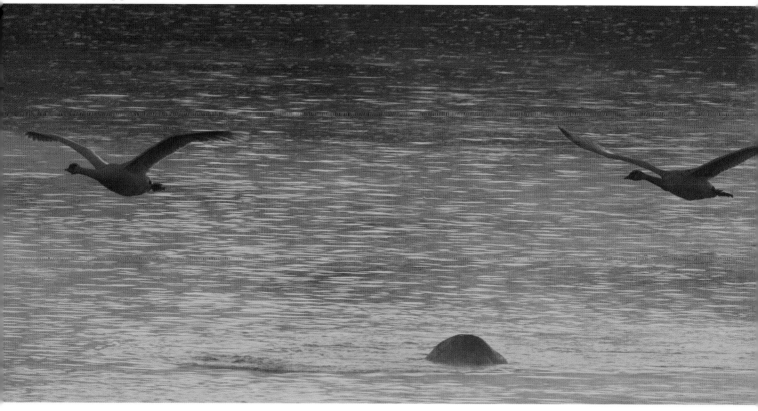

▲ Wintering Trumpeter Swans fly along the Mississippi River at sunrise, Monticello, MN. *Canon 1d Mark II Camera, 500mm f/4 lens, ISO 400, 1/1000 second at f/8.*

▼ Trumpeter Swans power their way into the air. *Canon 1d Mark II Camera, 500mm f/4 lens, ISO 400, 1/640 second at f/6.3.*

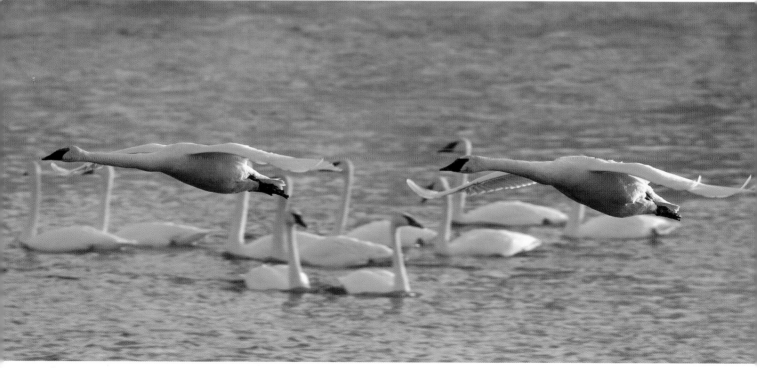

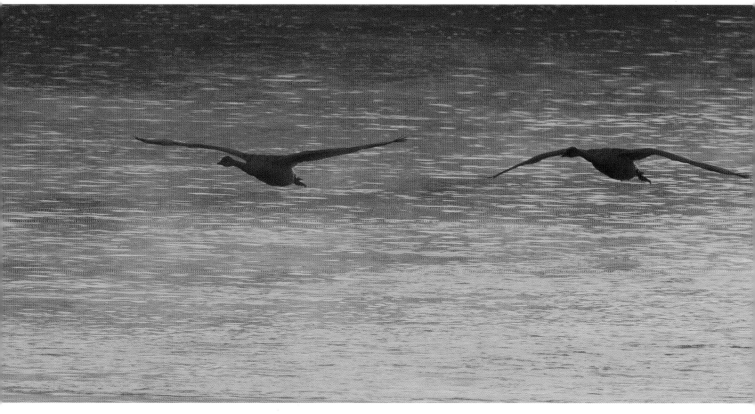

Trumpeter Swans

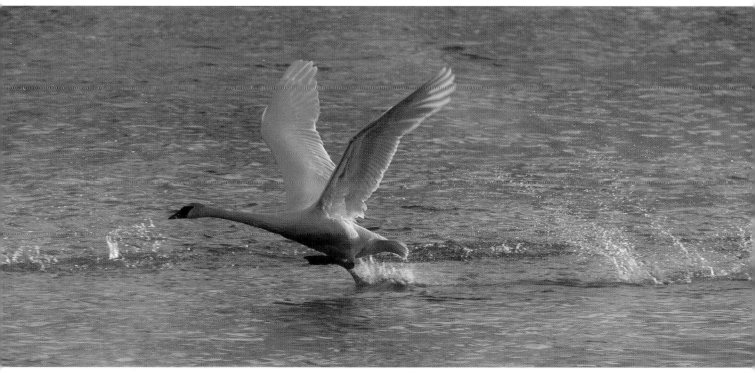

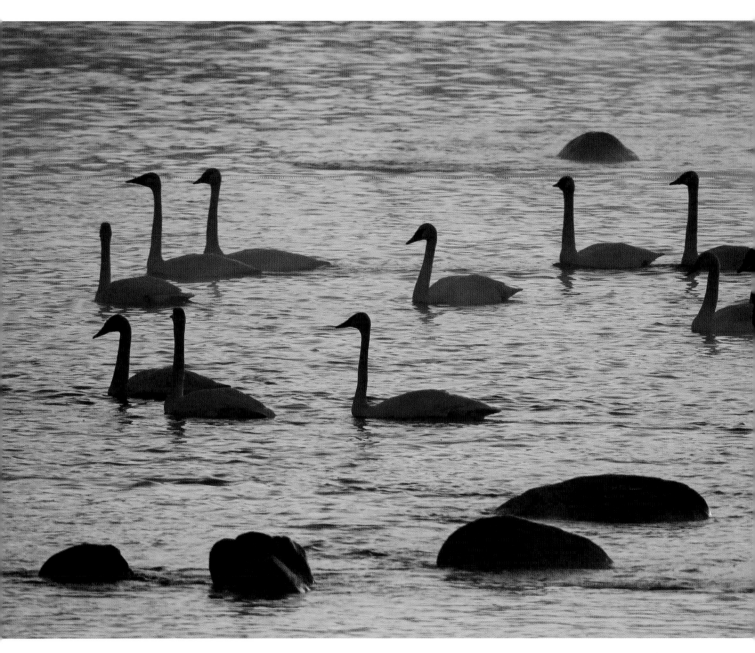

▲ Trumpeter Swans at sunrise on the Mississippi River, Monticello, MN. *Canon 1d Mark II Camera, 500mm f/4 lens, ISO 400, 1/1250 second at f/6.3.*

Just to the southwest of Sherburne National Wildlife Refuge, wintering Trumpeter Swans find open water along the Mississippi River sufficient to remain in the state year-round. Warm water discharges from the upstream Monticello Nuclear Power Plant raise water temperatures and is a welcome sight in an otherwise frozen landscape. Just a mere 500 feet wide at this location, the Mississippi River moves at a slow pace. At sunrise the river erupts with color as the swans welcome in a new day.

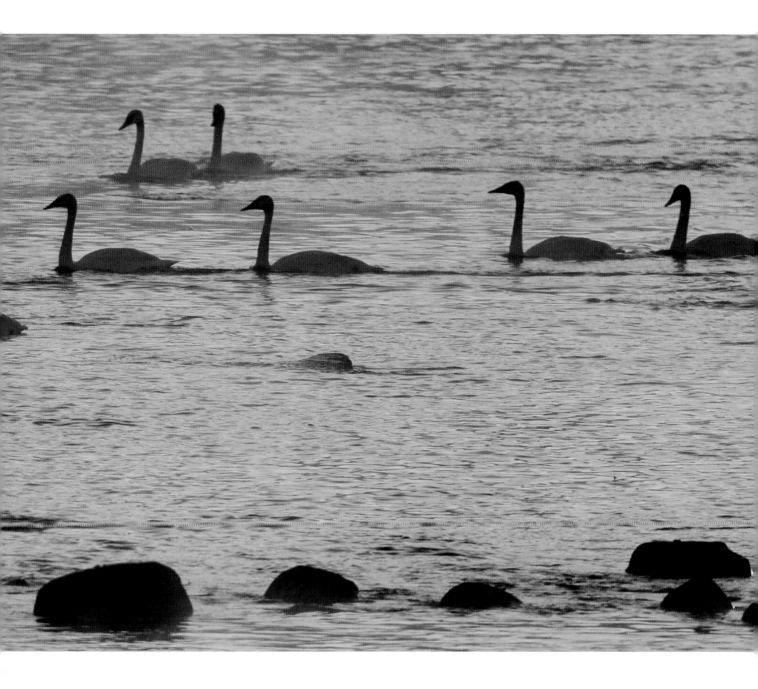

Sunrise

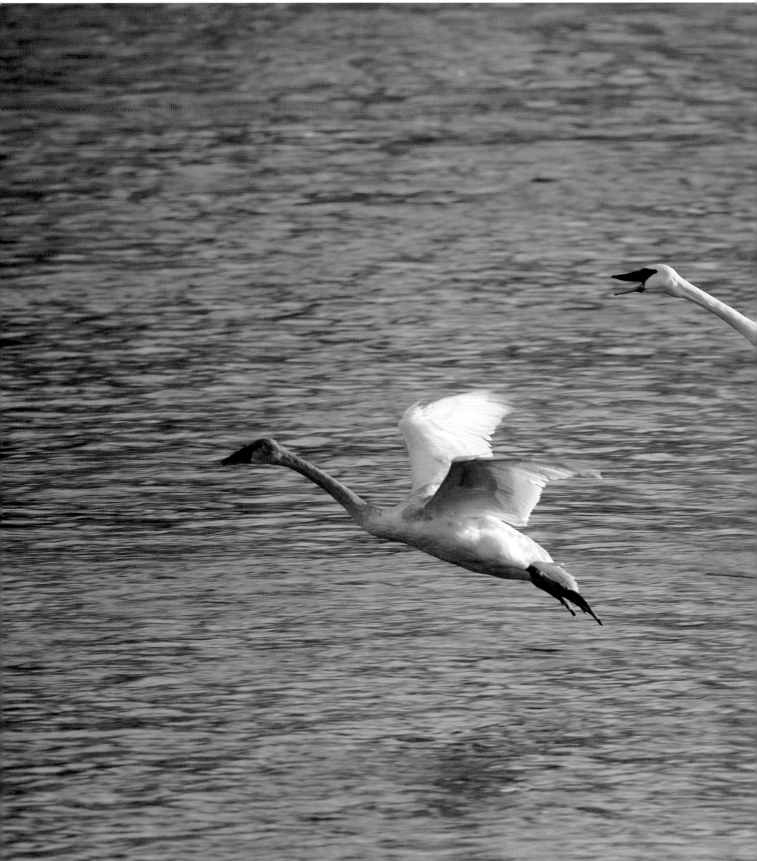

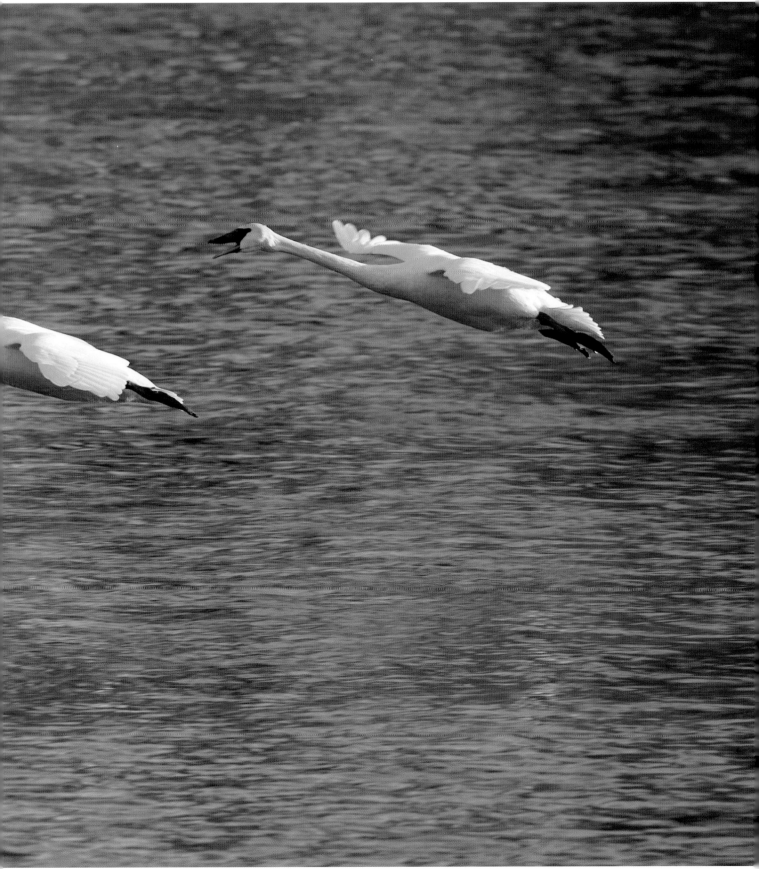

Meandering Rivers

Minnesota is not only known for its magnificent lakes, but also is home to the St. Croix National Scenic Riverway and headwaters of the Mississippi River. Along the eastern boundary of the state, the St. Croix enters from Wisconsin and becomes a major state boundary. At its furthest northern point within Minnesota, the river is a modest 300 feet across. For a 120 miles the St. Croix gently twists and turns, carving a path through sandstone cliffs and bedrock basalt. At its southern terminus north of Red Wing, the river has grown by a factor of 8 times to over 2,400 feet across to merge with the Mississippi. Within a span of just 30 miles, three great rivers, the St. Croix, Minnesota, and Mississippi, have combined into one known again as the Mississippi.

Satellite imagery not only shows the modern day course of the St. Croix, but also provides a clue to its former boundaries near the St. Croix State Park. During the last glacial period 10,000 years ago, meltwater from Lake Superior swelled into the St. Croix driving it to over 1.5 miles wide. This very significant flow of water and momentum scoured underlying lava fields, deposited rich sediments and carved intricate sandstone cliffs and potholes along the way.

Today, this violent past has subsided and rugged cliffs and outstretched trees provide a perfect wintering location for Bald Eagles.

Digital Equipment
• *Flexibility.* When hiking riverways in the winter, I typically pack two cameras: one with a mounted wide angle zoom lens, the other with a 100-400mm telephoto for wildlife. Since these areas are lightly traveled in the winter, it's easy to come up-on unsuspecting wildlife requiring a quick response to capture the image.

▶ Barely hanging on, soon this large tree will give way to the Kettle River within the St. Croix State Park . *Canon 1ds Mark II Camera, 16 - 35mm f/2.8 lens, 23mm, ISO 100, 1/5 second at f/22.*

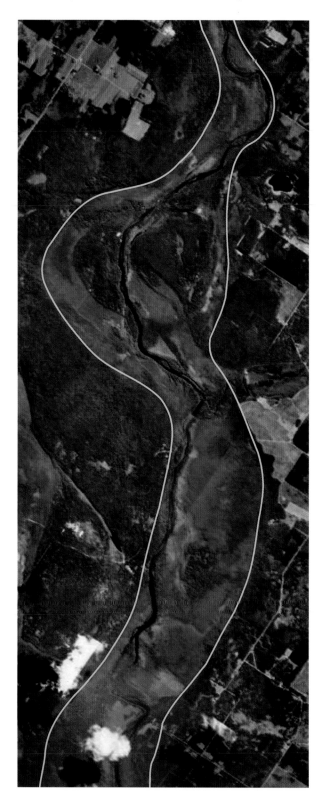

▶ Satellite image of St. Croix State Park showing the modern day river boundaries and former extremes.

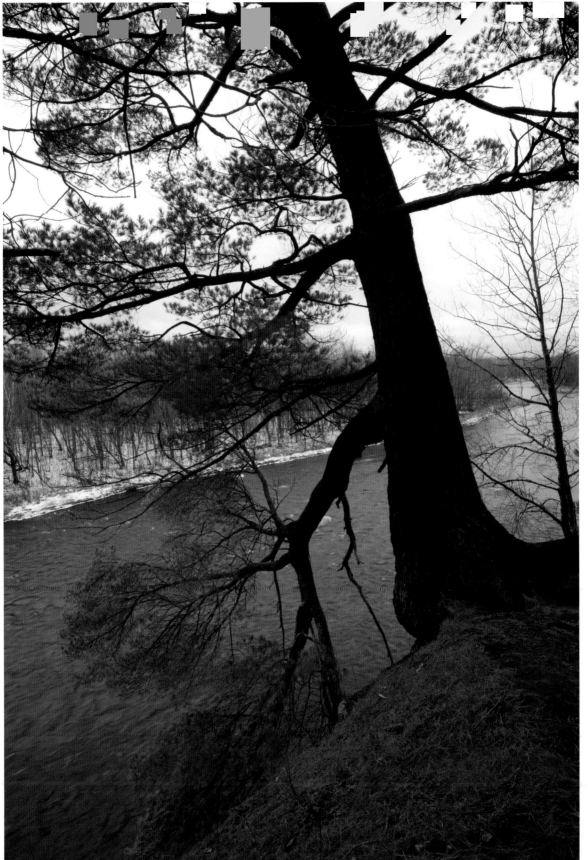

In Search of Wildlife

▶ The handy work of a Beaver at St. Croix State Park. *Canon 1ds Mark II Camera, 16 - 35mm f/2.8 lens, 34mm, ISO 100, 1/15 second at f/5.*

Hiking along the St. Croix in the winter can be a cold, monotonous trip with few signs of life or color. Along a slow moving section of the river I discovered a small doe crossing, quickly reached for my camera, and was able to get one shot from a considerable distance. Continuing back on the trail I found dozens of trees carefully cut by the handiwork of a beaver. Earlier in the morning I stumbled upon a Bald Eagle finishing off the remains of a fish on frozen Lake Clayton. Being the only hiker in the area for days, the eagle quickly saw me as an intruder and moved on before I could get a shot.

Wildlife interaction in the winter can be very subtle and requires an awareness of your surroundings, wildlife behaviors, winter habitats, and to also be prepared with your camera at the ready. With the exception of wintering Bald Eagles, winter wildlife can be challenging to find on foot as you can be seen long before you see the wildlife.

▼ A small doe crosses a quiet section of the St. Croix River. *Canon 1d Mark II Camera, 100-400mm f/4 lens, 400mm, ISO 100, 1/50 second at f/5.6.*

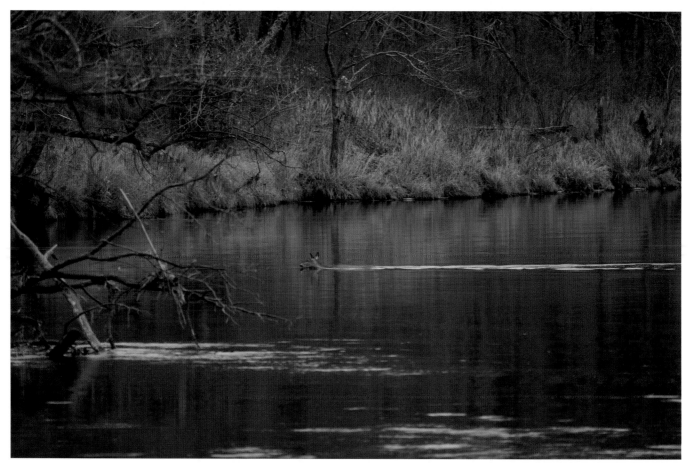

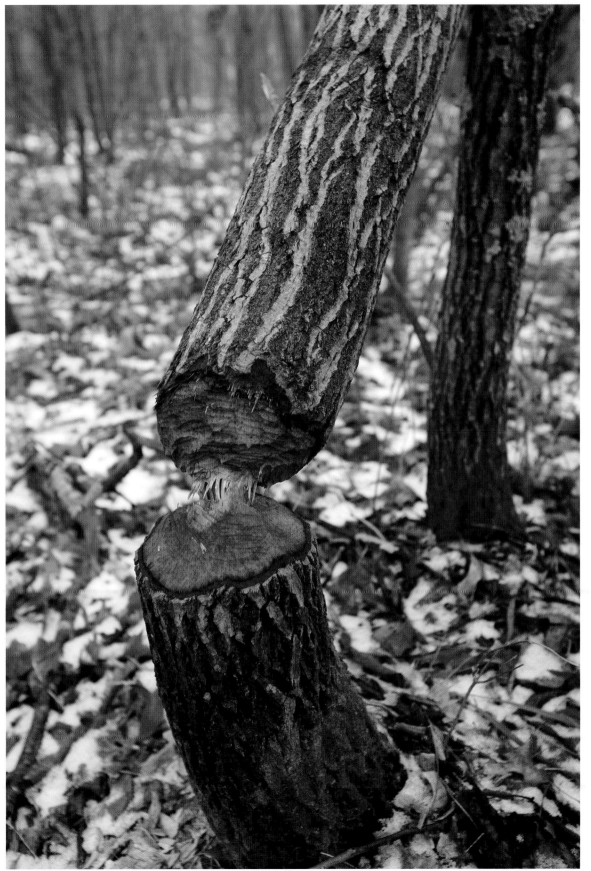

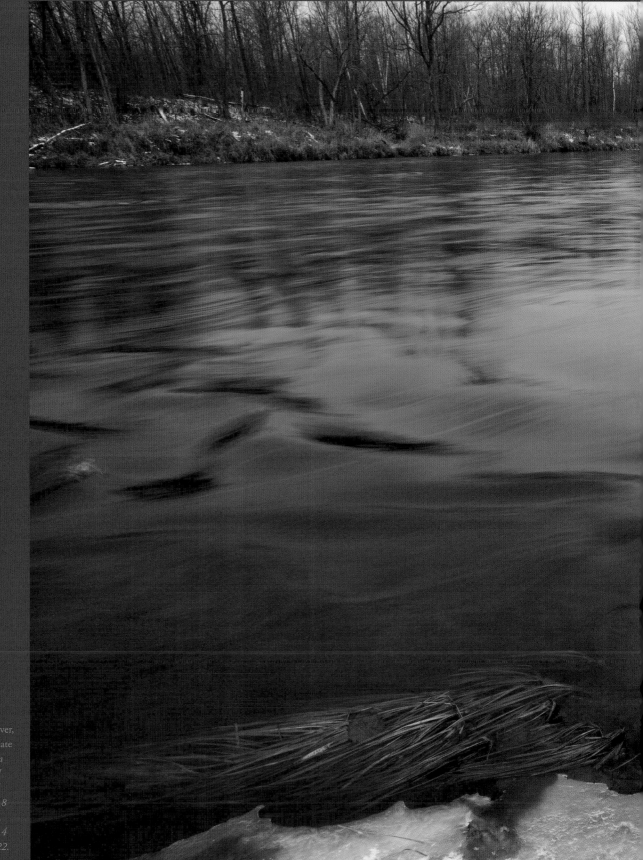

▶ Kettle River, St. Croix State Park, *Canon 1ds Mark II Camera, 16 - 35mm f/2.8 lens, 22mm, ISO 100, 0.4 second at f/22.*

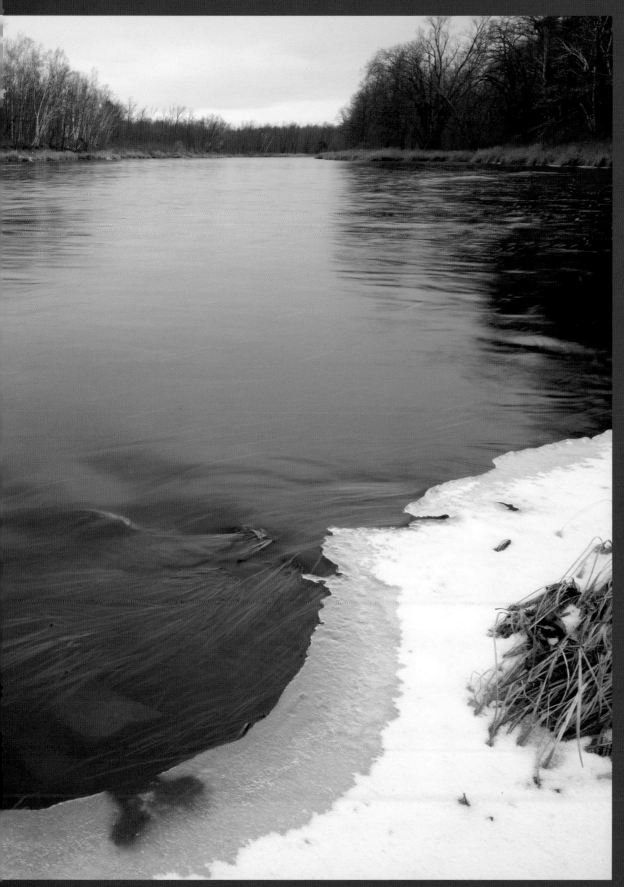

Lakes and River Banks

Lakes and small streams begin to freeze in early November and continue to build ice well into February. During this period of shortened daylight and cold temperatures, aquatic plants and algae die, decaying on stream and lake bottoms. As winter progresses heavy snowfall on the ice effectively cuts off sunlight into the water necessary for photosynthesis and the production of oxygen. Below the ice and snow, bacteria in the water facilitates the decay and breakdown of aquatic plants consuming large amounts of oxygen in the water. With dissolved oxygen levels in the water continuing to decline, remaining weeds

▼ A Bald Eagle carefully watches a stream below at the St. Croix State Park. *Canon 1d Mark II Camera, 100-400mm f/4 lens, 400mm, ISO 100, 1/60 second at f/5.6.*

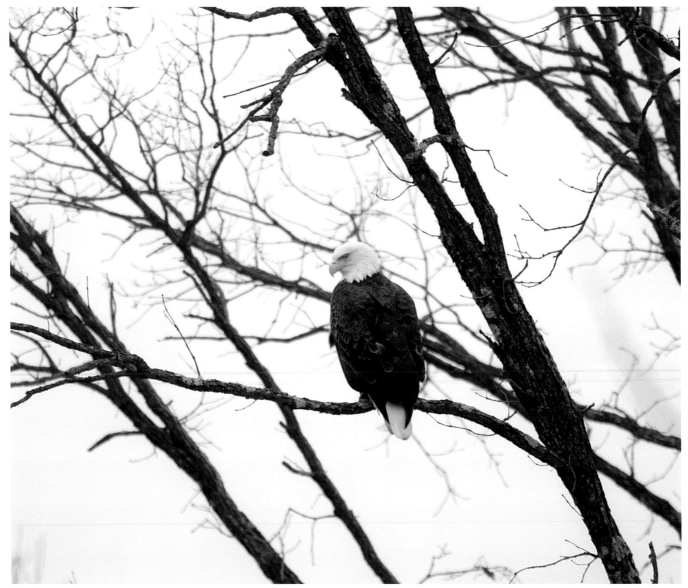

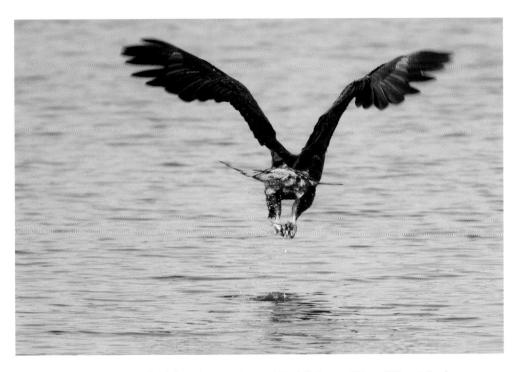

▲ A Bald Eagle snatches a small fish from the river. *Canon 1d Mark II Camera, 500mm f/4 lens, 1.4x teleconverter (effectively 910mm) ISO 320, 1640 second at f/5.6.*

stop producing oxygen from photosynthesis and rely on the remaining dissolved oxygen. This downward spiral of cold temperatures and lack of sunlight and oxygen-producing sources not only kills off aquatic materials, it can result in winterkill of fish. In Minnesota this process of life and death through seasonal changes is repeated each year. Winters with below average snowfall see fewer incidents of winterkill. Likewise, mild Decembers and early spring thaws effectively shorten the severity of winter and impact on photosynthesis critical to providing needed oxygen. In severe winter periods, it's not uncommon for dozens of lakes to experience significant winterkill of fish and aquatic plants.

Fast moving streams and merging rivers have the distinct benefit of remaining open due to the turbulent water not being able to freeze even in the most severe winter conditions. These parts of the river become an ecosystem oasis with abundant oxygen levels attracting large concentrations of fish, wintering migratory birds, deer, and Bald Eagles.

As the St. Croix twists and turns to make its way south to the Mississippi, portions freeze while others remain open. Within these open stretches Bald Eagles can be found carefully watching the water below for fish.

Digital Equipment

• *When possible shoot from the car.* Wintering Bald Eagles depend upon the availability of food sources scarce in the bitter winter. Open water next to roadways offers an excellent opportunity for photos. Using your car as a bird blind, eagles are generally not threatened by a vehicle as long as you do not get out of your car.

• *Use a window mount.* Photographing from a vehicle can be accomplished by using a window mount to attach your camera and lens to the door / window of your vehicle. This provides added stability and an opportunity to smoothly pan for birds in motion. I've found that shooting this way dramatically minimizes the impact on eagles.

• *Seek open water.* Open water in the winter is an oasis for wintering Bald Eagles. Carefully scan the shoreline trees, ridgelines, adjoining ice, and sky overhead.

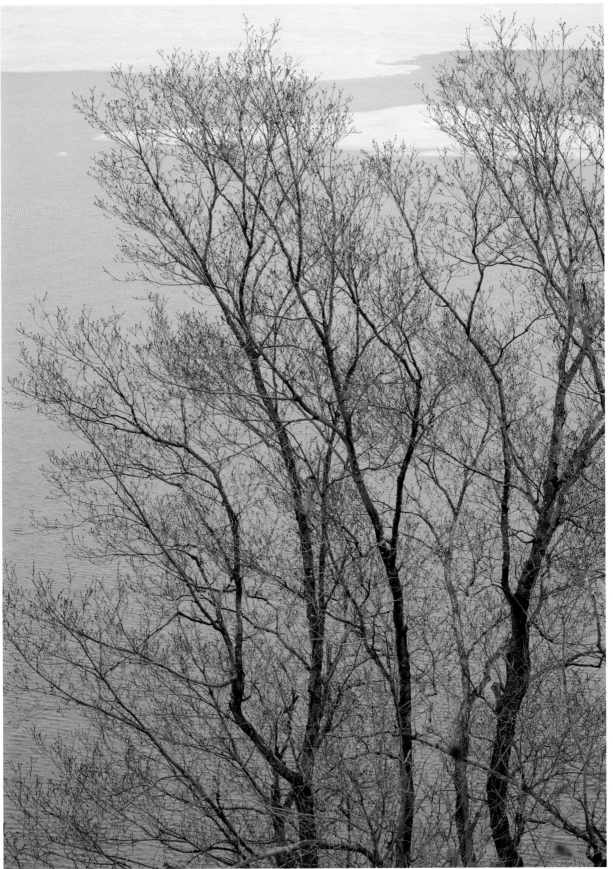

Wintering Bald Eagles

The abundance of lakes available in the summer supporting waterfowl, birds of prey, and fish in Minnesota are only outmatched by the availability of major riverways along the Minnesota / Wisconsin border supporting wintering Bald Eagles. While portions of the Minnesota, St. Croix, Mississippi, Chippewa, and other great rivers freeze, significant segments remain open due to swift currents and the discharge of warm water from power plants.

In the winter, southeastern Minnesota towns such as Red Wing, Reads Landing, Wabasha, and others along the Mississippi with open water undergo seasonal invasions of hundreds of Bald Eagles. As winter advances and retreats, so too does the river ice and eagles. Almost daily, wintering Bald Eagles adjust by moving up or down river to stay near to the open water and food sources. Swiftly cruising overhead or intently watching from the shore, the river has become the life-blood of the winter ecosystem.

▶ A swift moving juvenile Bald Eagle sweeps through Colvill Park in Red Wing. *Canon 1d Mark II Camera, 500mm f/4 lens, 1.4x teleconverter (effectively 910mm) ISO 640, 1/500 second at f/5.6.*

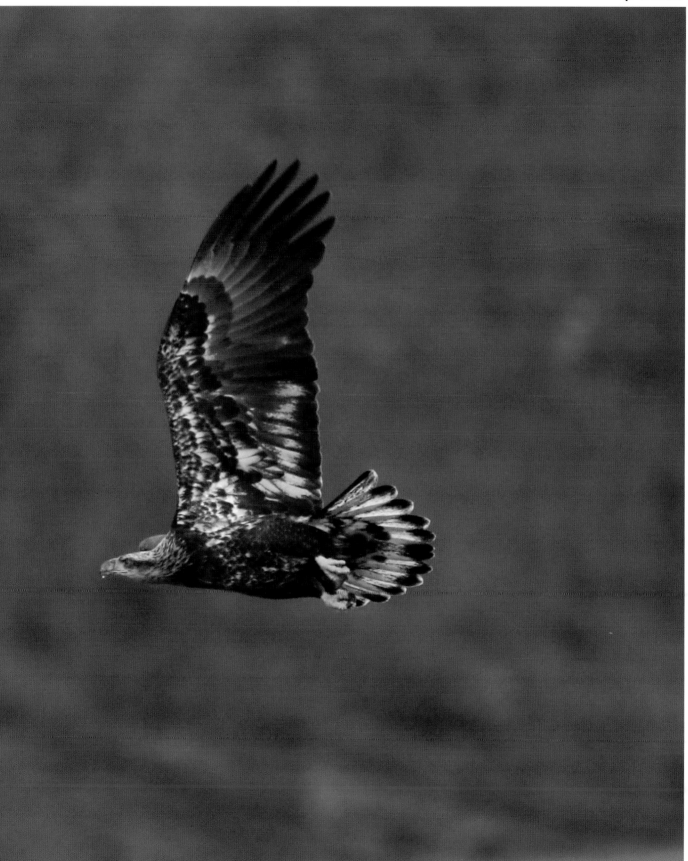

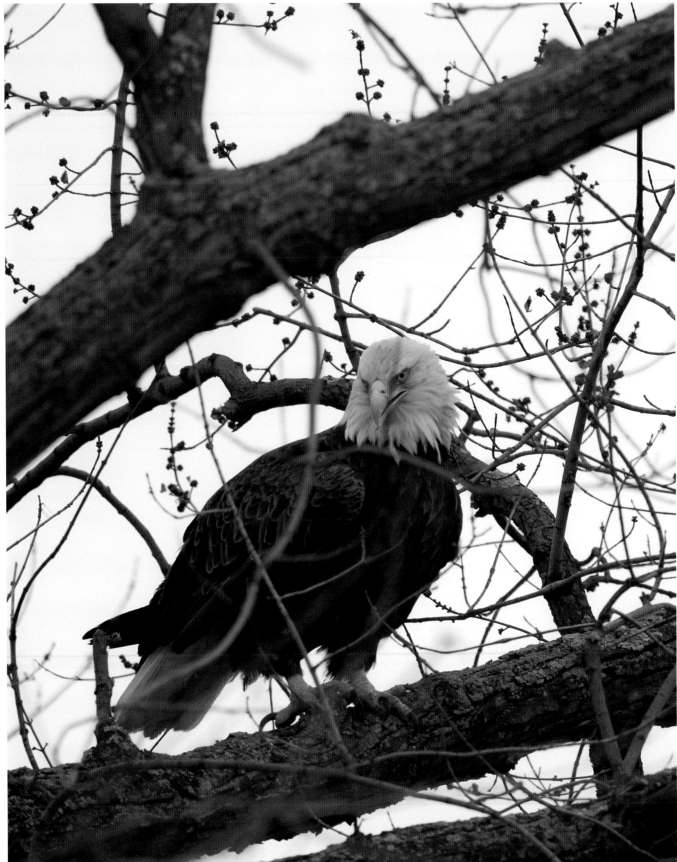

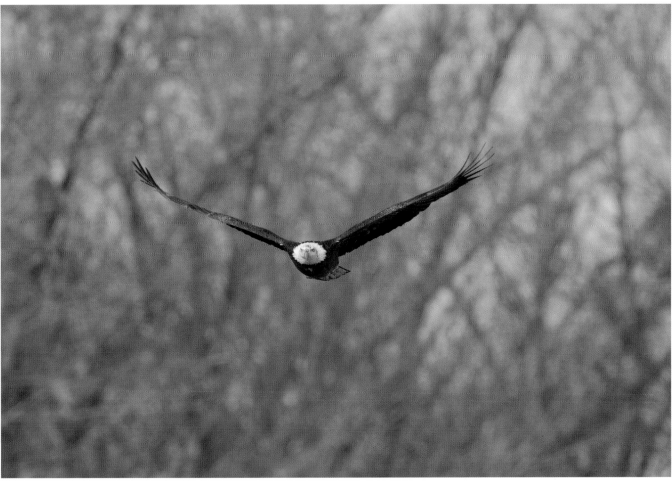

▲ A Bald Eagle zeroes in on potential prey. *Canon 1d Mark II Camera, 500mm f/4 lens, 1.4x teleconverter (effectively 910mm) ISO 320, 1/1000 second at f/6.3.*

Bitter Temperatures

In mid-January it's not uncommon for temperatures to dip below -10F in the morning with a brisk northerly wind. Yet despite these bitter temperatures the pace of life continues, but slower and at a lower altitude. In these conditions the strain on the eagles can become visibly apparent. Often perching right on the ice, inches away from open water food sources, the eagles conserve energy. Flights are limited to launching from a nearby tree, pulling a fish, and then landing on the ice to feed with little interaction from other birds - other than to fight over the fish.

This type of weather can be difficult to photograph in as camera batteries degrade quickly, metal tripods and mounting heads become difficult to manipulate, cameras can malfunction, and the heat rising off the water can create optical distortions quickly reducing image quality.

◀ Colvill Park, Red Wing. *Canon 1d Mark II Camera, 500mm f/4 lens, 1.4x teleconverter (effectively 910mm) ISO 400, 1/320 second at f/6.3.*

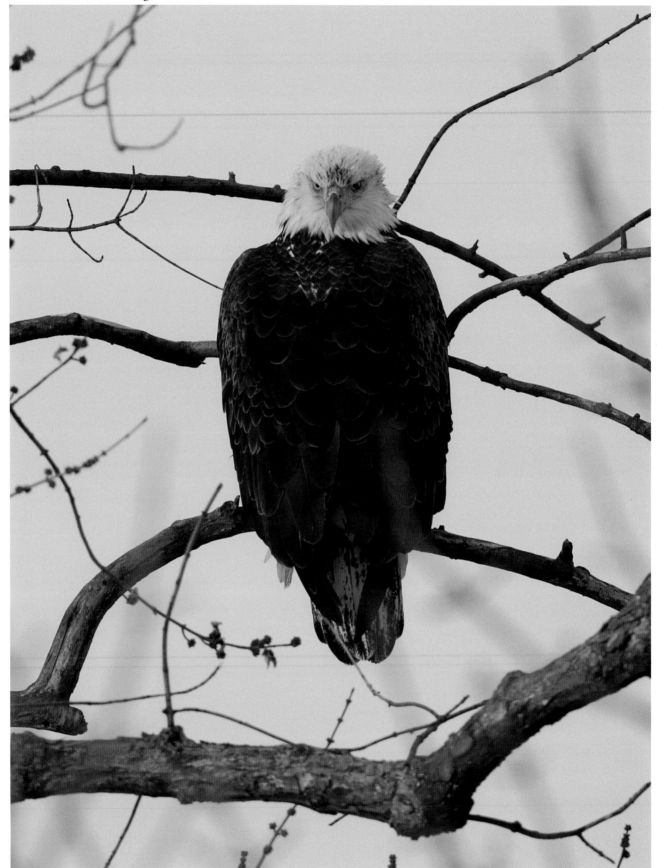

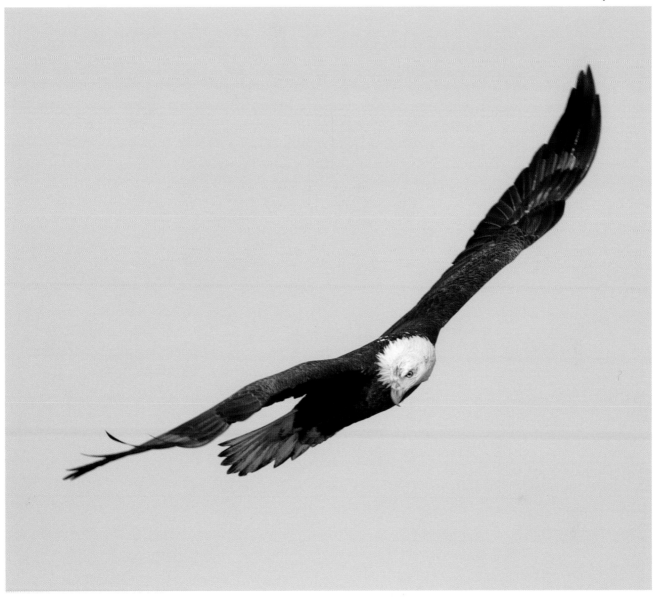

▲ While in flight, a Bald Eagle quickly scans the open water and adjusts course. *Canon 1d Mark II Camera, 500mm f/4 lens, 1.4x teleconverter (effectively 910mm) ISO 320, 1/1000 second at f/6.3.*

◀ With it's head completely turned around, a Bald Eagle keeps a vigilant eye on the open water at Colvill Park, Red Wing. *Canon 1d Mark II Camera, 500mm f/4 lens, 1.4x teleconverter (effectively 910mm) ISO 320, 1/1000 second at f/6.3.*

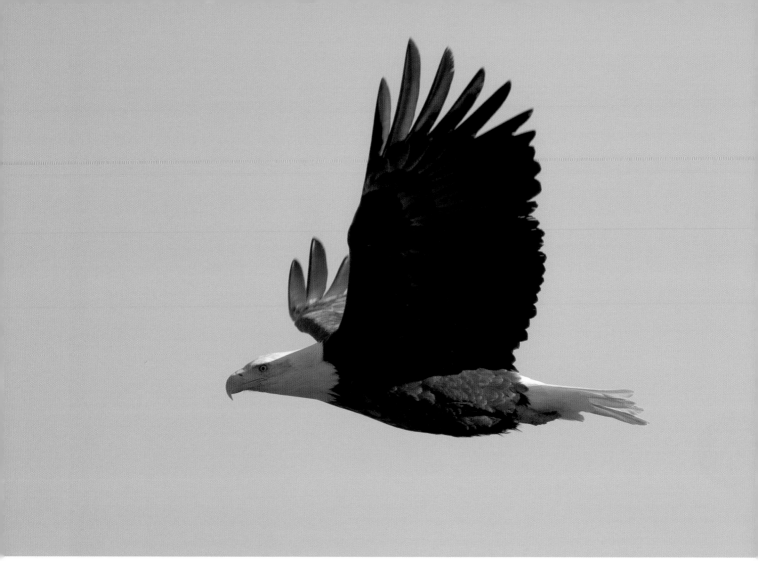

▲ A Bald Eagle effortlessly rides the ridgeline along the Mississippi at Reads Landing. *Canon 1d Mark II Camera, 500mm f/4 lens, 1.4x teleconverter (effectively 910mm) ISO 100, 1/640 second at f/6.3.*

Flight Dynamics

As the winter season progresses, juvenile Bald Eagles exhibit a higher degree of interaction towards their older, more mature peers who spend most of their time perched in trees overlooking the water. Typically a younger Bald Eagle will fly directly to a perching site of the more mature eagle and overtake that portion of the tree branch. Sometimes this cat and mouse exchange of continually pushing one another off of perching locations can continue throughout the morning. Audible interchanges precede the exchange with calls echoing throughout the valley in the cold, dense air. More often territory is temporarily given up provided sufficient open water exists elsewhere.

As the winter season progresses Bald Eagles are forced into smaller and smaller regions of open ice. Here competition runs high and if an eagle is skillful enough to catch a fish, five more will be in pursuit to snatch it away. Battles ensue on the shore as resources and energy levels become scarce.

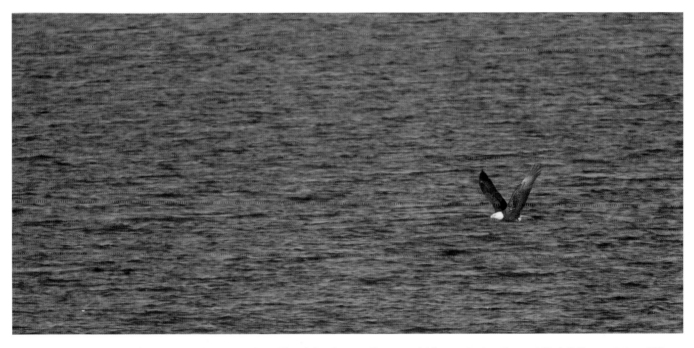

▲ Flying over vast sections of open water in late winter, this Bald Eagle has dramatically increased fishing territories. *Canon 1d Mark II Camera, 500mm f/4 lens, 1.4x teleconverter (effectively 910mm) ISO 100, 1/500 second at f/6.3.*

Soon March enters in with receding ice and open waters increasing daily hunting ranges. As ranges extend and temperatures rebound, Bald Eagles increase their flight altitudes soaring higher and higher for courtship and spiral mating in seemingly effortless flight.

Almost overnight the pace changes from one of survival, sitting on the ice near the water, to one of fast moving flights over expansive distances of the Mississippi. Along the elevated river banks of Reads Landing, magnificent views of the river allow Bald Eagles to be photographed at close ranges as they ride the ridgeline along Highway 61. As is typical with bird photography, early morning is best to see the transition from overnight perching locations to fishing on the Mississippi. By 9 am it's not uncommon to see a number of Bald Eagles circling high overhead. Locking claws in a downward spiral flight with a prospective mate, a new generation is building.

By late February and early March, the eagles have renewed energy after the harsh Minnesota winter and conditions are ideal to observe and photograph them in small towns lining the Mississippi river.

Digital Equipment

• *Tripod / panning mount.* Bald Eagles in flight can move relatively quickly perpendicular to your camera view. It's critical to have a camera mount that can move quickly side to side in extreme temperatures.

• *Camera mount.* Make sure your mount is able to operate in cold temperatures. Fluid-based mounts can freeze at -10F or much sooner and be completely ineffective.

• *Dress warm.* Use layers and wicking fabrics to remain warm.

• *Slip resistant, warm boots.* By February the ground will be snow-packed and very icy. Use cleats that can grip the ice . Icy pathways can be a real hazard while carrying heavy camera equipment . To extend your visit, warm, ice gripping boots are a must.

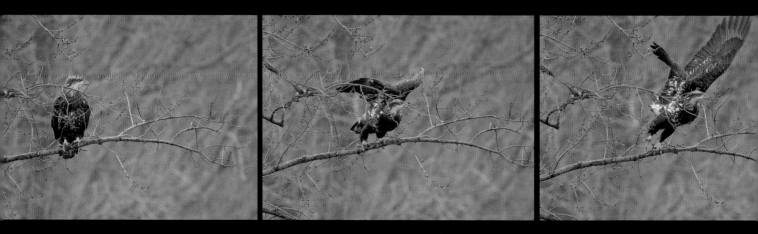

▲ A Bald Eagle launches at Colvill Park at 8.5 frames per second to catch a fish. *Canon 1d Mark II Camera, 500mm f/4 lens, 1.4x teleconverter (effectively 910mm) ISO 640, 1/500 second at f/5.6.*

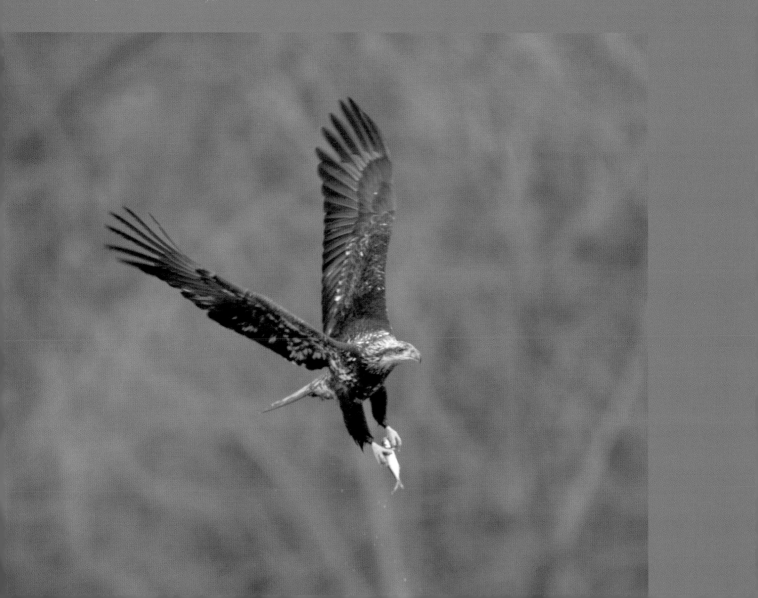

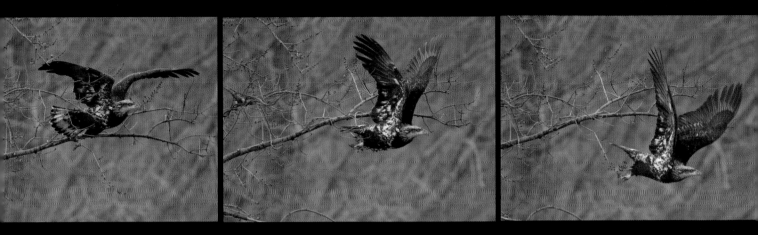

▼ Two Bald Eagles compete for a fish. *Canon 1d Mark II Camera, 500mm f/4 lens, 1.4x teleconverter (effectively 910mm) ISO 640, 1/400 second at f/5.6.*

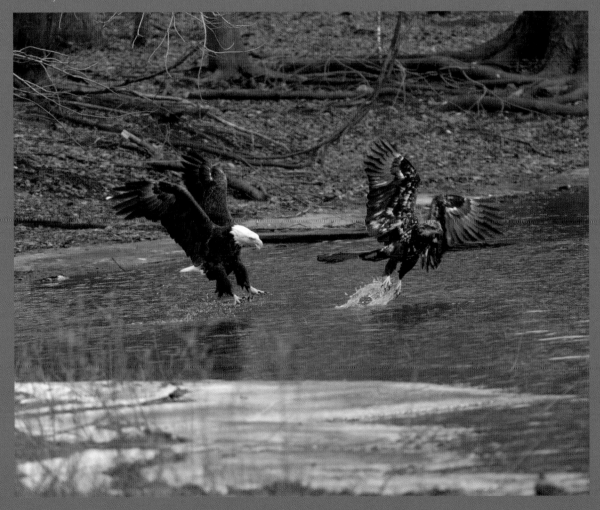

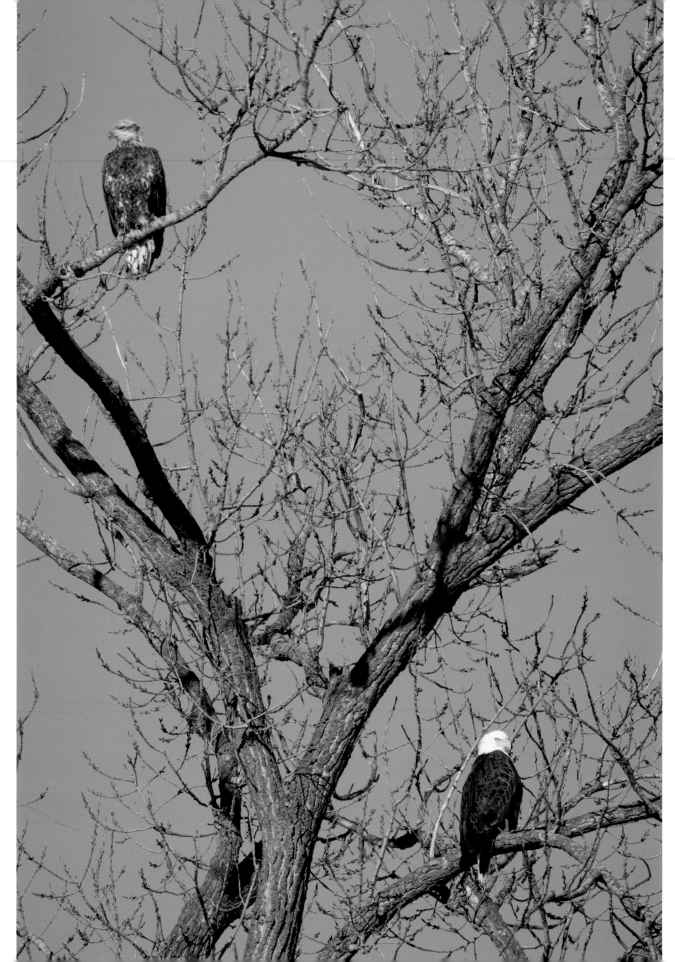

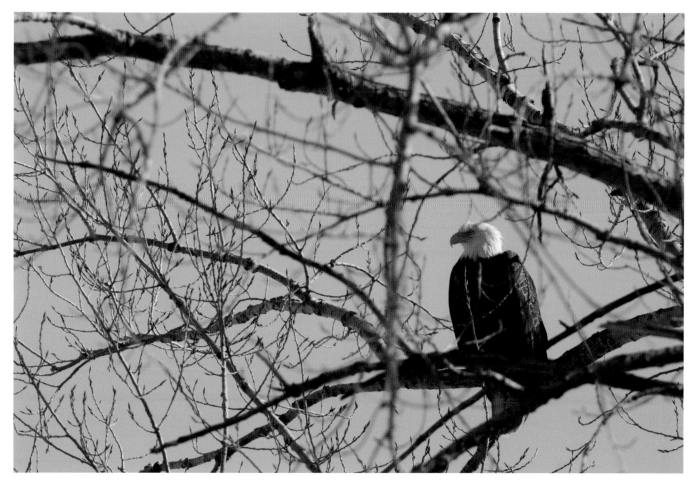

▲ Hundreds of Bald Eagles temporarily invade a small town while they migrate up the Mississippi. *Canon 1d Mark II Camera, 500mm f/4 lens, 1.4x teleconverter (effectively 910mm) ISO 200, 1/400 second at f/8.*

Invasion

Along the Mississippi from Red Wing, Minnesota headed south to the Iowa border, thousands of Bald Eagles scan the open waterways invading local communities. Sitting for hours at a time they carefully watch the water below for fish and grow in a community for mating and migration north. Audible interchanges occur regularly. Despite the cold temperatures during this time of the year, Bald Eagles show an incredible resistance to the noise and intrusion of trains and vehicles lining the river. In southern Minnesota along the Mississippi, Highway 61 and the railroad tracks traces along the river for miles. With hourly passenger and freight traffic, the trains vibrate the ground and pass just feet below perching Bald Eagles that have grown accustomed to the noise and movement. Fishing, and the community of other eagles seems to take a priority over potential threats during this time of the year.

◄ Bald Eagles, Wabasha, MN. *Canon 1d Mark II Camera, 500mm f/4 lens, 1.4x teleconverter (effectively 910mm) ISO 200, 1/640 second at f/7.1.*

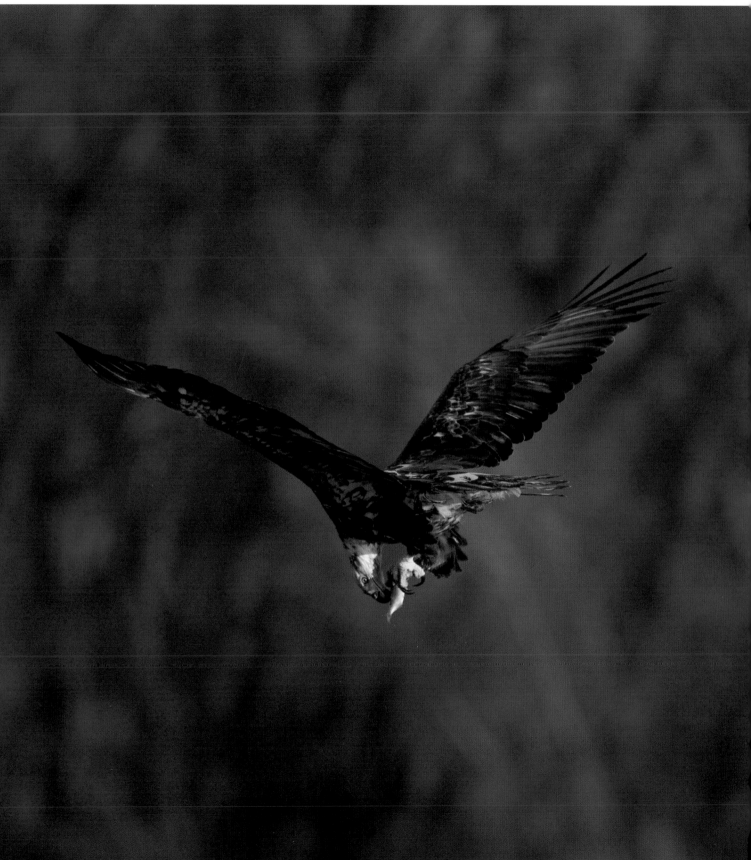

Fishing

Bald Eagles can be incredibly resourceful when it comes to catching and manipulating prey. Having competed on the ground for caught fish, this juvenile Bald Eagle has learned it's better to feed in flight than run the risk of losing prey on the ground to competitors. Throughout the morning small fish are pulled out of the river occasionally slipping out of the massive claws.

For their efforts, fish near the surface of the Mississippi tend to be small requiring numerous trips for sufficient food. When one is finally caught, very careful attention is made to making the most of the opportunity.

◀ A delicate balance. *Canon 1d Mark II Camera, 500mm f/4 lens, 1.4x teleconverter (effectively 910mm) ISO 400, 1/1000 second at f/6.3.*

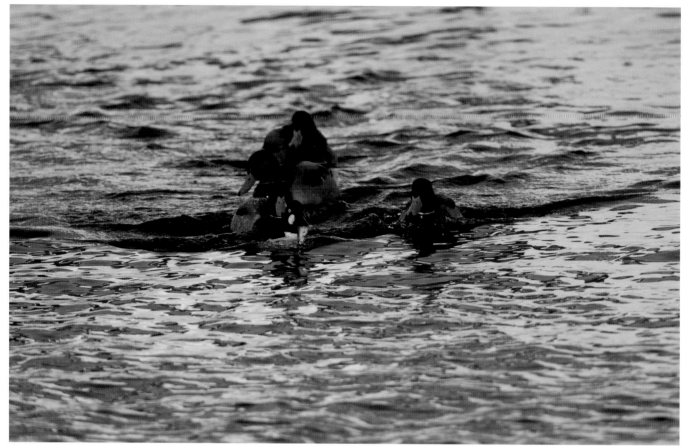

▲ A migratory Barrow's Goldeneye competes with local Mallards for a fish. *Canon 1d Mark II Camera, 500mm f/4 lens, 1.4x teleconverter (effectively 910mm) ISO 320, 1/1000 second at f/6.3.*

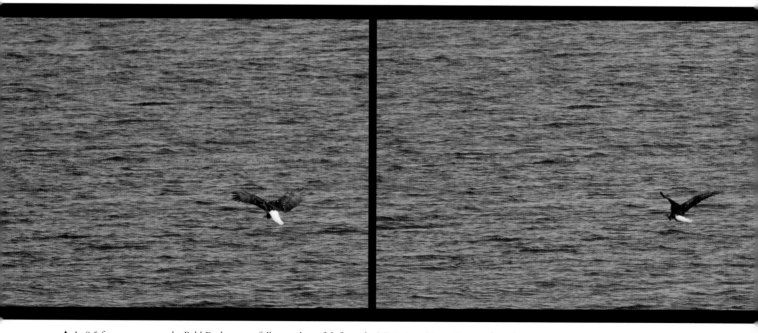

▲ At 8.5 frames per second a Bald Eagle successfully snatches a fish from the Mississippi River. *Canon 1d Mark II Camera, 500mm f/4 lens, 1.4x teleconverter (effectively 910mm) ISO 100, 1/500 second at f/6.3.*

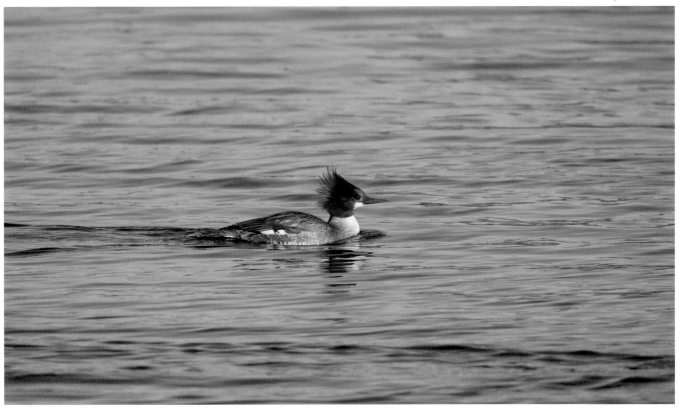

▲ A Common Merganser takes a brief stop before continuing north on the Mississippi. *Canon 1d Mark II Camera, 500mm f/4 lens, 1.4x teleconverter (effectively 910mm) ISO 400, 1/1600 second at f/6.3.*

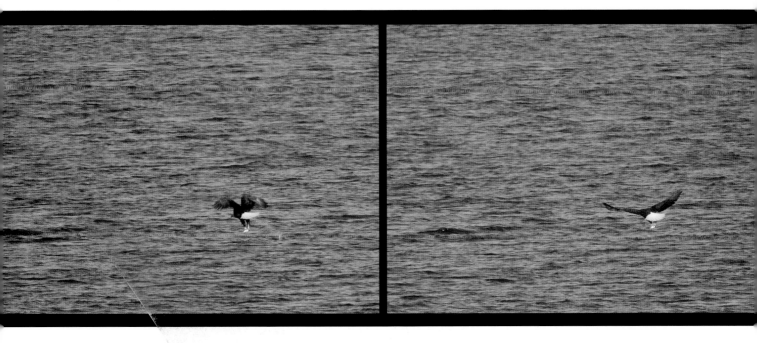

Northern Migration

By mid-March hundreds of Bald Eagles continue to invade river towns along the Mississippi from Winona to Red Wing. Joined by thousands of migratory birds, each continues to push north following the retreating ice. During this time of the year the river can change dramatically over the span of several days swelling from the run-off of winter snow and melting ice. Breaking up, chunks of ice collide and spin about breaking down into smaller and smaller sections. Occasionally eagles ride the ice and float the river. With the river opening up, hundreds of goldeneye, mergansers, and others dot the horizon in the equivalent of a migration log-jam.

On both sides of the Mississippi, highways in Minnesota and Wisconsin trace the river with intermittent sweeping views and pull-offs of the river valley below. During this time of the year Highway 61 in Minnesota can get very busy with birders and photographers following the migration north. Each day real advancements can be seen as pull-offs once home to numerous eagles in the trees and overhead are gone for the season. Unlike the bitter temperatures of winter and waiting from a tree branch for a fish to pass below, eagles have now become much more active, soaring and scanning expansive areas of open

▼ Bald Eagle on the hunt in Wabasha. *Canon 1d Mark II Camera, 500mm f/4 lens, 1.4x teleconverter (effectively 910mm) ISO 200, 1/800 second at f/6.3.*

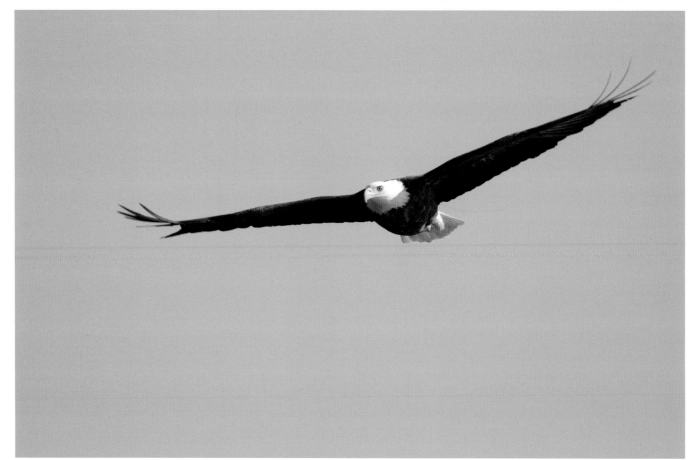

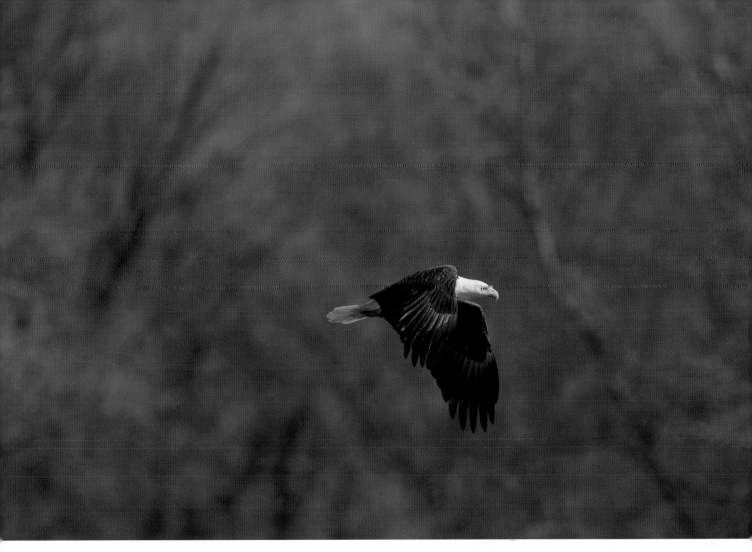

▲ *Canon 1d Mark II Camera, 500mm f/4 lens, 1.4x teleconverter (effectively 910mm) ISO 200, 1/1000 second at f/6.3.*

water. Fish that are pulled out will often be brought back to the trees lining the shore to feed with little competition. Fast moving, sweeping turns are the patterns for the day.

The rate of the onset of seasonal changes at the end of winter can be a significant factor in how readily eagles and other migratory birds can be observed and photographed. Late season cold temperatures delay the thawing of riverways critical for migration along the Mississippi Flyway. With migration stalled awaiting ice-out and thousands of birds headed north, concentrations increase dramatically in a log-jam as they follow the melting ice.

Conversely a warm end to the season can quickly shorten the duration of river and lake ice, opening up numerous and distributed waterways. This has the effect of quickly dispersing birds along and away from major riverways such as the Mississippi, bringing a sudden and dramatic end to migration. During these periods migratory birds and eagles spread out at a much greater rate, lowering concentrations and the chance to view them up close.

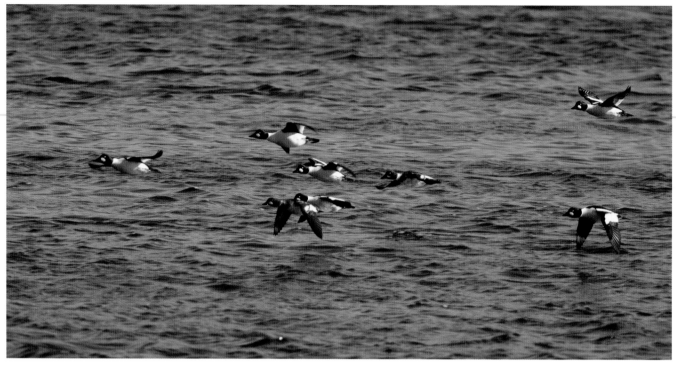

▲ *Canon 1d Mark II Camera, 500mm f/4 lens, 1.4x teleconverter (effectively 910mm) ISO 200, 1/1000 second at f/6.3.*

Migratory Birds

The end of winter is not only marked by the ascent of Bald Eagles for courtship, it is also followed by the return of hundreds of thousands of migratory waterfowl working their way up the Mississippi Flyway. Barrow's Goldeneye, Trumpeter Swans, mergansers, and many more slowly follow the retreating ice deep into Minnesota. Small flocks of birds are in continual motion across the Mississippi River, some spooked by eagles, others anxious to get to northern breeding grounds. Flying low they ride a cushion of air for extended distances over the water avoiding strong winds and preserving energy levels.

During the month of March the river is jammed with thousands of birds. Occupying remote areas of the river, getting close can be very difficult. Photographing in these situations is possible by looking for sections of the river near adjoining roads and parks. If after waiting 10-15 minutes for birds to pass by with none in sight, move on to more productive areas. In the morning birds tend to be closer to the shoreline than by mid-day. Large concentrations can be seen at the ice and water boundary.

Digital Equipment

• *Increase shutter speeds.* Small birds in flight require significantly higher shutter speeds due to the speed of flight. This can be achieved by faster lenses, limiting the use of teleconverters, and increasing ISO - even when in bright conditions. Aim for 1/640s at a minimum.

• *Decrease aperture.* Birds in flight require additional depth of field so that the entire flock can remain in focus. Select f/6.3 or smaller.

• *Mobility.* Migratory birds by their nature are on the move. If your selected location does not have traffic within 10-15 minutes, move on to more productive areas.

• *Long lens with image stabilization.* For migratory bird photography, a 500mm or longer lens is essential. Using the image stabilization features on the Canon lenses allow for fast tracking, stable images while panning.

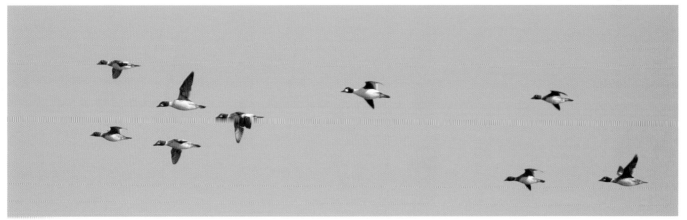

▲ A small grouping of Barrow's Goldeneye is on the move. *Canon 1d Mark II Camera, 500mm f/4 lens, 1.4x teleconverter (effectively 910mm) ISO 250, 1/1000 second at f/6.3.*

▼ A Barrow's Goldeneye drops in near the shore for a rest. *Canon 1d Mark II Camera, 500mm f/4 lens, 1.4x teleconverter (effectively 910mm) ISO 160, 1/800 second at f/6.3.*

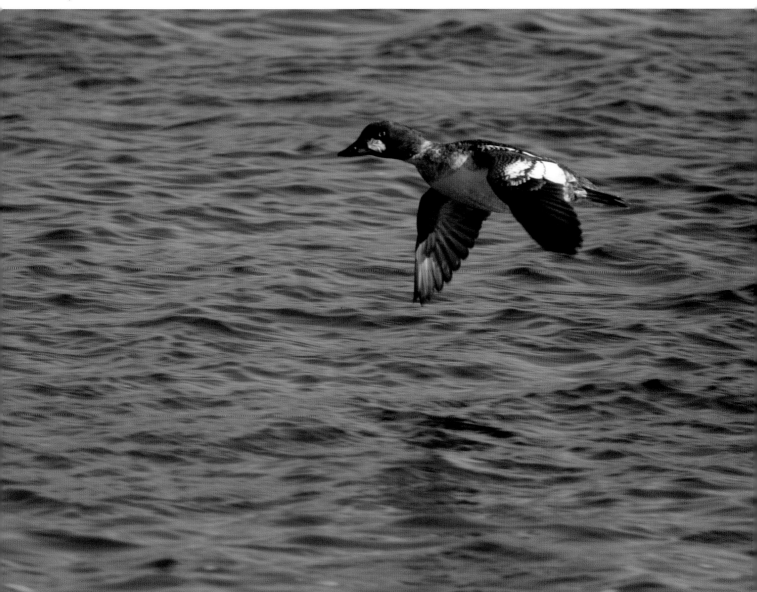

Mid-morning

As the morning progresses the intensity of flight and fishing continues to increase. In Wabasha tens of eagles soar along the riverway launching from neighborhood trees. Smooth, gently flowing waters, warm temperatures, and plentiful fish are ideal conditions for bird photography. Shooting from the car has some real advantages; allowing mobility, minimal disturbance, and a solid shooting platform for heavy camera lenses.

▶ A Bald Eagle catches a fish in Wabasha, MN. *Canon 1d Mark II Camera, 500mm f/4 lens, 1.4x teleconverter (effectively 910mm) ISO 200, 1/1000 second at f/6.3.*

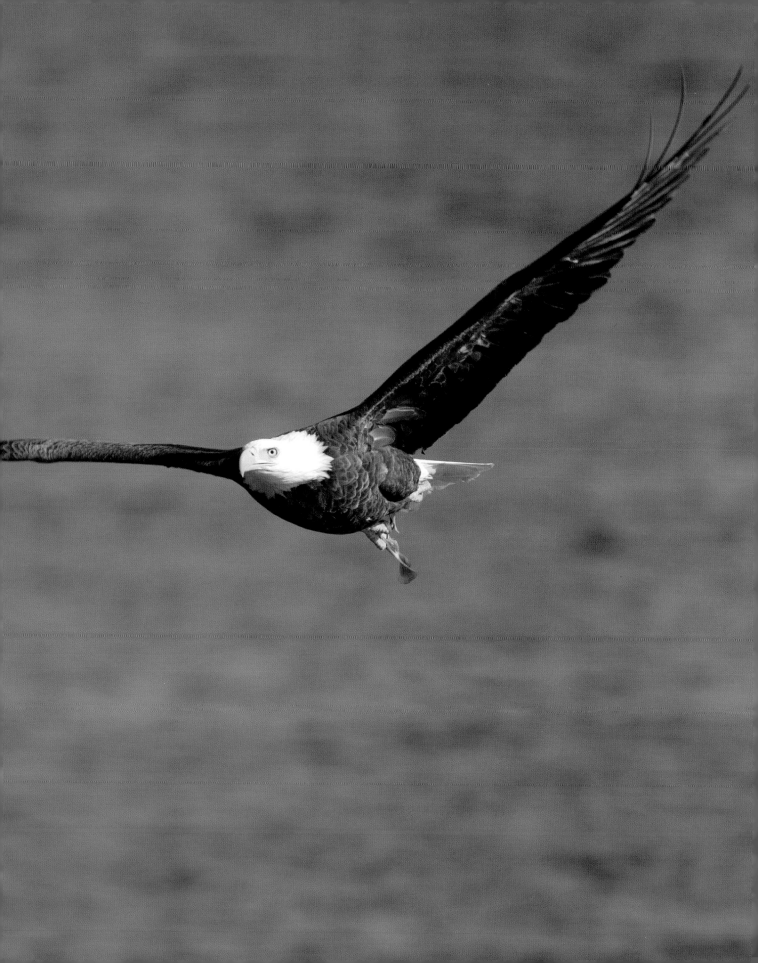

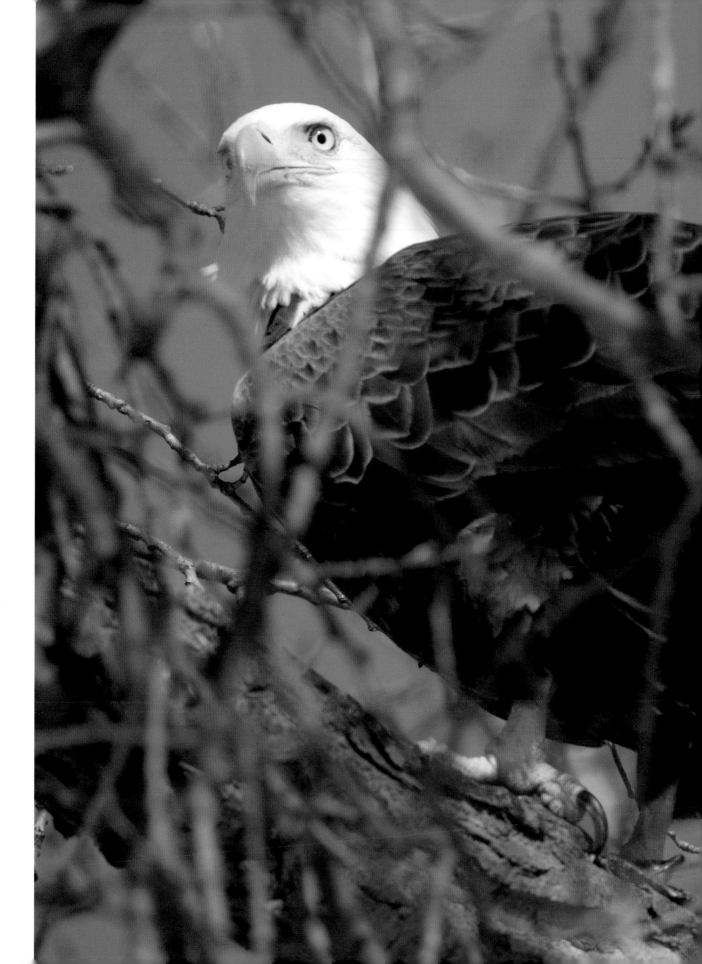

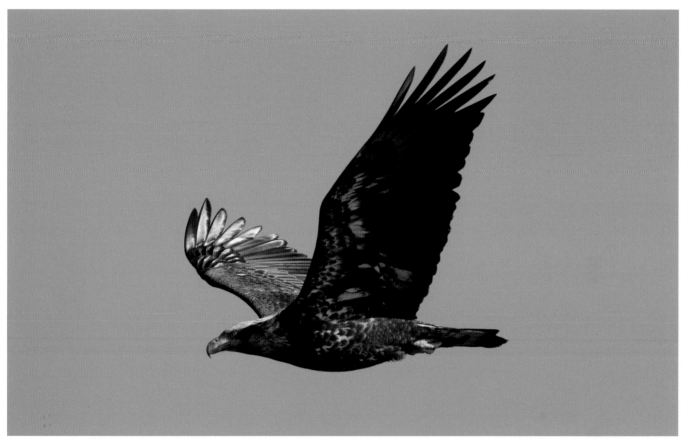

▲ Having survived the long winter an immature Bald Eagle heads north to spring nesting grounds. *Canon 1d Mark II Camera, 500mm f/4 lens, 1.4x teleconverter (effectively 910mm) ISO 200, 1/1000 second at f/6.3.*

◀ Located just off a city street, this Bald Eagle seems unaware of my presence. *Canon 1d Mark II Camera, 500mm f/4 lens, 1.4x teleconverter (effectively 910mm) ISO 200, 1/1000 second at f/6.3.*

Spring

Spring Thaw

As early April approaches low altitude air temperatures and dewpoints often merge forming ground fog and the potential for supercooled precipitation and freezing rain.

Murphy-Hanrehan Park Reserve is located just south of the Twin Cities encompassing 2,400 acres of glacial ridges, deciduous forests, and wetlands. The parks is also home to the rare Blanding's Turtle.

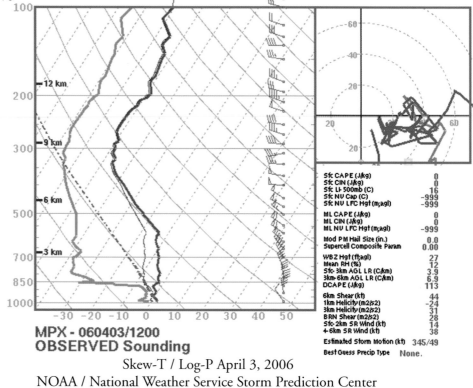

MPX - 060403/1200
OBSERVED Sounding

Skew-T / Log-P April 3, 2006
NOAA / National Weather Service Storm Prediction Center

Sfc CAPE (J/kg)	0
Sfc CIN (J/kg)	0
Sfc LI 500mb (C)	16
Sfc NV Cap (C)	-999
Sfc NV LFC Hgt (m;agl)	-999
ML CAPE (J/kg)	0
ML CIN (J/kg)	0
ML NV LFC Hgt (m;agl)	-999
Mod PM Hail Size (in.)	0.0
Supercell Composite Param	0.00
WBZ Hgt (ft;agl)	27
Mean RH (%)	12
Sfc-3km AGL LR (C/km)	3.9
3km-6km AGL LR (C/km)	6.9
DCAPE (J/kg)	113
6km Shear (kt)	44
1km Helicity (m2/s2)	-24
3km Helicity (m2/s2)	31
BRN Shear (m2/s2)	28
Sfc-2km SR Wind (kt)	14
+6km SR Wind (kt)	38
Estimated Storm Motion (kt)	345/49
Best Guess Precip Type	None.

▼ Freezing rain and fog settle into Murphy-Hanrehan Park Reserve. *Canon 1d Mark II Camera, 100-400mm IS lens, ISO 1250, 1/400 second at f/5.6.*

▲ Murphy-Hanrehan Park Reserve. *Canon 1d Mark II Camera, 100-400mm IS lens, ISO 1250, 1/100 second at f/5.6.*

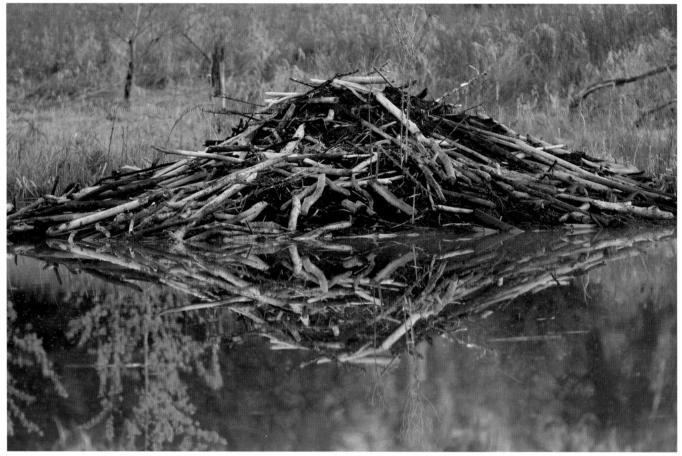

▲ Beaver's lodge, Sherburne NWR. *Canon 1d Mark II Camera, 500mm f/4 lens, 1.4x teleconverter (effectively 910mm) ISO 800, 1/60 second at f/5.6.*

Renewal

After a long winter, River Otters, Beavers, and Sandhill Cranes can be some of the first openly visible wildlife at Sherburne National Wildlife Refuge in early April. Located just northwest of the Twin Cities, the refuge encompasses 30,700 acres in a transitional zone of marshlands, deciduous hardwood forests, and tall grass prairie. As spring sets in, small ponds surrounding the refuge thaw leaving behind glassy surfaces ideal for waterfowl or a reflecting Beaver's lodge.

A primary public access route through the refuge is the Prairie's Edge Wildlife Drive, a 7.3 mile gravel road offering excellent access to the refuge and wildlife. Access is restricted until late April and remains open through October. The official opening date each season shifts slightly to ensure nesting Bald Eagles have hatched without the potential for disturbance from vehicles or pedestrian traffic.

Digital Equipment

• *Stay mobile.* Sherburne NWR and the surrounding farmlands are expansive areas. Your likelihood of finding wildlife can increase by searching from your vehicle.

• *Road safety.* It's not uncommon to see waterfowl next to roadside ponds. When stopping, use great care to not become a traffic hazard. Keep in mind however slowing vehicles are different than normal road traffic and can spook wildlife.

• *Rain cover.* Small and lightweight, the Tenba RC-26 Rain Cover is a constant accessory in my photo backpack. This nylon cover easily fits over a 500mm or larger lens and body to allow shooting even in the most severe rain.

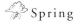

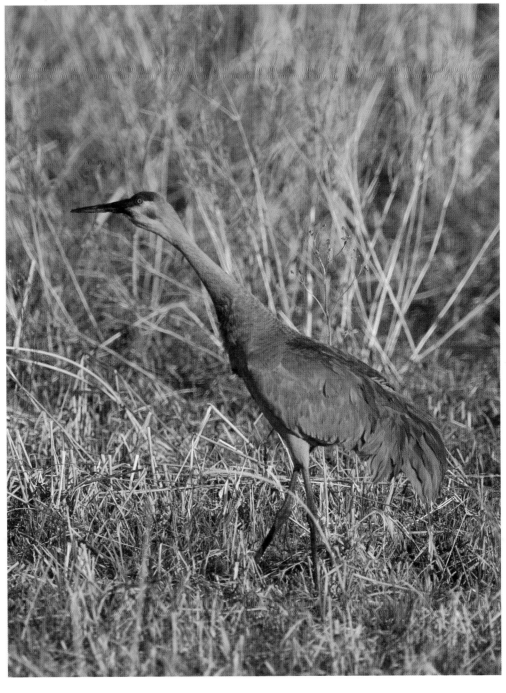

▼ Sandhill Crane. *Canon 1d Mark II Camera, 500mm f/4 lens, 1.4x teleconverter (effectively 910mm) ISO 200, 1/800 second at f/5.6.*

Week by week the refuge goes through a series of rapid changes. Snow and cool spring rains finally give way for the opportunity to clear the refuge of the prior season's marsh growth.

In early April, portions of the refuge may undergo prescribed burns to reduce the potential for major fire hazards later in the season. These controlled burns temporarily change the rhythm on the refuge diverting waterfowl, cranes, and small birds to other undisturbed areas of the refuge. Just weeks following the burn the marsh quickly starts its reappearance. In the forested areas new ferns are the first to quickly reclaim the land carpeting the blackened ground in lush green.

By mid-May Wild Lupine, an invasive species, blooms in large sections, new reeds begin to reclaim burned areas, and a new generation of Canadian Geese are born.

Also taking up residence are Yellow-headed Blackbirds, Red-winged Blackbirds, Red-tailed Hawks, and Double-crested Cormorants. Across the refuge Sandhill Cranes spread out in small groups of 3-5 and can often be easily seen from the wildlife drive in the morning or flying overhead. Depending upon the weather and time of day, several nesting Trumpeter Swans can also be found near the road.

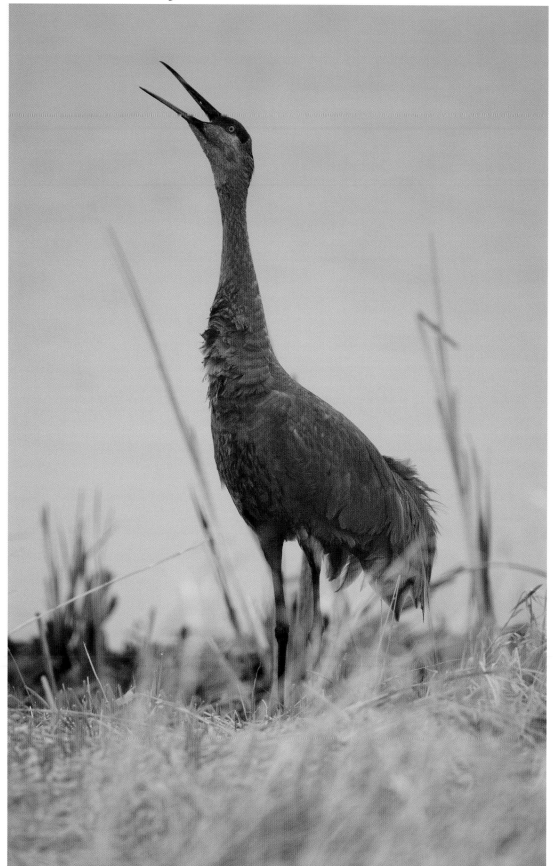

▲ Trumpeter Swan in a cold, soaking rain. Sherburne NWR. *Canon 1d Mark II Camera, 500mm f/4 lens, ISO 400, 1/200 second at f/4.5.*

◀ A Sandhill Crane calls out across the refuge. Sherburne NWR. *Canon 1d Mark II Camera, 500mm f/4 lens, ISO 800, 1/200 second at f/4.5.*

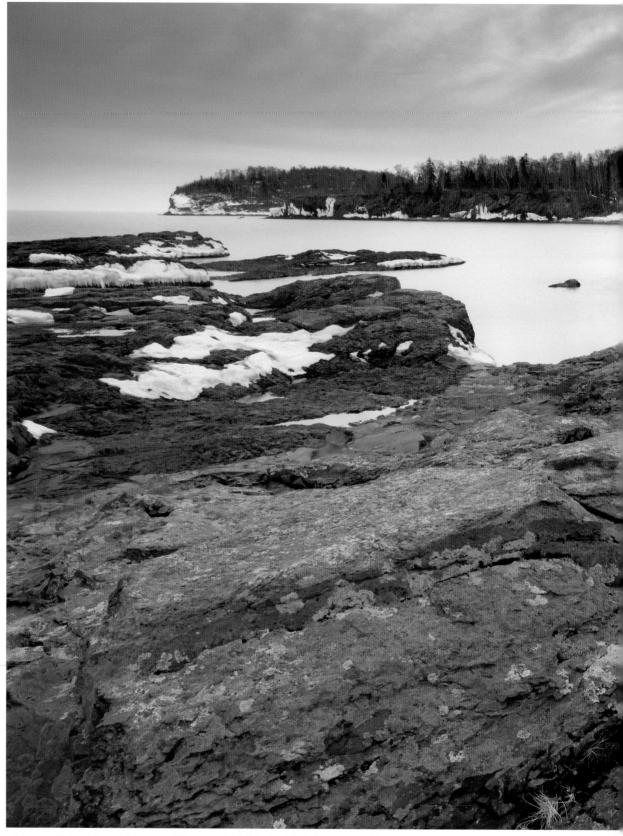

▲ Orange Lichens cling to the rocks on Ellington Island, Split Rock Lighthouse State Park. *Canon 1ds Mark II Camera, 16-35mm, f/2.8, ISO 100, 0.8 second at f/22.*

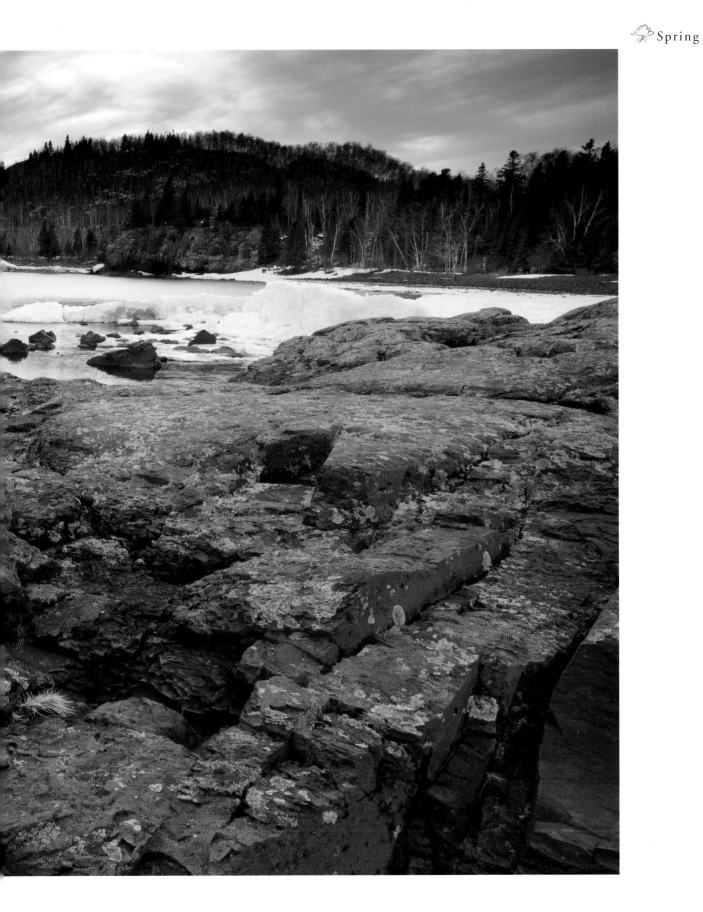

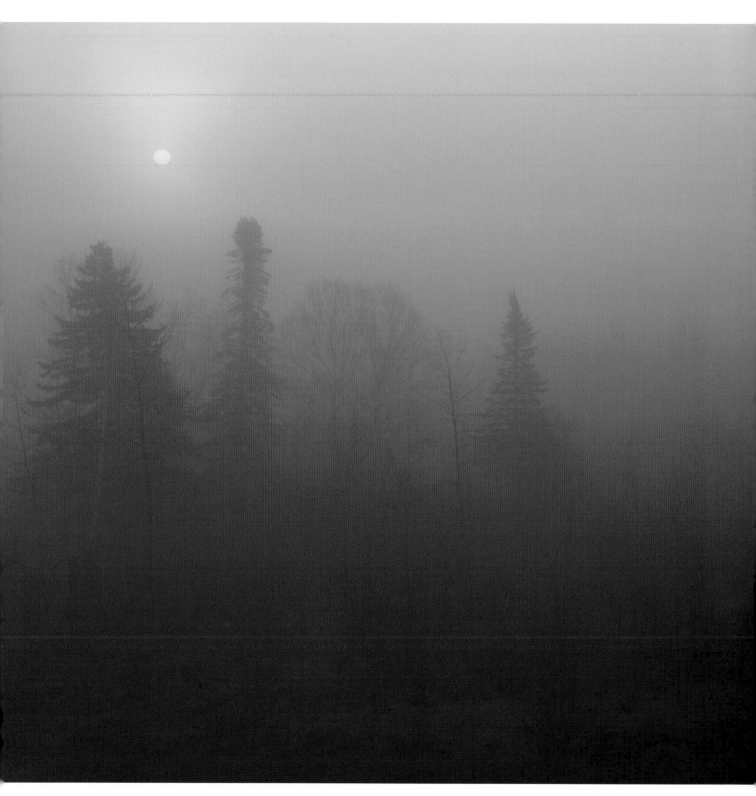

▲ With the ground still frozen, warm temperatures set up a dense early morning fog at Split Rock Lighthouse State Park. *Canon 1ds Mark II Camera, 16-35mm lens, ISO 200, 1/40 second at f/18.*

▶ Despite warm spring temperates by mid-day, large blocks of ice remain well into spring on the shore of Lake Superior, pages 108-111. *Canon 1ds Mark II Camera, 16-35mm f/2.8 lens, ISO 100, 1/40 second at f/22.*

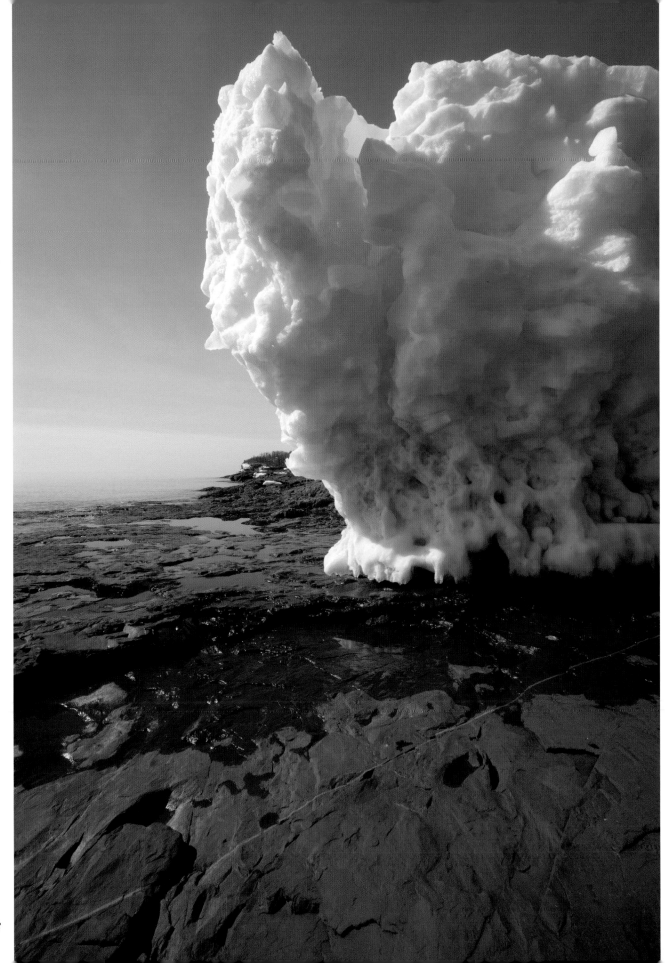

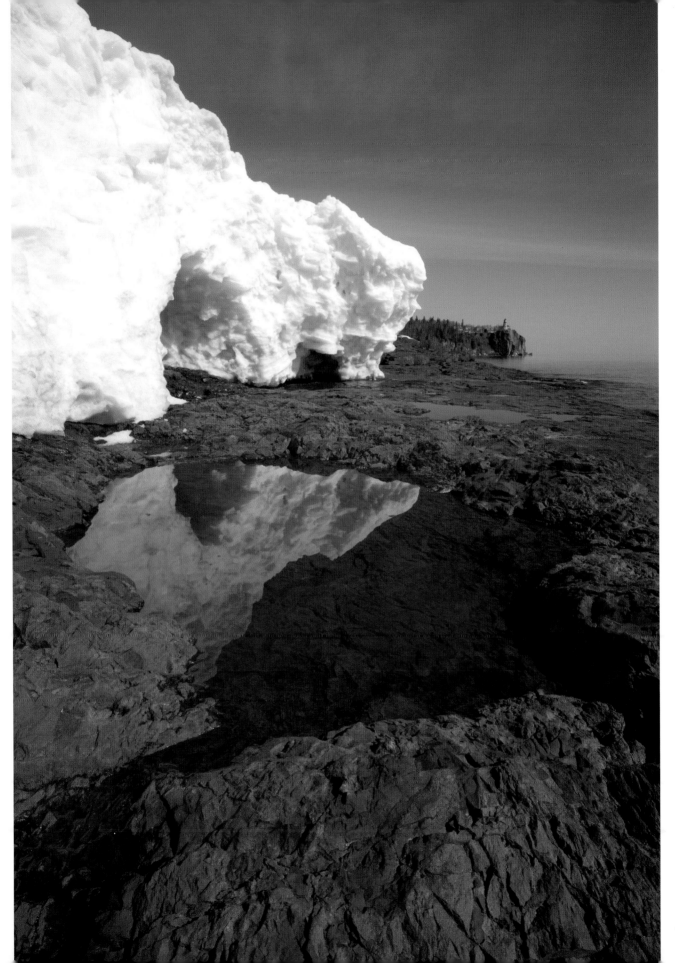

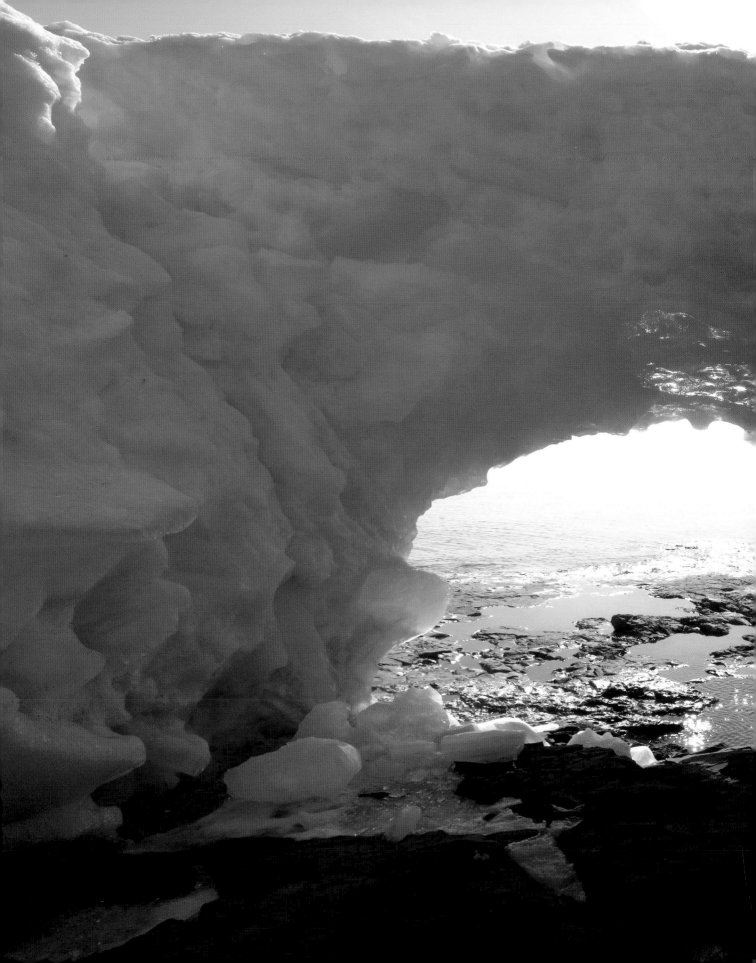

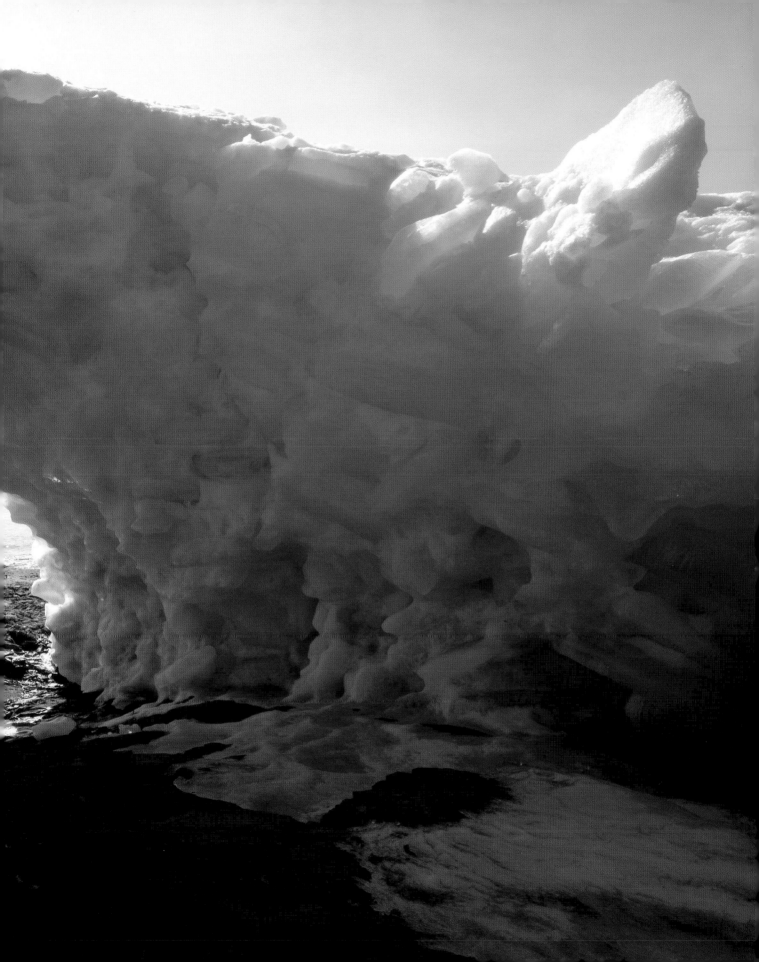

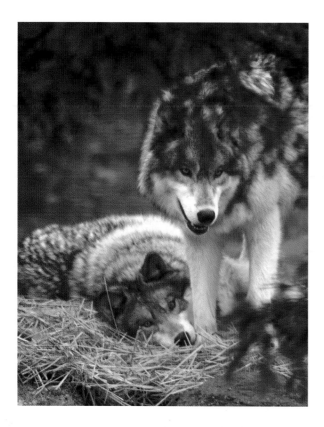

International Wolf Center

In addition to being a primary entry point into the Boundary Waters Canoe Area Wilderness, Ely, Minnesota is also home to the International Wolf Center. In an outdoor year-round habitat, these Gray Wolves help in educating the public on wolves and how we can advance their survival in the wild and across the state.

Northern Minnesota Grey Wolf populations have been on the increase since 1970 with population estimates approaching 3,000. Despite this number, numerous deer populations continue to advance at an alarming rate. At Split Rock Lighthouse, deer bed down without the threat of wolves in a dense morning fog.

◀ International Wolf Center, Ely, Minnesota. Grizzer and Maya (Captive), both are Great Plains subspecies of the Gray Wolf *Canon 1d Mark II Camera, 100-400mm, 180mm, ISO 400, 1/250 second at f/5.6.*

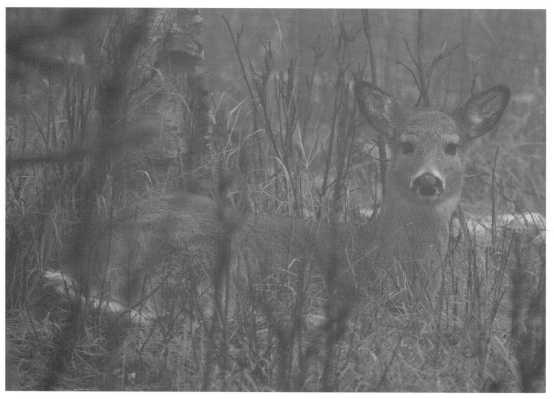

▶ Split Rock Lighthouse. Deer in dense fog. *Canon 1d Mark II Camera, 100-400mm, ISO 320, 1/400 second at f/7.*

▶ International Wolf Center, Ely, Minnesota. Grizzer (Captive), a Great Plains subspecies of the gray wolf. *Canon 1d Mark II Camera, 100-400mm, 180mm, ISO 400, 1/250 second at f/5.6.*

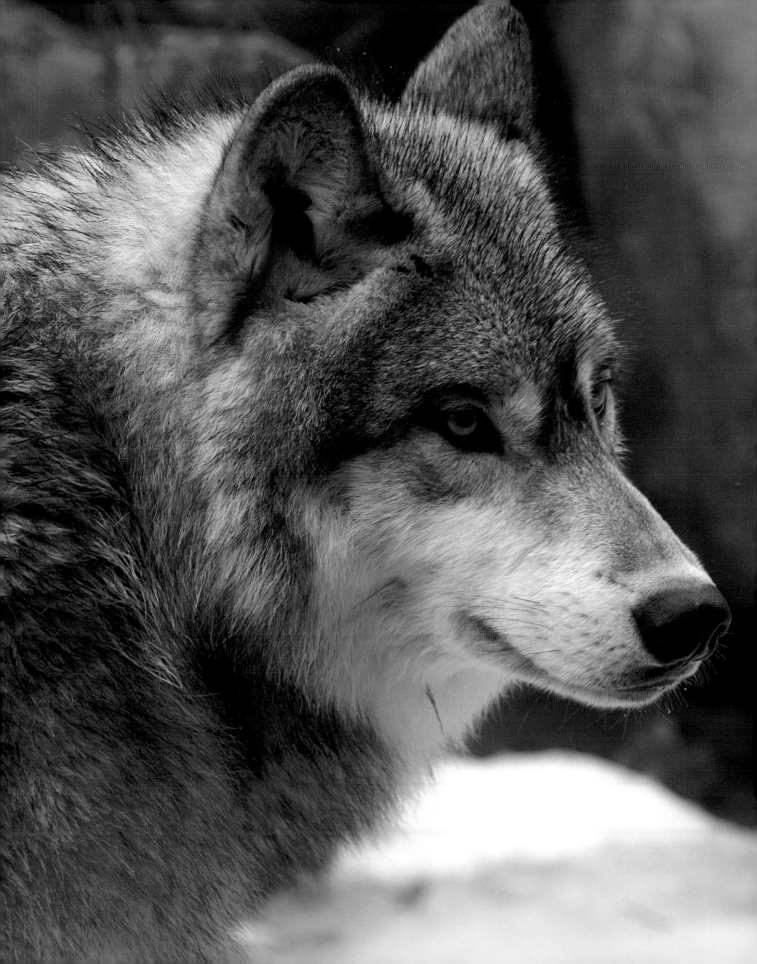

▲ Minnesota Valley National Wildlife Refuge. *Canon 1ds Mark II Camera, 16-35mm f/2.8 lens, ISO 100, 1/60 second at f/6.3.*

Timing

By mid-April the first outward signs of spring are the receding floodwaters and wildflowers along the Mississippi and Minnesota Rivers. Located just 10 miles from downtown Minneapolis, the Minnesota River cuts through 14,000 acres of the Minnesota Valley National Wildlife Refuge. One of the state's largest refuges, it extends for 34 miles along the river from Fort Snelling State Park to Jordon. Still awaiting trees to bud, and against a grey and lifeless forest, vibrant wildflowers are one of the few signs of life.

A full week later and 80 miles south of the Minnesota Valley National Wildlife Refuge near Rochester, trees are just now starting to bud surrounding the waterfalls at Minneopa Creek. Once a drainage route for the Glacial Lake Agassiz 15,000 years ago, Minneopa Creek flows into the Minnesota River. The word Minneopa is derived from the Dakota language meaning "water falling twice".

As the weeks progress, a line of vibrant green sweeps north wrapping around Duluth and along the North Shore. Soon Gooseberry Falls, Tettegouche, and other state parks of the North Shore are in full bloom.

▶ Minneopa State Park. *Canon 1ds Mark II Camera, 16-35mm f/2.8 lens, ISO 100, 1/50 second at f/13.*

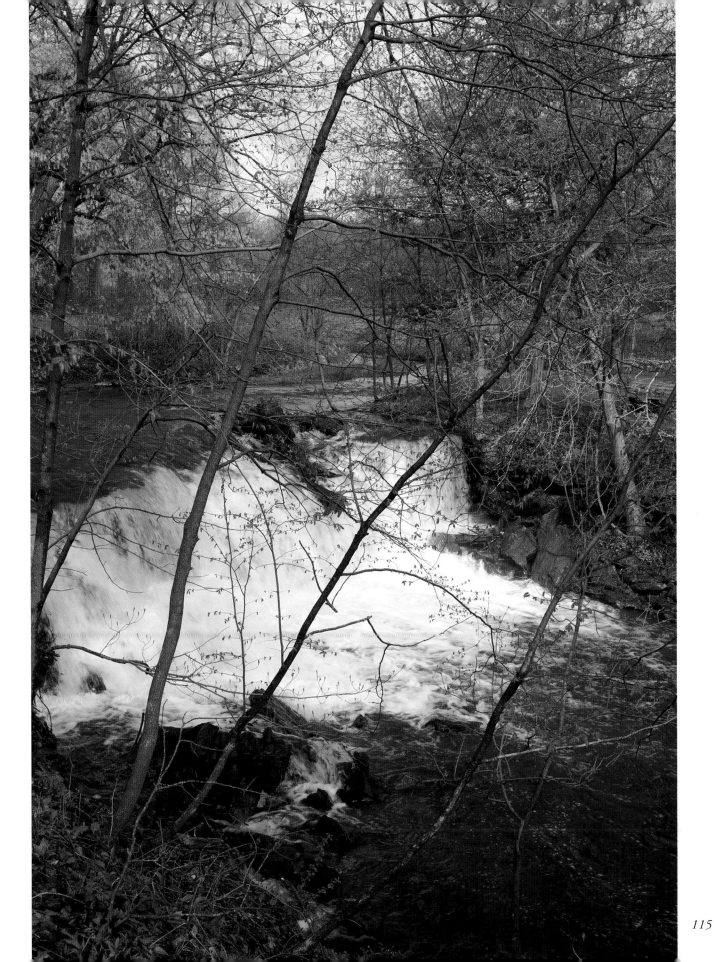

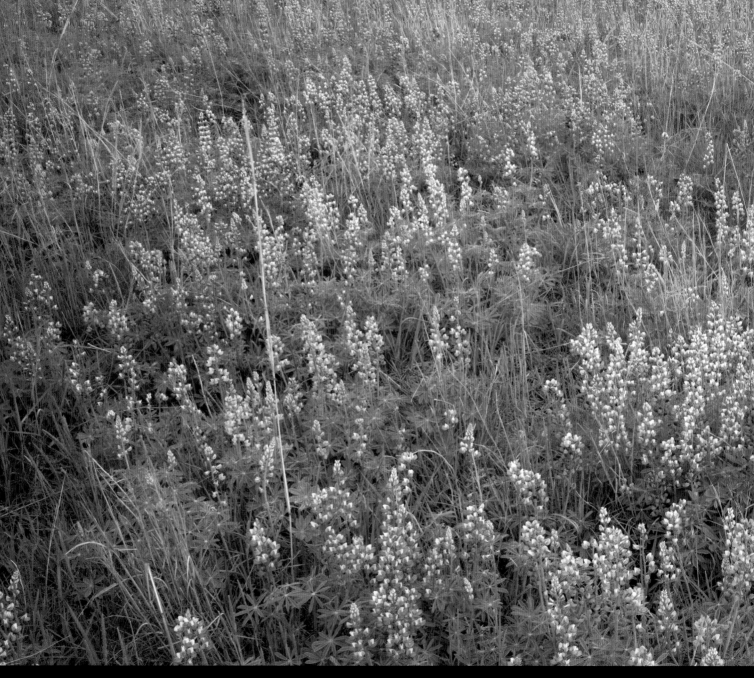

▲ Wild Lupine. *Canon 1ds Mark II Camera, two images stitched together, 45mm f/2.8 TS-E lens, ISO 100, 1/4 second at f/20.*

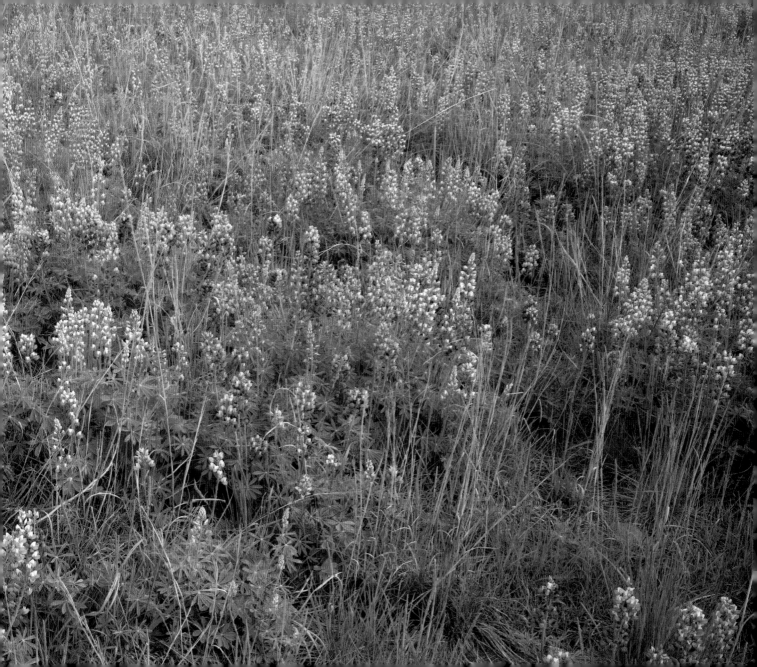

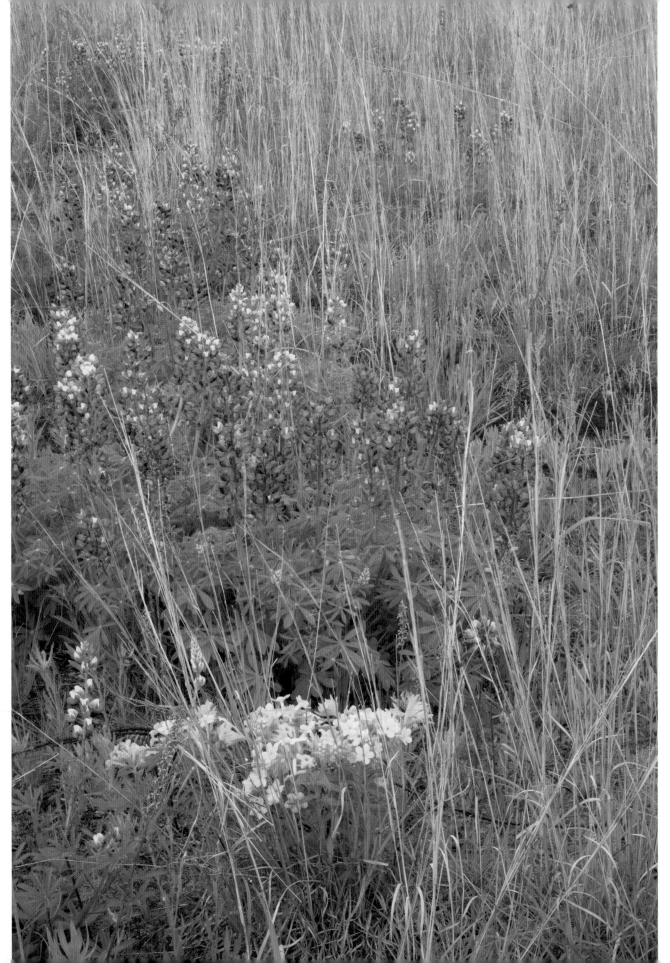

▼ Yellow Goatsbeard open in early morning. *Canon 1ds Mark II Camera, 90mm f/2.8 TS-E lens, ISO 100, 1/500 second at f/4.5.*

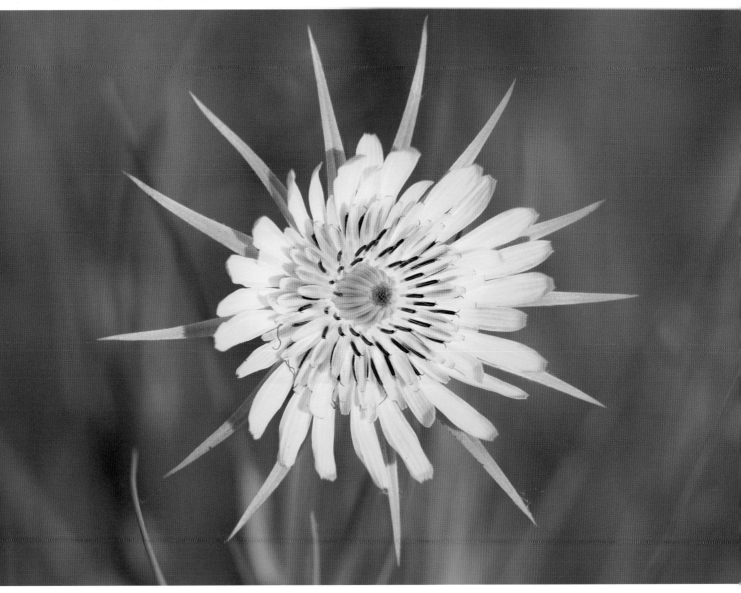

Digital Equipment
• *Arrive early.* Light winds and soft warm light can make early morning conditions ideal for wildflower photography.

• *Timing.* Peak wildflower conditions can vary greatly by species, location, and soil conditions. It's essential to visit the same area regularly to learn these variations.

Late April to early May are excellent times to see prairie wildflowers at Sherburne National Wildlife Refuge. While Wild Lupine continues to expand across the refuge as an invasive species, periodically Yellow Goatsbeard can often be seen but much less widely. Opening in the early morning and then closed by noon, Yellow Goatsbeard can be difficult to find. In fact, while it is a relatively common flower, it was only until the sixth year of photographing on the refuge that the timing, weather, and conditions came together for this image. Over the years, I've found it absolutely essential to revisit areas like this often to understand the rhythms of the land.

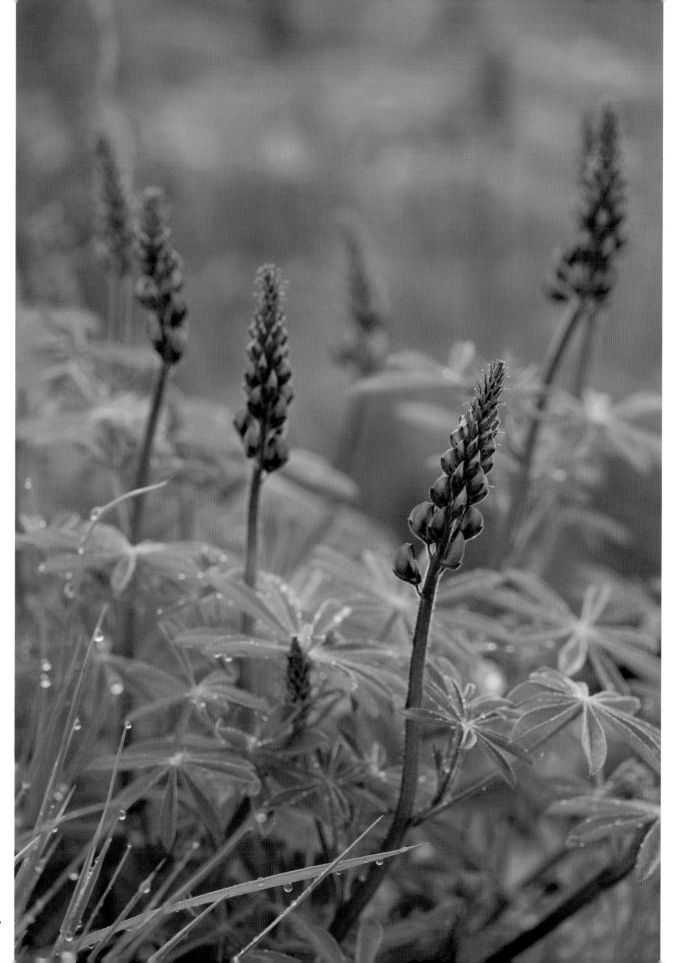

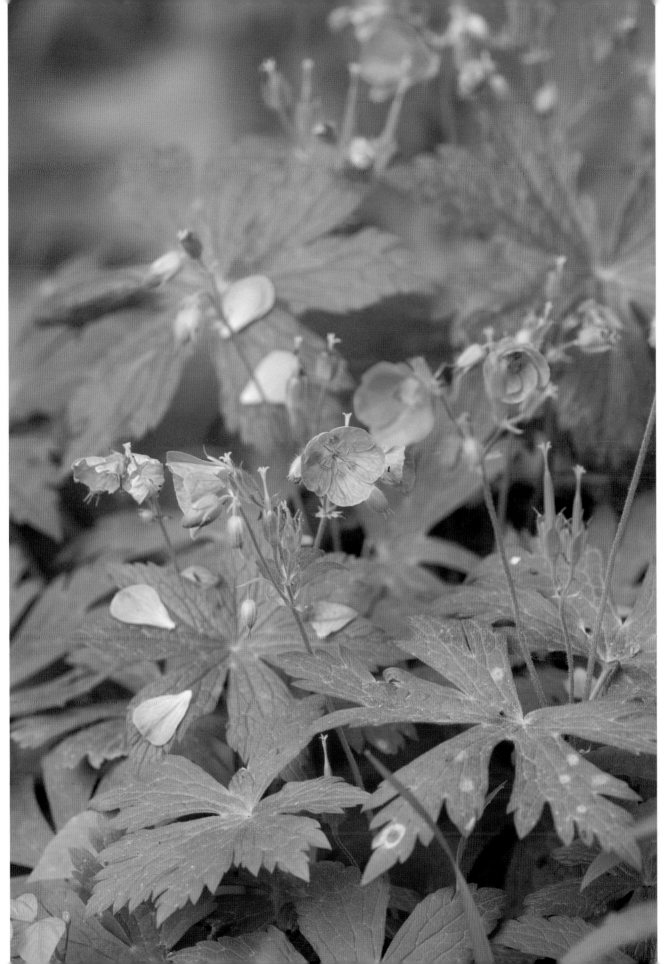

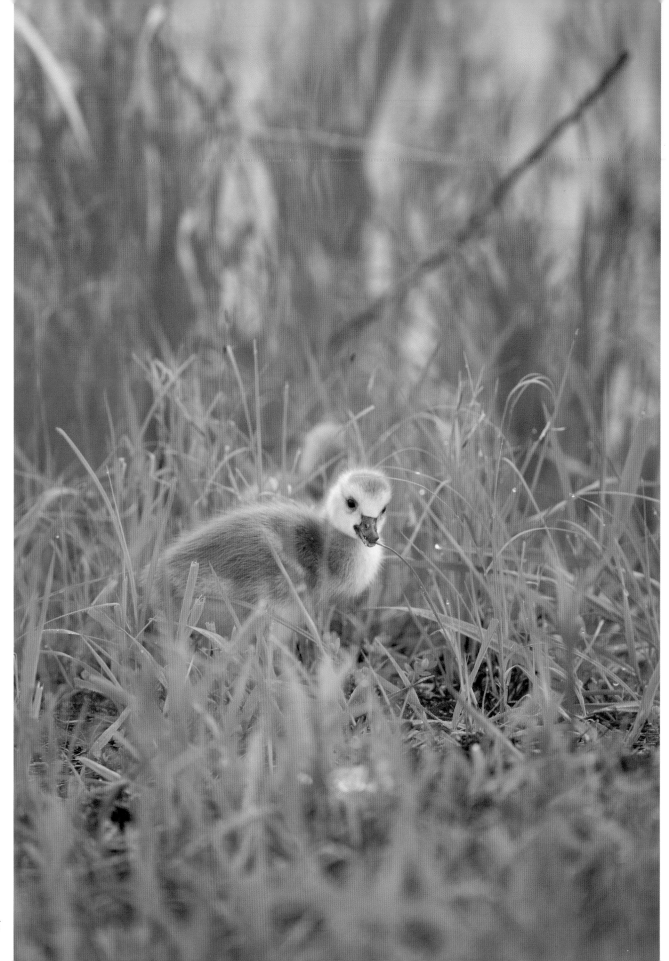

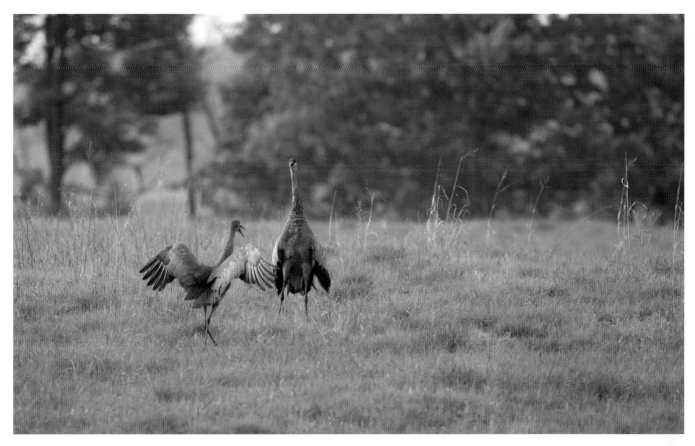

▲ Sandhill Cranes honk and dance wildly at Sherburne NWR. *Canon 1d Mark II Camera, 500mm f/4 lens, ISO 400, 1/800 second at f/5.0.*

Wildlife Interaction

Sherburne National Wildlife Refuge with its marshes, prairie ponds, and surrounding farmlands is an ideal location and habitat for Sandhill Cranes. Regularly hosting a small colony of cranes throughout the spring, summer, and fall, cranes are typically seen on the first visit in the morning.

Mating for life, Sandhill Cranes maintain a strong family and social bond through spectacular jumps, outstretched wings, and a refuge-echoing call that can be heard at great distances. Studies suggest Sandhill Cranes with bright white cheeks have already paired with a lifetime mate while others indicate the varied calls have specific meanings.

◀ Wild Geranium. *Canon 1d Mark II Camera, 500mm f/4 lens, ISO 400, 1/100 second at f/7.1.*

Digital Equipment
• *Use your large lens for wildlife and wildflowers.* We often think of large lenses for wildlife. In fact, another use is tight shots of wildflowers where access can be difficult. Not only does this produce frame-filling results, it also lessens the impact where no trails exist.
• *Visit often.* Returning week after week, some are more productive visits than others. Soon wildlife and habitat areas will become familiar making it much easier to spot potential photographs.

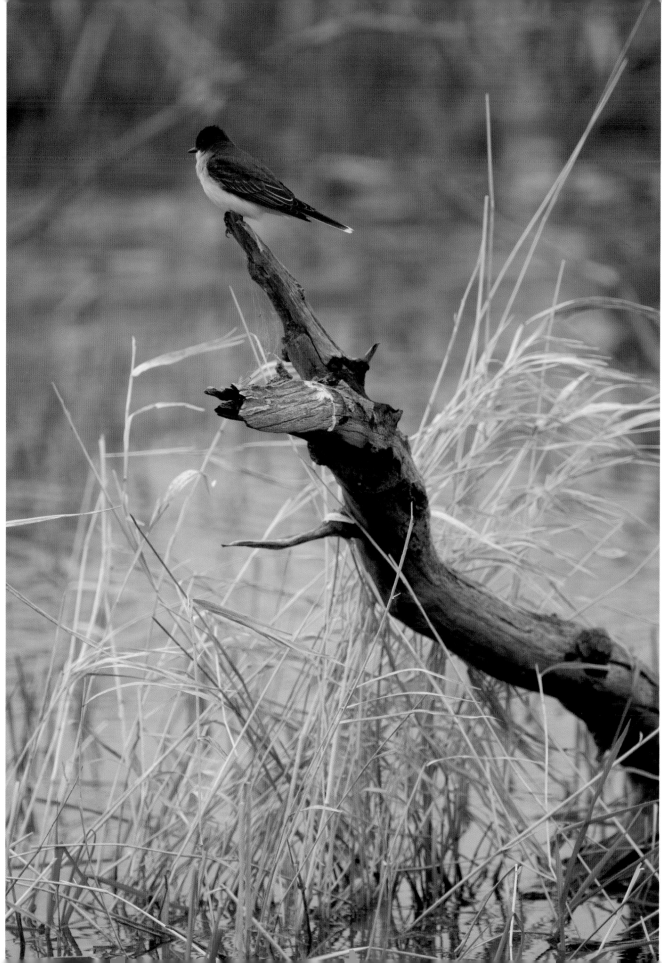

New Life

By mid to late May the refuge is bustling with activity. Numerous Blue-winged Teal scour small ponds for food. Meanwhile, under the protective and watchful eye of a Canadian Goose, young geese venture out to explore the refuge. Ever mindful of potential threats on the refuge, Herons, River Otters, and Bald Eagles carefully watch for unsuspecting mothers and their baby geese. By far the largest inhabitant of Sherburne, Canadian Geese find ample ponds and lakes to raise their young.

▼ Blue-winged Teal on approach, Sherburne NWR. *Canon 1d Mark II Camera, 500mm f/4 lens, 1.4x teleconverter (effectively 910mm) ISO 100, 1/800 second at f/5.6.*

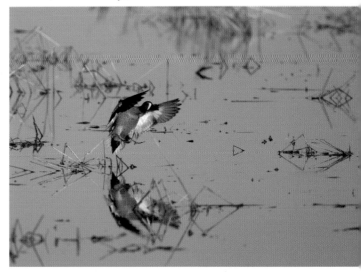

◀ Eastern Kingbird, Sherburne NWR. *Canon 1d Mark II Camera, 500mm f/4 lens, 1.4x teleconverter (effectively 910mm) ISO 100, 1/320 second at f/5.6.*

▼ Canadian Geese, Sherburne NWR. *Canon 1d Mark II Camera, 500mm f/4 lens, 1.4x teleconverter (effectively 910mm) ISO 100, 1/320 second at f/5.6.*

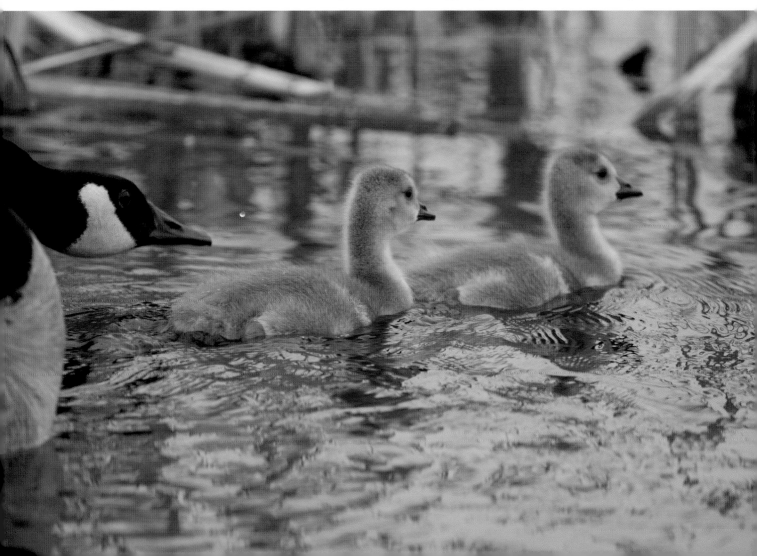

Superior National Forest

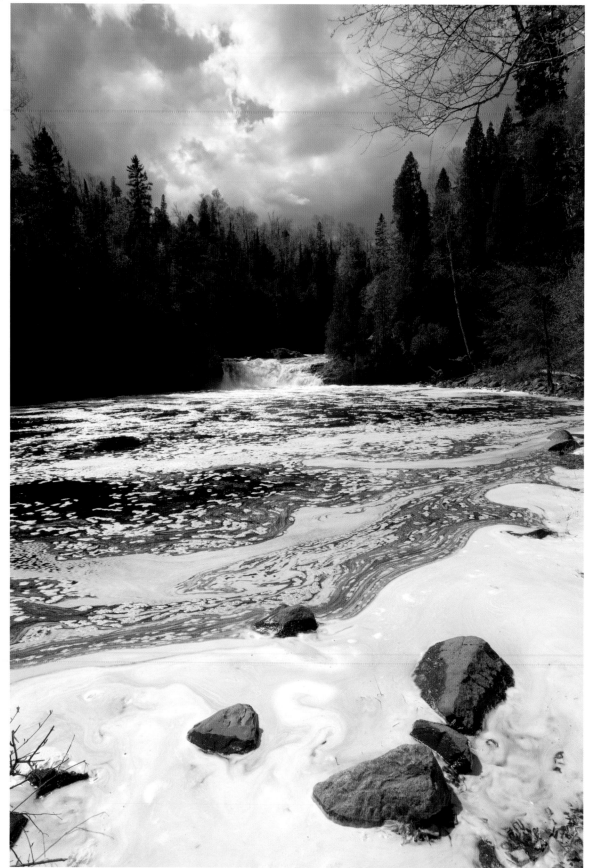

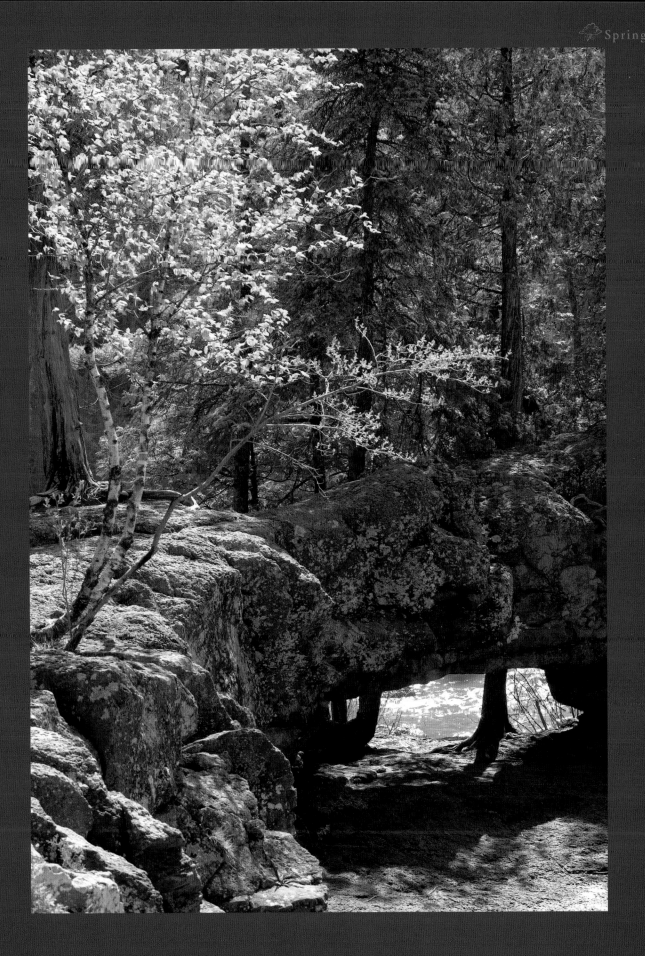

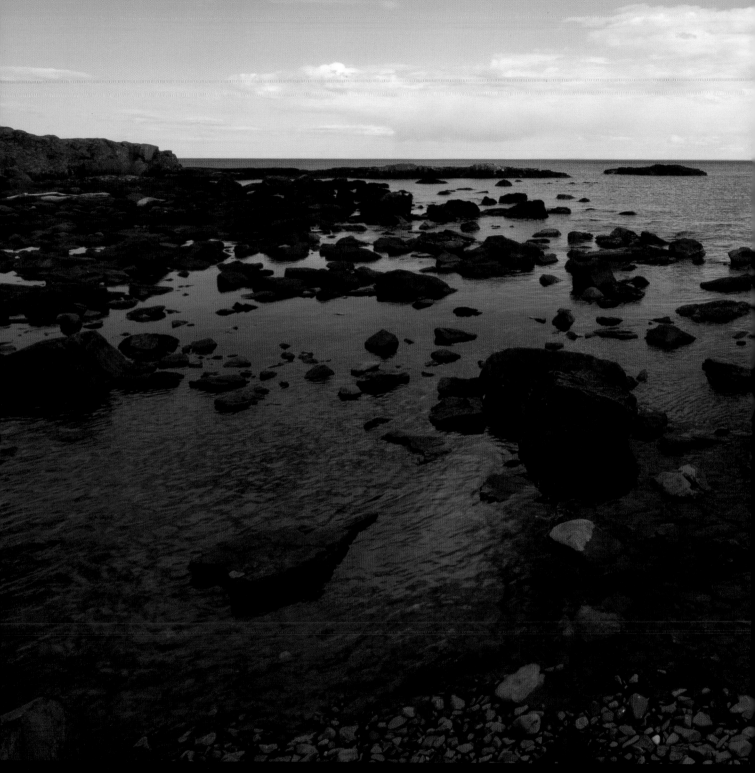

▲ Lake Superior and Ellington Island to the left. *Canon 1ds Mark II Camera, 16-35mm f/2.8 lens, ISO 100, 1/30 second at f/22.*

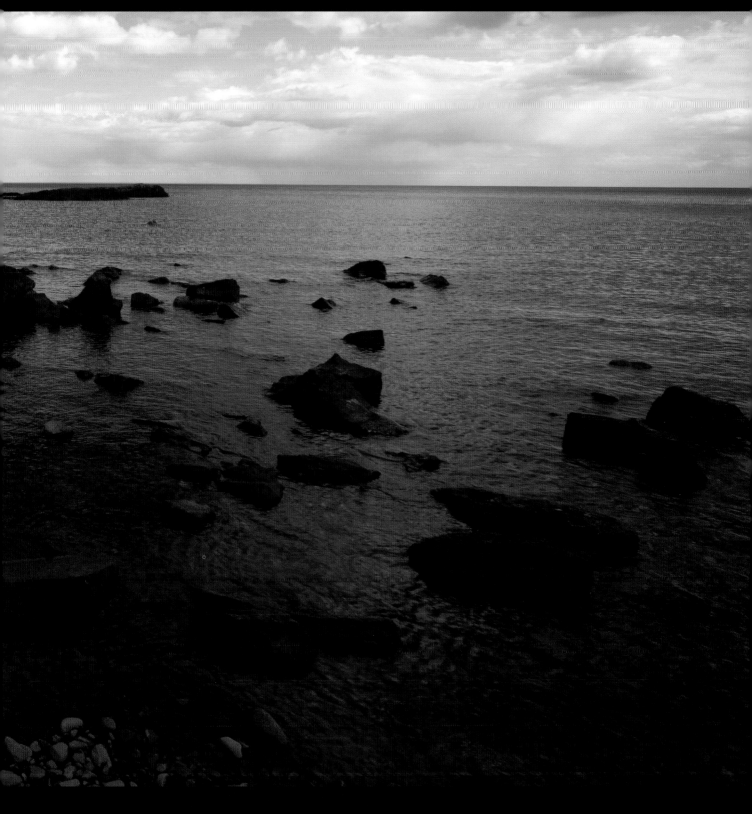

Vastness

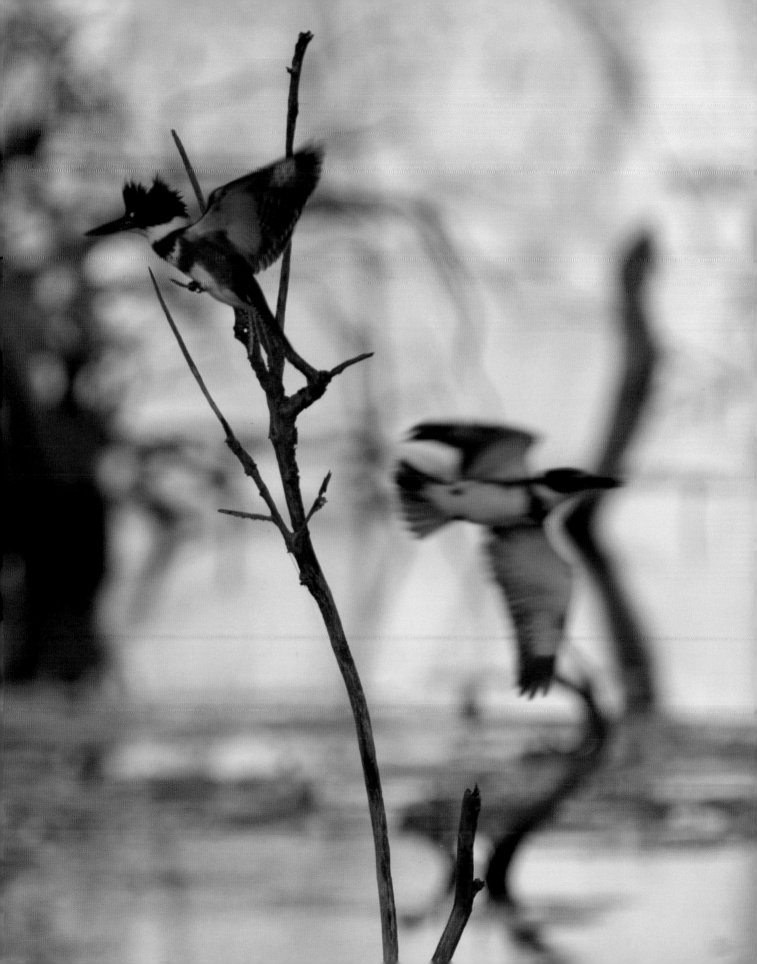

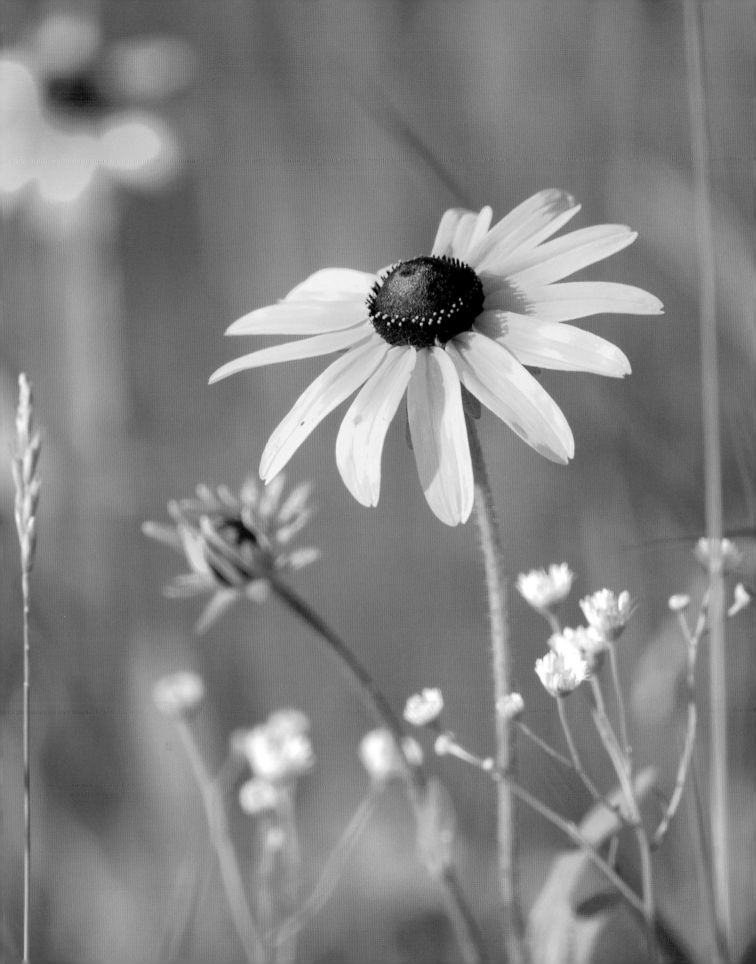

Daily Routines

With the explosive changes of spring now behind, wildflowers, aquatic plants, fish, and wildlife settle into a long and productive summer. From the rugged ancient bedrock and basalt outcroppings of the North Shore to the expansive Mississippi River and bluffs of southeastern Minnesota, summer has arrived in full force.

Throughout eastern Minnesota and across the edge of the Boreal Forest, the rhythm of life is relentless. Nowhere can this be seen better in the summer than at Sherburne National Wildlife Refuge in east central Minnesota. Sherburne's unique location and history places it at the nexus of prairie parklands, deciduous forests, lakes, and marshes. On the refuge, Common Loons, Bald Eagles, Great Blue Heron and numerous others successfully raise new generations year after year. Returning regularly throughout the summer, Common Loons can be seen feeding their young right next to the Prairie's Edge Wildlife Drive. Meanwhile, a pair of Bald Eagles have returned to the refuge to announce two new hatchlings. Over the weeks they gain strength under the careful eye of a parent and quickly set out to explore their new surroundings.

◀ Black-eyed Susan. *Canon 1d Mark II Camera, 500mm f/4 lens, 1.4x teleconverter (effectively 910mm) ISO 100, 1/320 second at f/5.6.*

▼ Common Loon. *Canon 1d Mark II Camera, 500mm f/4 lens, 1.4x teleconverter (effectively 910mm) ISO 100, 1/500 second at f/5.6.*

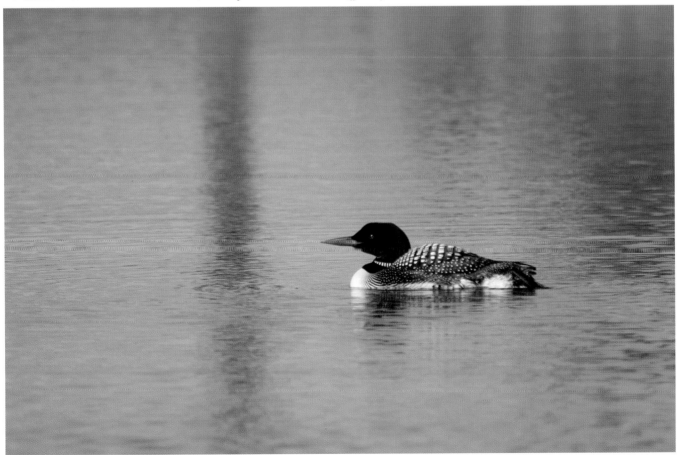

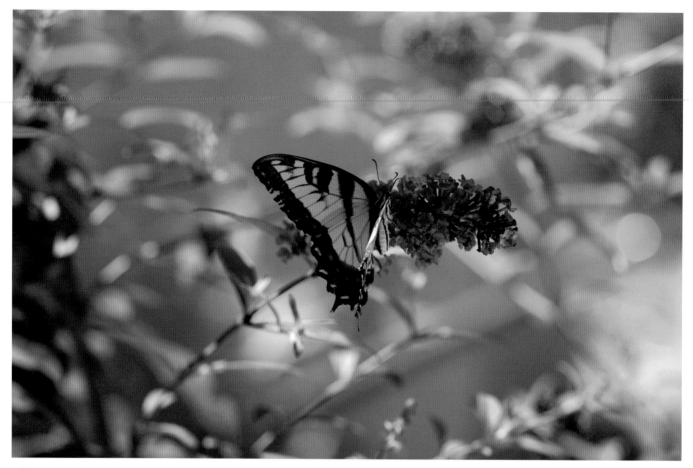

▲ Eastern Tiger Swallowtail, Minnesota Zoo (Captive). *Canon 1d Mark II Camera, 100-400mm f/4 lens, 180mm, ISO 100, 1/200 second at f/5.6.*

Habitat

Critical to the survival of Minnesota wildlife is sufficient habitat. While areas such as Sherburne National Wildlife Refuge offer an oasis of vast and unspoiled lakes and prairies capable of hosting productive nesting grounds for Bald Eagles, Common Loons, and other migratory waterfowl, unfortunately that's not necessarily the case across the entire state.

In the 1850's roughly half of Minnesota's 50.8 million acres were considered old-growth forests. Taking 120 years or more to mature, old-growth forests today within the state have become quite rare. In fact, while Minnesota's forest acreage fell by 43% over the last 150 years, old-growth forests shrank by an amazing 95%.

Compounding the issue has been shoreline development on an ever-increasing percentage of the 90,000 miles of shoreline within the state. If implemented poorly, this development can reduce the availability of shoreline for nesting, decrease buffer zones for run-off, and degrade water clarity essential for diving waterfowl such as loons. To monitor water clarity over time and assess its impact on wildlife, the Minnesota Pollution Control Agency has implemented a statewide Citizen-Lake Monitoring Program since the 70's. By taking Seechi Transparency readings (a depth reading of a disk lowered from the surface), lake transparency can be sampled and tracked over time.

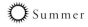

Average Transparency
Reading (Feet)

▲ < 2.0
○ 2.0 - 4.9
■ 5.0 - 7.9
◇ 8.0 - 14.9
● 15.0 or Greater

Not surprising, areas adjacent to extensive farms and urban developments have increased content of allege and other particles in the water column decreasing lake transparency. Conversely, areas of high water clarity occur within the Laurentain and Eastern Broadleaf forests of central and northeast Minnesota.

Within the state there are a number of organizations from the Department of Natural Resources to the Minnesota Zoo who regularly monitor and aid in restoration from aquatic species to injured Bald Eagles.

▼ *Canon 1d Mark II Camera, 500mm f/4 lens, 1.4x teleconverter (effectively 910mm) ISO 400, 1/125 second at f/5.6.*

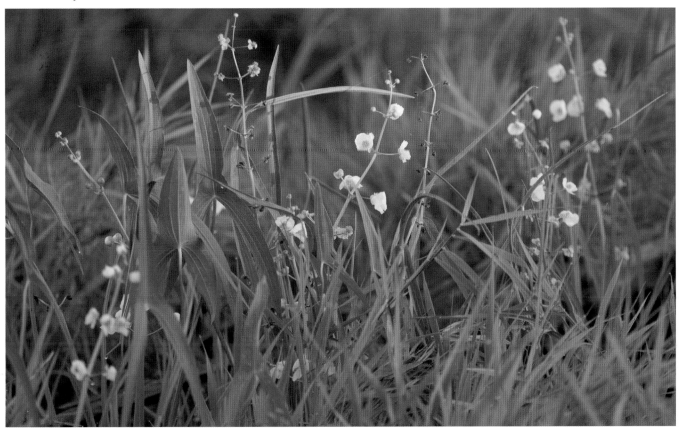

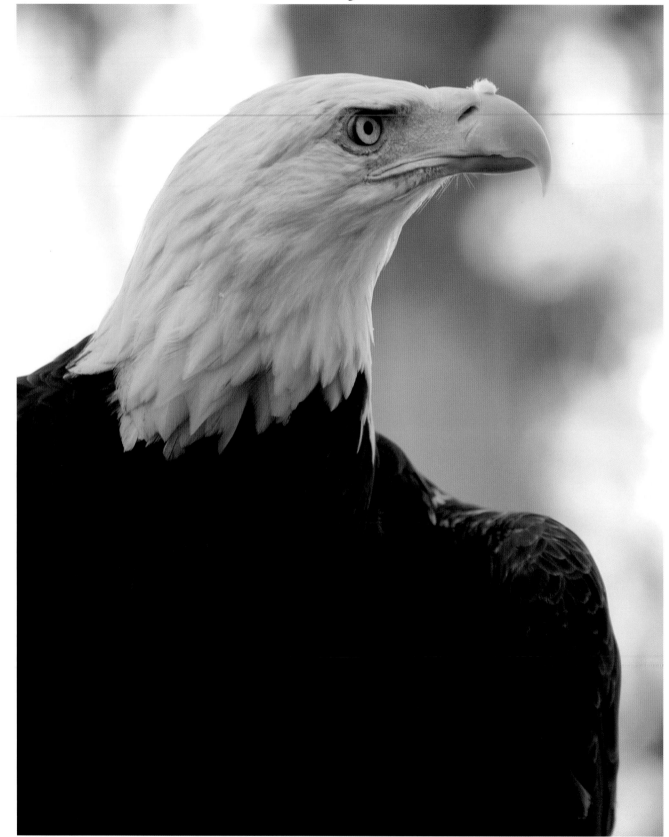

▲ Recovered Bald Eagle, Minnesota Zoo (Captive). *Canon 1d Mark II Camera, 100-400mm f/4 lens, 320mm, ISO 100, 1/250 second at f/5.6.*

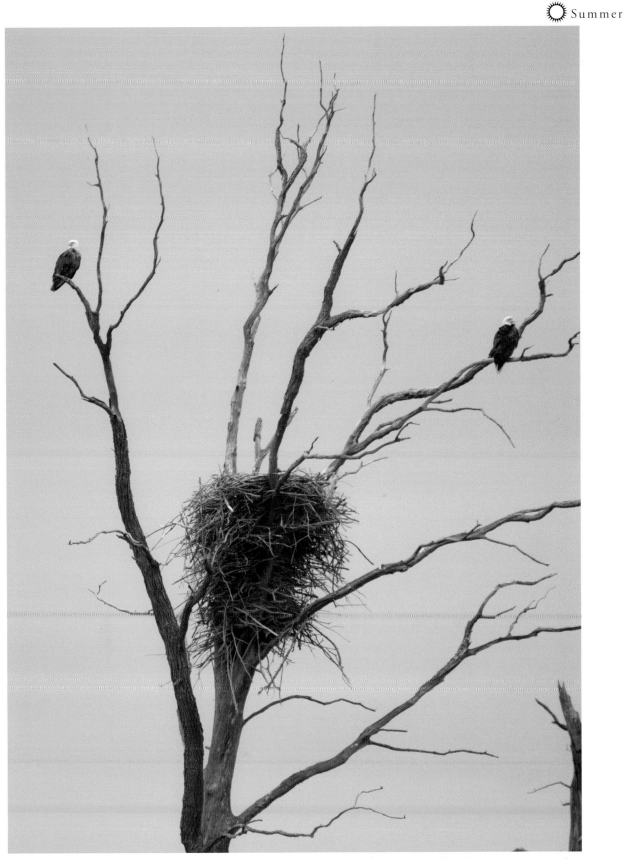

▲ Nesting Bald Eagles, Sherburne NWR. *Canon 1d Mark II Camera, 500mm f/4 lens, 1.4x teleconverter (effectively 910mm) ISO 200, 1/400 second at f/5.6.*

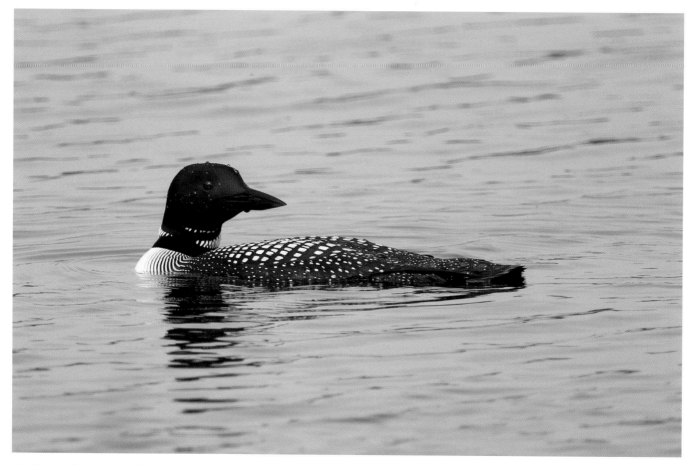

▲ Common Loon. *Canon 1d Mark II Camera, 500mm f/4 lens, 1.4x teleconverter (effectively 910mm) ISO 100, 1/320 second at f/5.6.*

Refuge Wildlife

The 7.3 mile Prairie's Edge Wildlife Drive twists and turns through marshes, lakes, and hardwood forests at Sherburne National Wildlife Refuge. Lightly visited, at each turn new opportunities emerge to see and photograph loons, cormorants, hawks, eagles, grebes, coots, warblers, geese, swans, and River Otters at close ranges. As summer progresses, the rhythm of life on the refuge unfolds and is repeated with daily rigor. Visiting in the morning offers the best chance to see a wide array of wildlife near the access roads. Occasionally a River Otter makes an appearance on the road while Wood Ducks remain very skittish. Similar to when approached on the water from a boat or kayak, Common Loons seem to have no fear of approaching vehicles but are rather more concerned with diving to feed.

The numerous Canadian Geese hatchlings have grown quickly and continue to spread out across the refuge while Blue-winged Teals have taken on a much reduced presence.

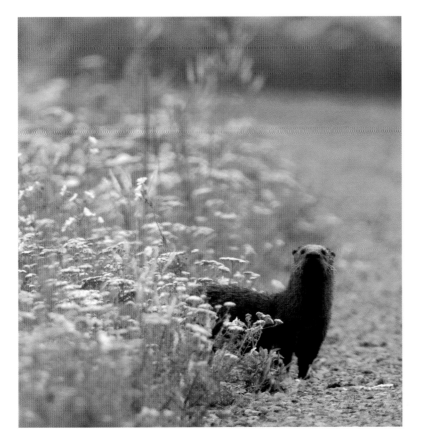

◀ River Otter, Sherburne NWR *Canon 1d Mark II Camera, 500mm f/4 lens, 1.4x teleconverter (effectively 910mm) ISO 400, 1/400 second at f/5.6.*

Greeted by a proud River Otter for a few seconds along the road, I quickly turned my lens to a Great Blue Heron blending into the dead and twisted tree branches just a few yards away.

With only a few herons on the refuge they are easily spooked, more so than at other locations throughout the state. At 8.5 frames per second, this huge bird (next page) put out a pre-historic squawk and quickly departed to another location several hundred yards away.

Meanwhile, overhead a Canadian Goose makes a close fly-by to let me know I'm in its territory.

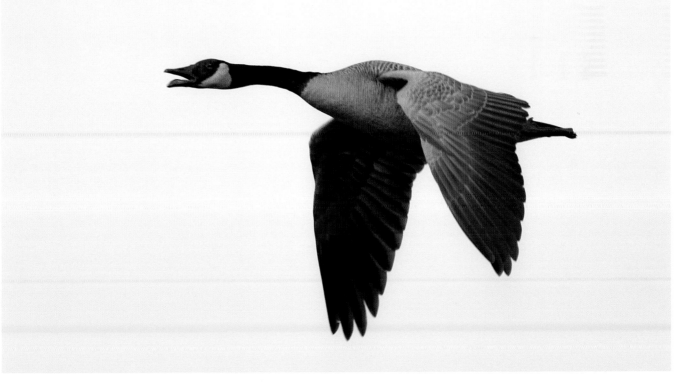

▲ Canadian Goose. *Canon 1d Mark II Camera, 500mm f/4 lens, 1.4x teleconverter (effectively 910mm) ISO 160, 1/500 second at f/5.6.*

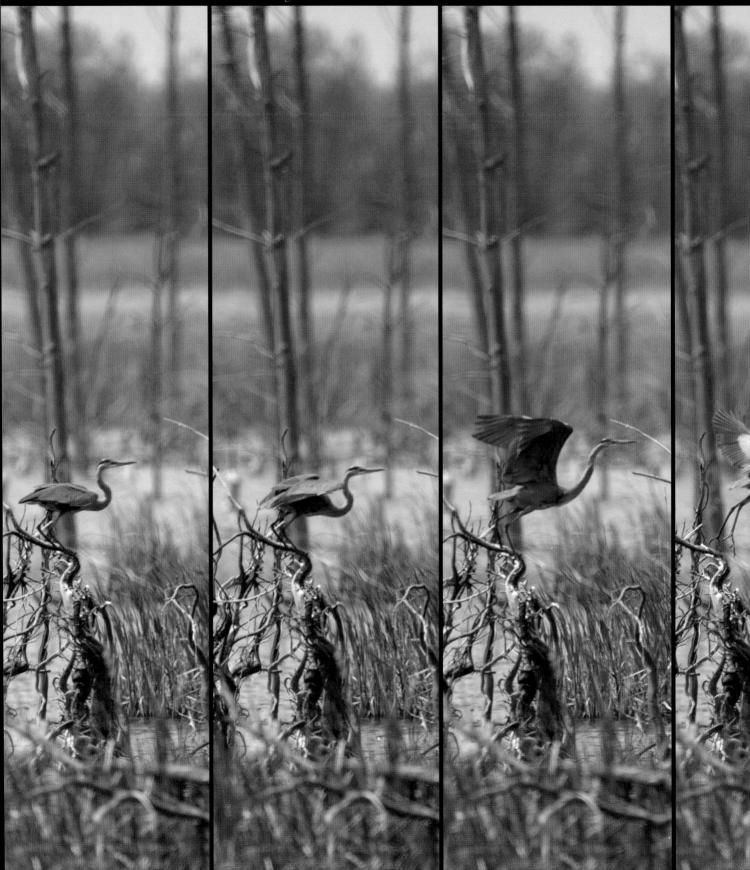

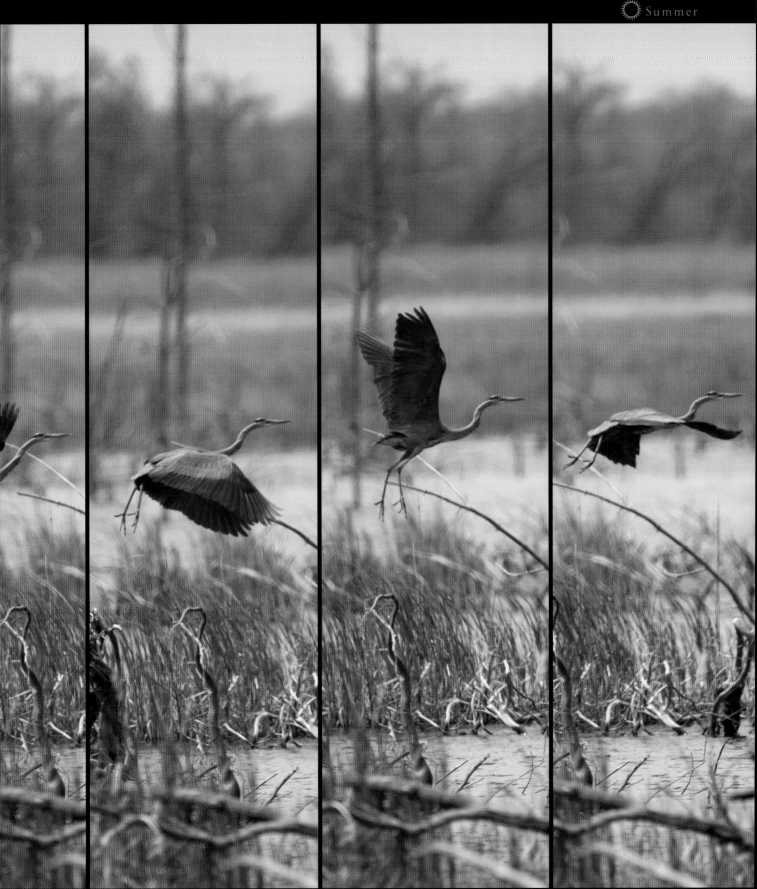

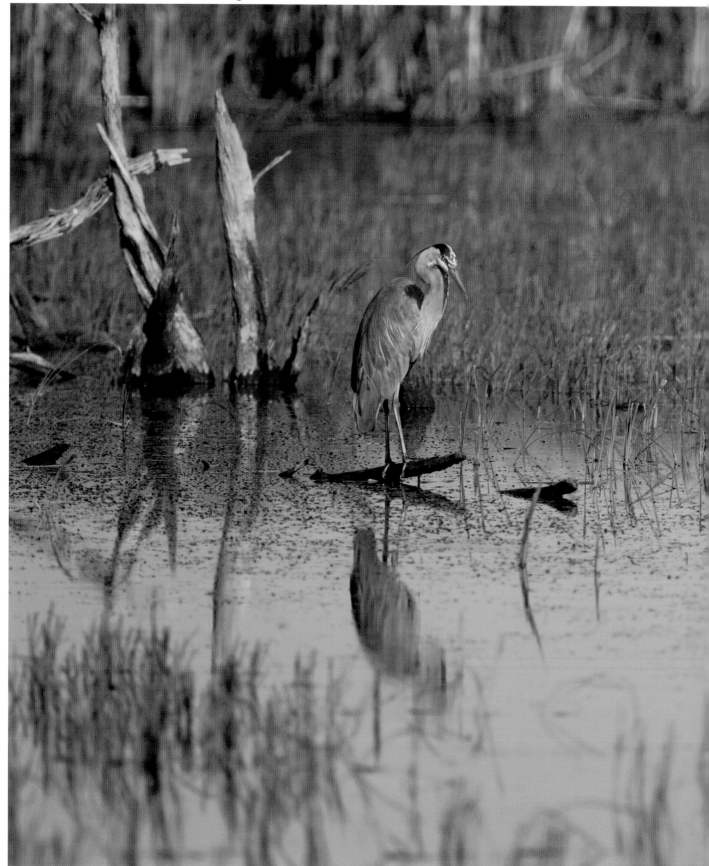

◀ Great Blue Heron, Sherburne NWR. *Canon 1d Mark II Camera, 500mm f/4 lens, 1.4x teleconverter (effectively 910mm) ISO 160, 1/ 1000 second at f/5.6.*

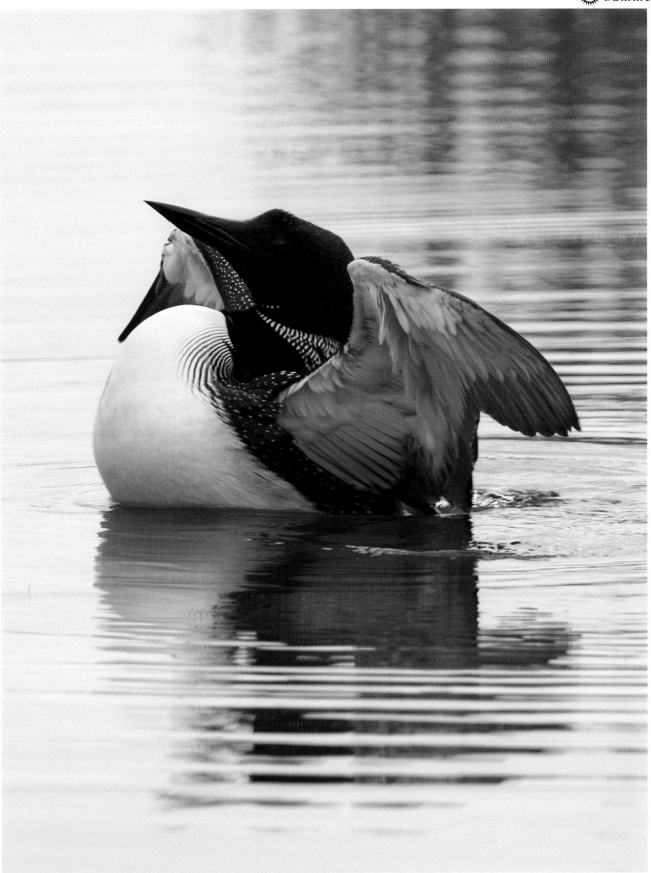

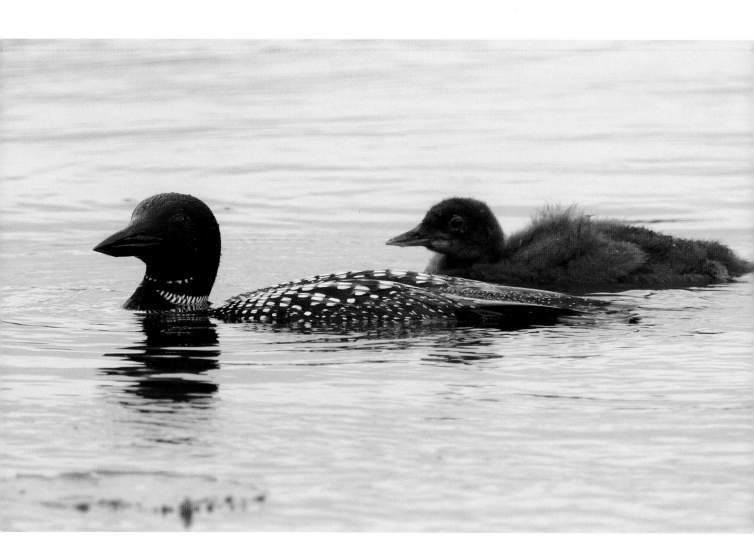

▲ Common Loon and hatchling. *Canon 1d Mark II Camera, 500mm f/4 lens, 1.4x teleconverter (effectively 910mm) ISO 500, 1/320 second at f/6.3.*

Digital Equipment
• *Exposure.* I often manually set my exposure to a neutral grey portion of the scene so as to not over/under expose the white feathers of the loon or strongly lit water surface.

As summer settles into early July, a new generation of Common Loons stay close to their parents under the watchful eye of a Bald Eagle. Within a day or so of hatching, newborn loons position atop their parents. With legs positioned far aft, they are much more accustomed to water than land. Coming to land only to nest, loons are virtually helpless on shore. Unfortunately this dependency on land for nesting often sits in conflict with lake development. Water clarity, shoreline development, boats, predators such as eagles, pike, muskie, and lead fishing tackle are just a few of the daily hazards.

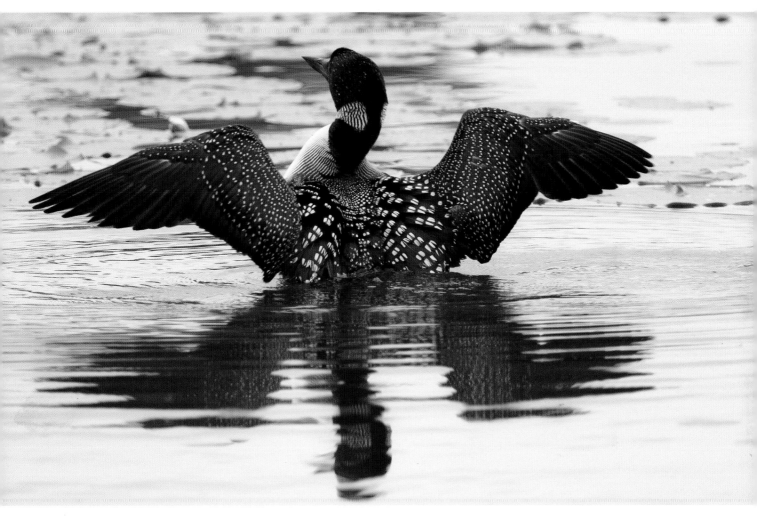

▲ Common Loon. *Canon 1d Mark II Camera, 500mm f/4 lens, 1.4x teleconverter (effectively 910mm) ISO 500, 1/320 second at f/6.3.*

Over the summer months, the parents continually dive and bring food to the surface for the hatchlings. As the months progress, quite often the young loon is temporarily alone on the surface awaiting a meal as the more mature loon hunts and feeds underwater. With outstretched wings, this loon is ready to move on to more productive areas of the refuge.

Lakes and Loons

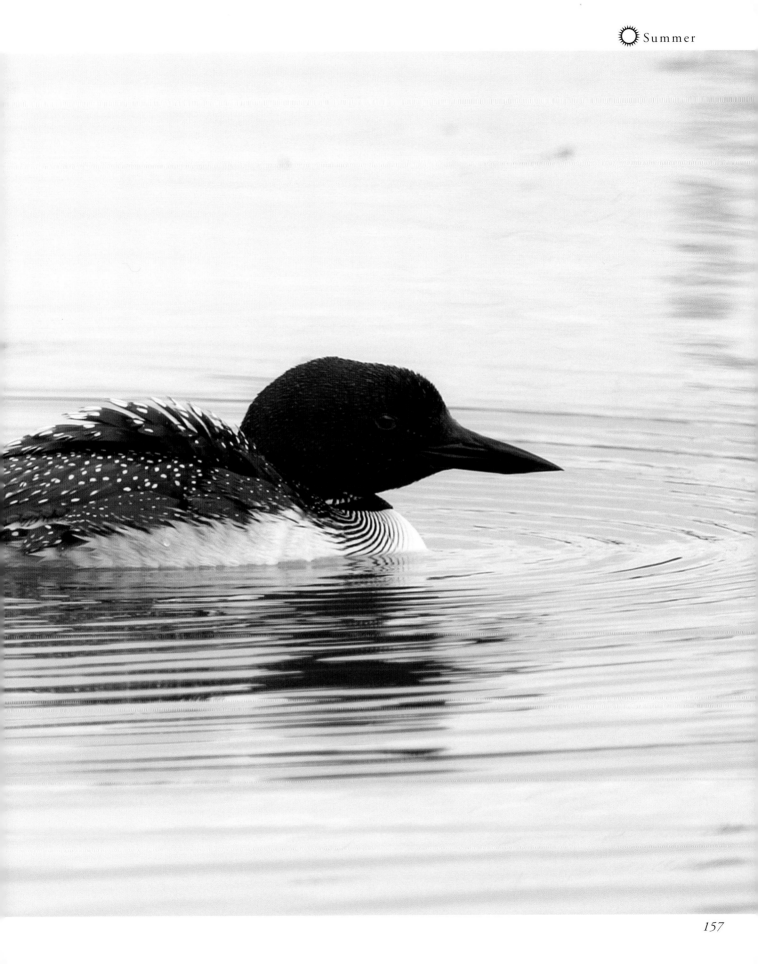

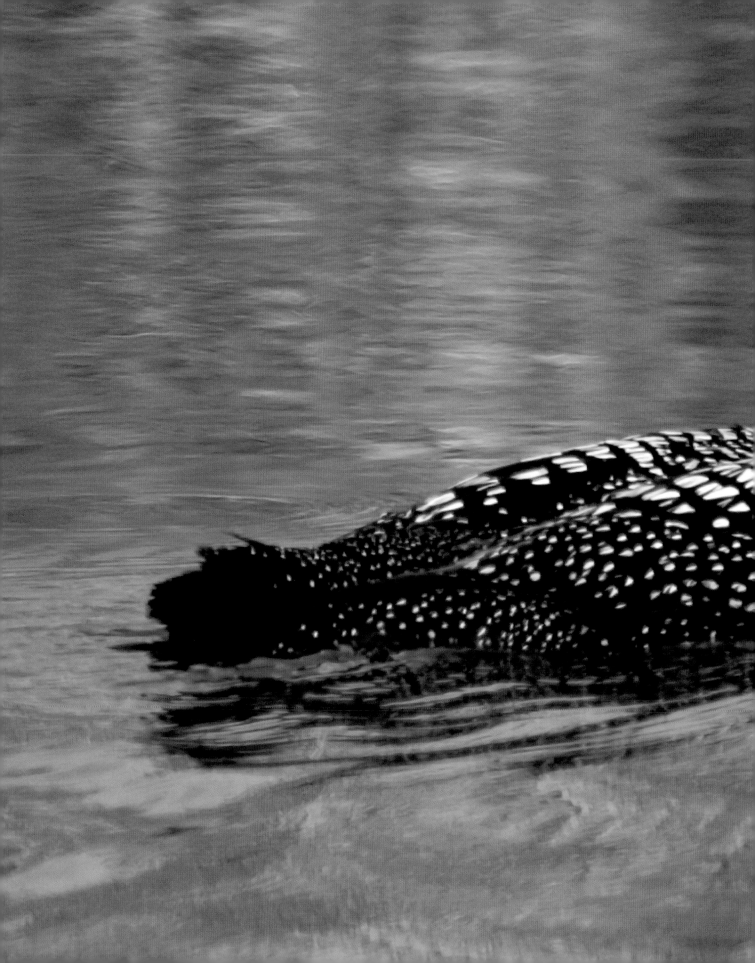

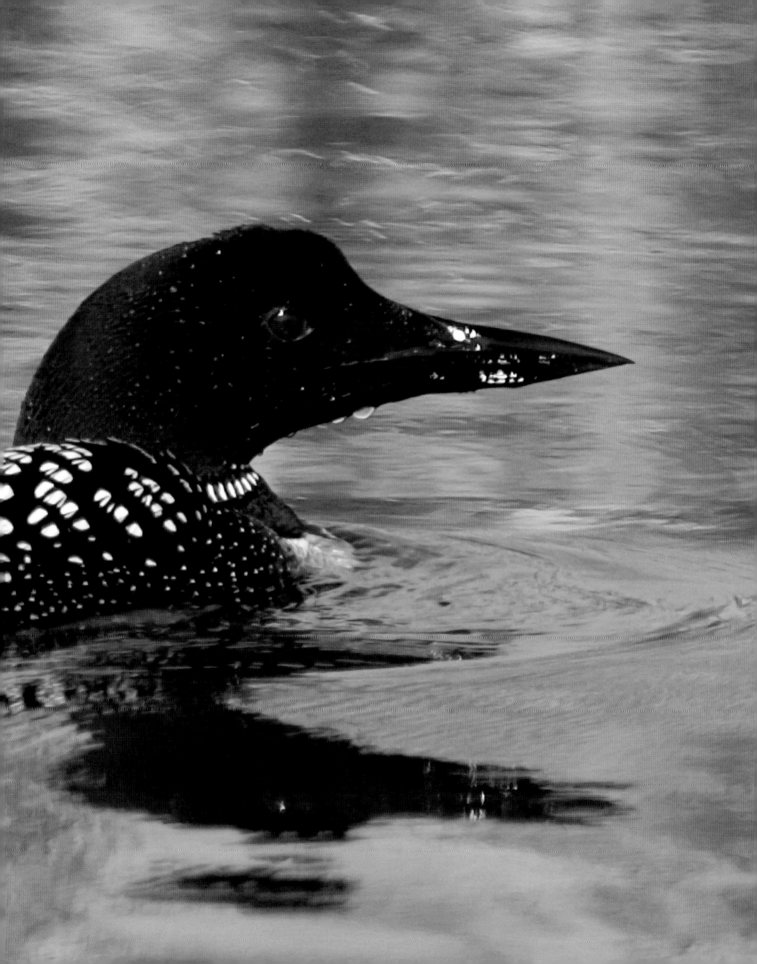

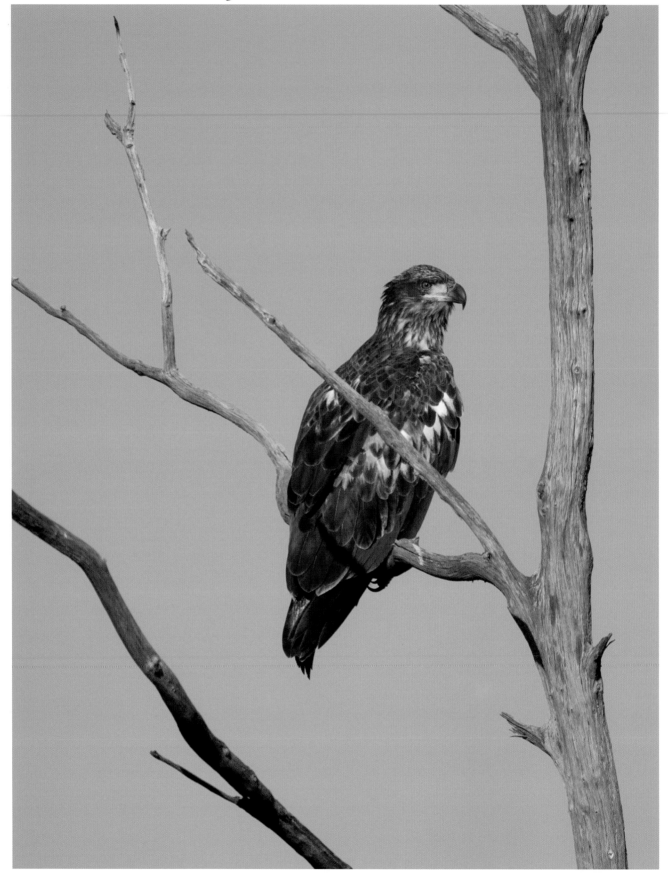

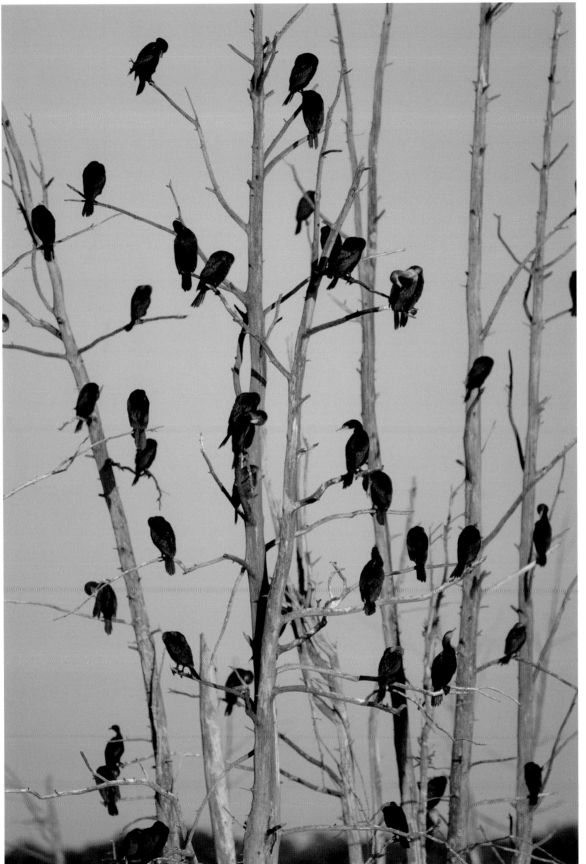

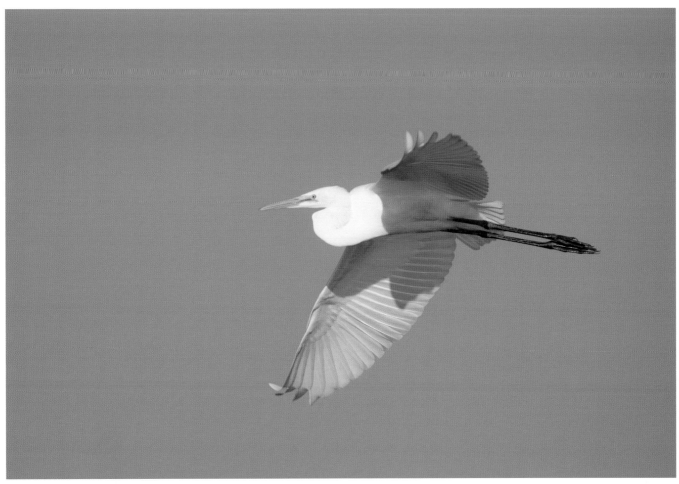

▲ Egret. *Canon 1d Mark II Camera, 500mm f/4 lens, 1.4x teleconverter (effectively 910mm) ISO 100, 1/800 second at f/6.3.*

Getting Close

Although access to the refuge from the Prairie's Edge Wildlife Drive offers close proximity to birds and wildlife, getting close enough for fast moving, frame-filling digital photography often requires high performance lenses. While typically used for bird photography, the Canon 500mm f/4 lens can become a standard lens to access wildflowers from the roads. Using a lens like this offers great access while not disturbing refuge plants.

Throughout the spring and summer the majority of visitors remain in their cars. Refuge birds grow accustom to this allowing vehicles to get very close without disturbance. Using a camera window mount and a 500mm lens allows birds and wildlife to be photographed from the car using it as a bird blind. Occasionally runners and bicyclist come through the refuge. While a great workout, their presence will scatter most birds within 200 - 300 meters.

◀ *Canon 1d Mark II Camera, 500mm f/4 lens, 1.4x teleconverter (effectively 910mm) ISO 100, 1/160 second at f/7.1.*

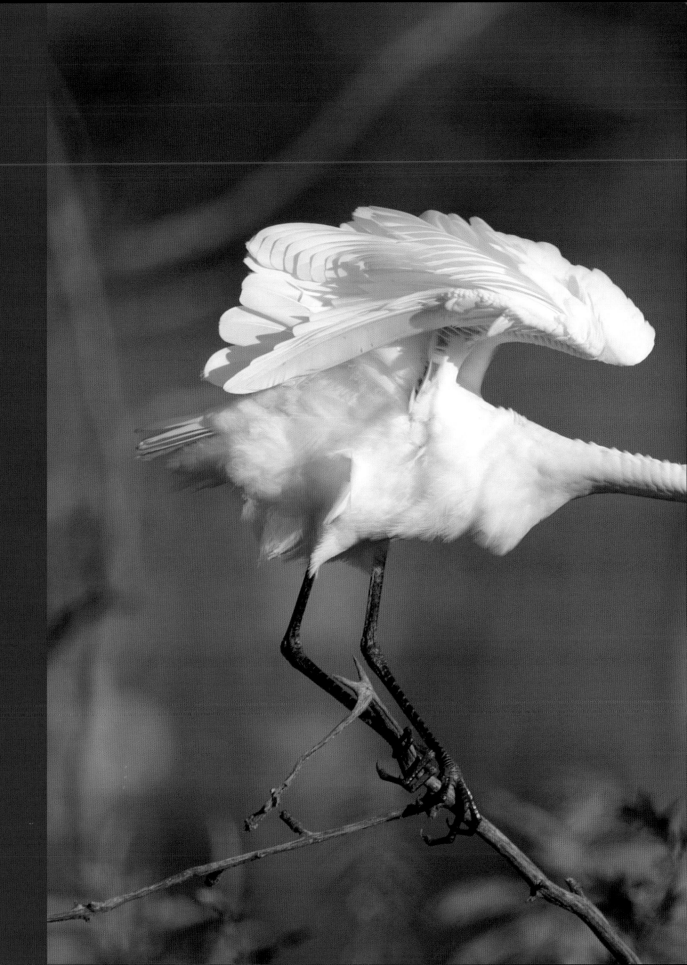

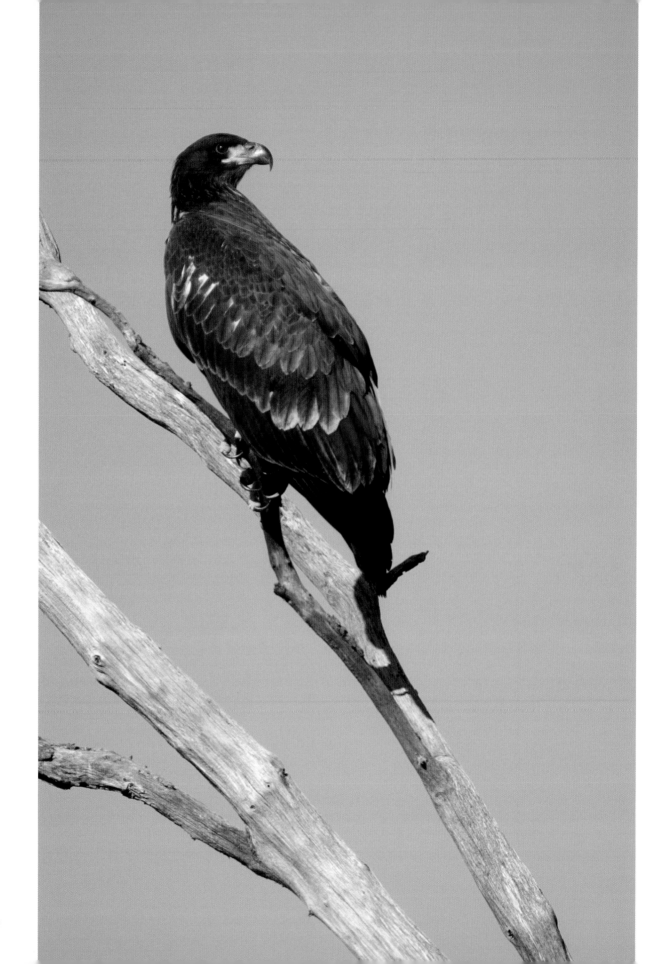

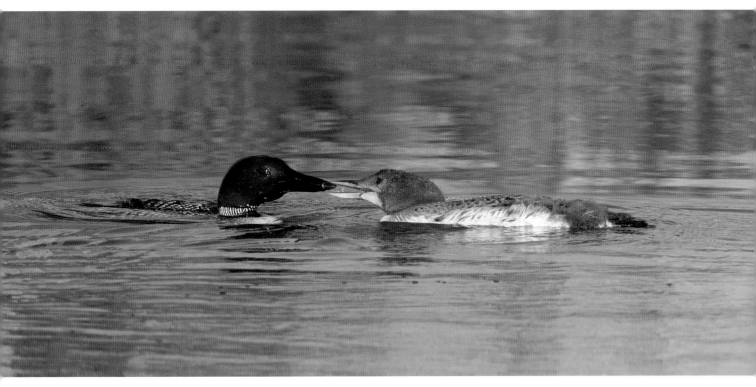

▲ Common Loons feed. *Canon 1d Mark II Camera, 500mm f/4 lens, 1.4x teleconverter (effectively 910mm) ISO 100, 1/320 second at f/6.3.*

End of Summer

By late July the young loon's plumage and beak have changed in coloration. Soon mother and sibling will part ways as the adults begin their journey south in September, leaving behind their newborns for another full month before they are ready to migrate.

As the heat of late summer persists, a group of Egrets spent the night near a refuge access road, unaware of my presence in my vehicle. In the early morning they stretch and loosen up for a new day of fishing on the refuge.

As quickly as it came in, soon summer winds down and is a thing of the past at Sherburne NWR with cool mornings, increasing colors, and maturing Bald Eagles.

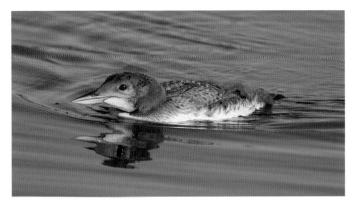

◀ A young Bald Eagle watches over Sherburne National Wildlife Refuge. *Canon 1d Mark II Camera, 500mm f/4 lens, 1.4x teleconverter (effectively 910mm) ISO 100, 1/500 second at f/6.3.*

Autumn

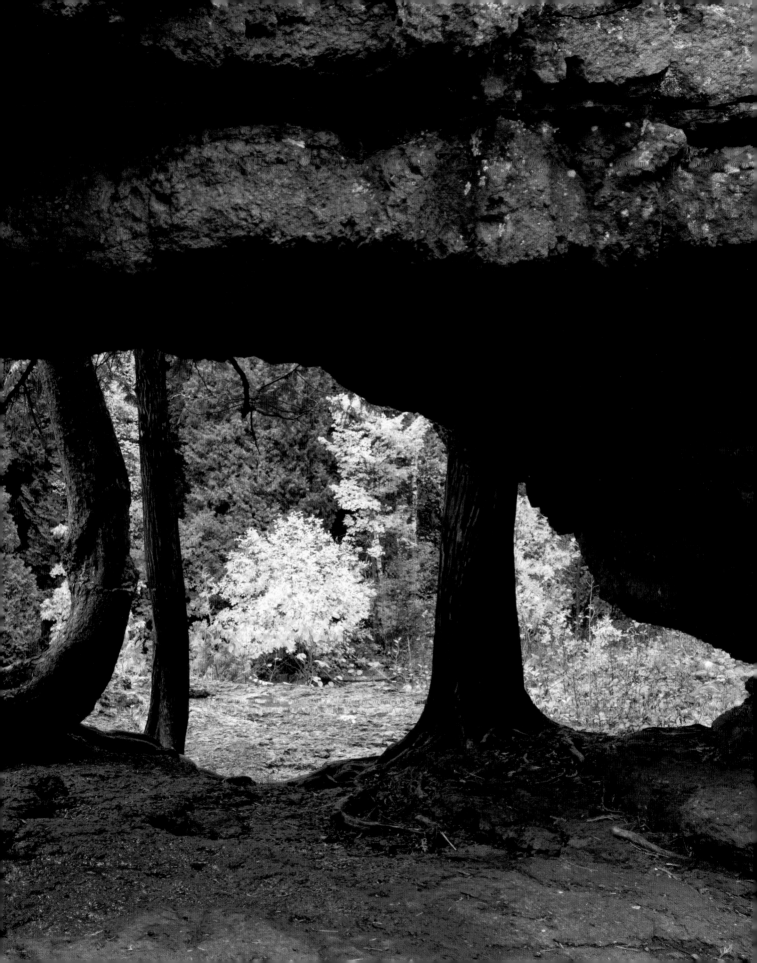

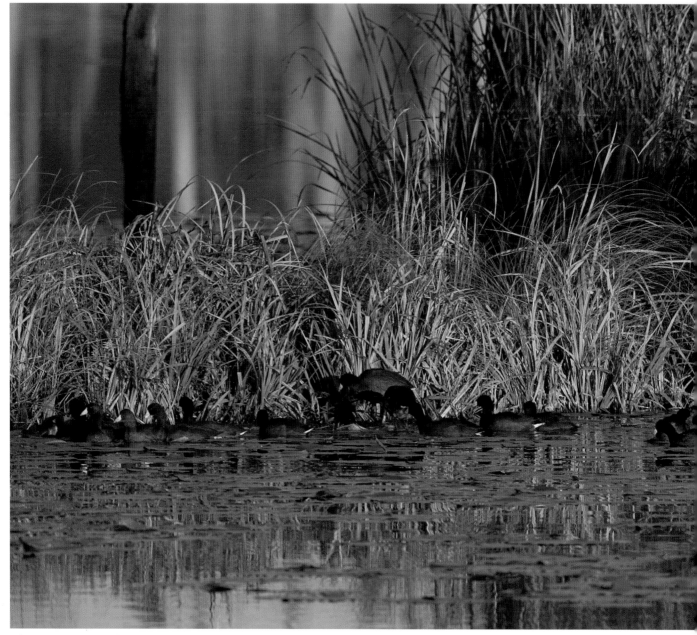

▲ American Coots, Sherburne NWR. *Canon 1d Mark II Camera, 500mm f/4 lens, ISO 100, 1/200 second at f/6.3.*

Migration

By October, swans, loons, eagles, and other refuge birds take to the air to warm-up for the long trip south. Not far away from Sherburne National Wildlife Refuge, the town of Monticello located along the Mississippi becomes the temporary wintering site for Trumpeter Swans. With warm waters from a nuclear power plant upstream, swans can remain throughout the winter season along with hundreds of Mallards and Canadian Geese.

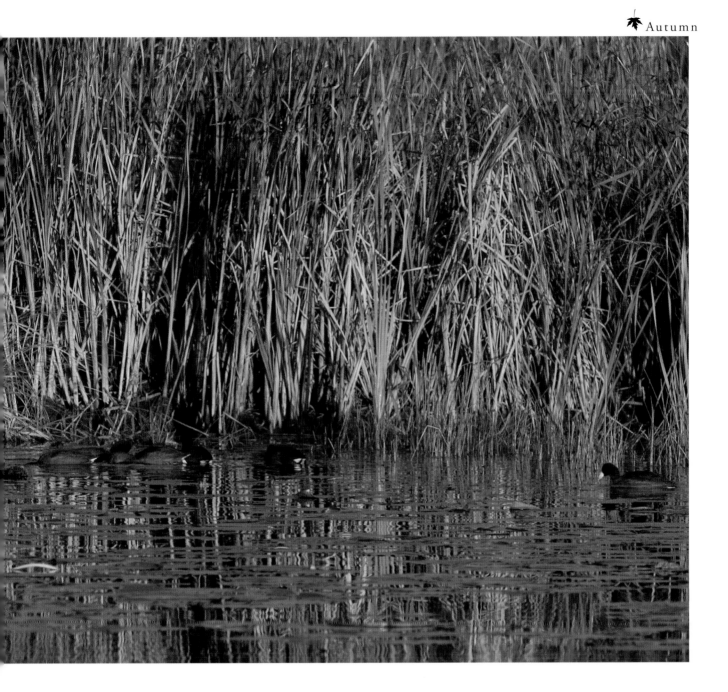

As fall progresses thousands of swans, geese, and ducks follow the arteries of the St. Croix, Minnesota, and Mississippi, Rivers. By late October hundreds of thousands of birds fly through Red Wing to the Brownsville, Minnesota stretch of the Mississippi River. In a race against time, migratory birds continue to shift south along the river before major sections freeze for the long winter.

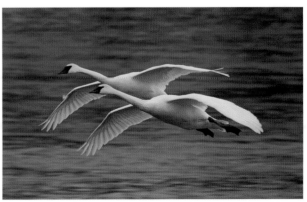

▶ Trumpeter Swans, Mississippi River, Monticello. *Canon 1d Mark II Camera, 500mm lens, ISO 200, 1/200 second at f/6.3.*

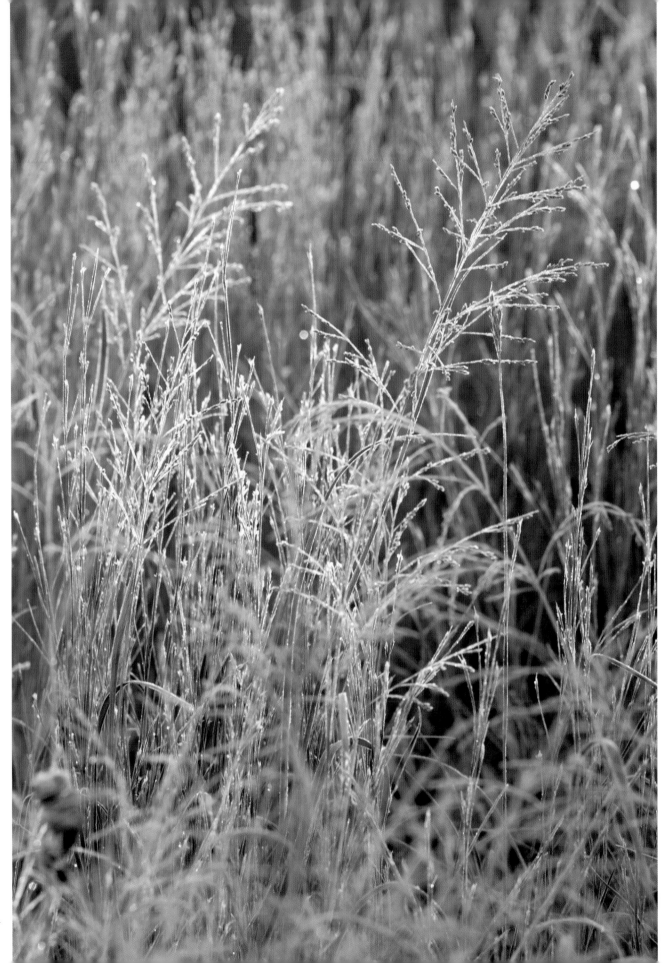

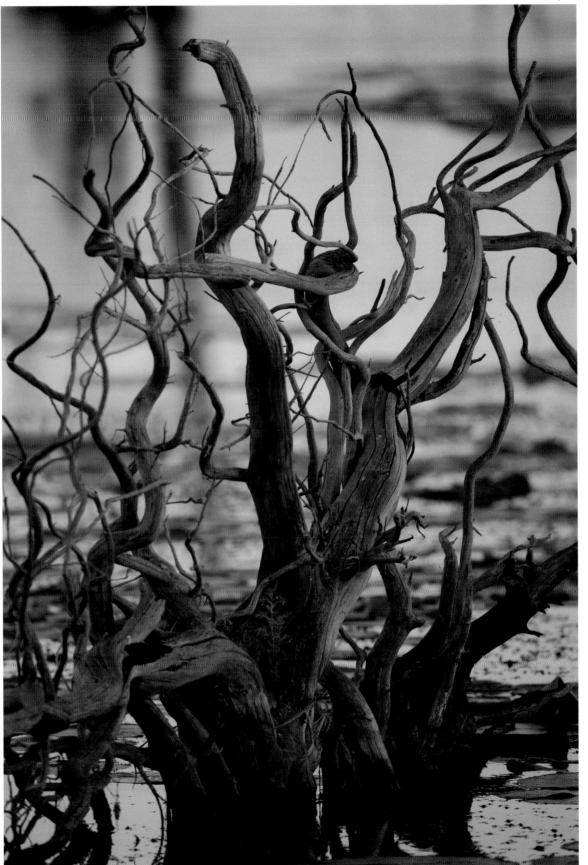

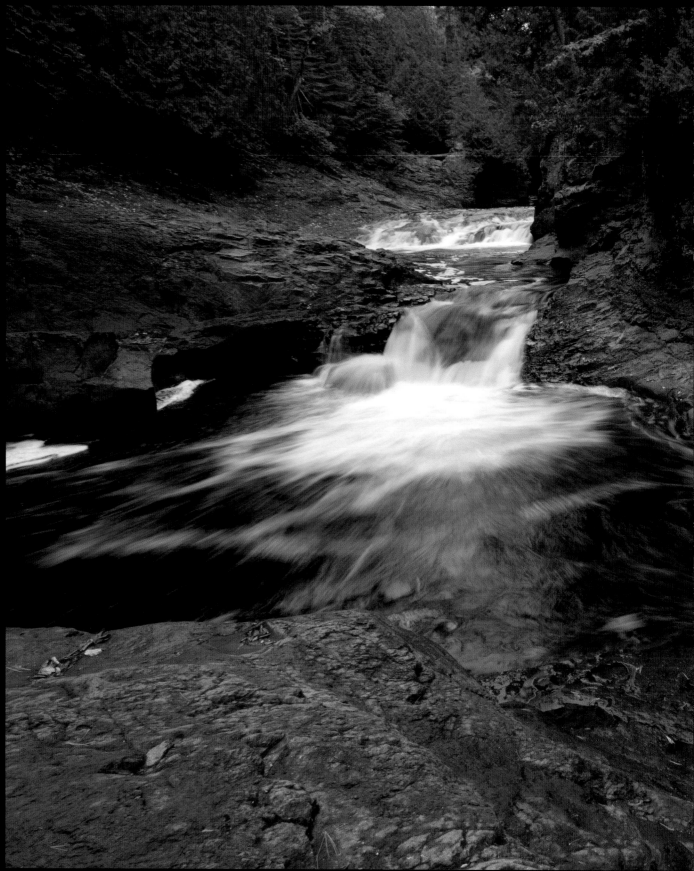

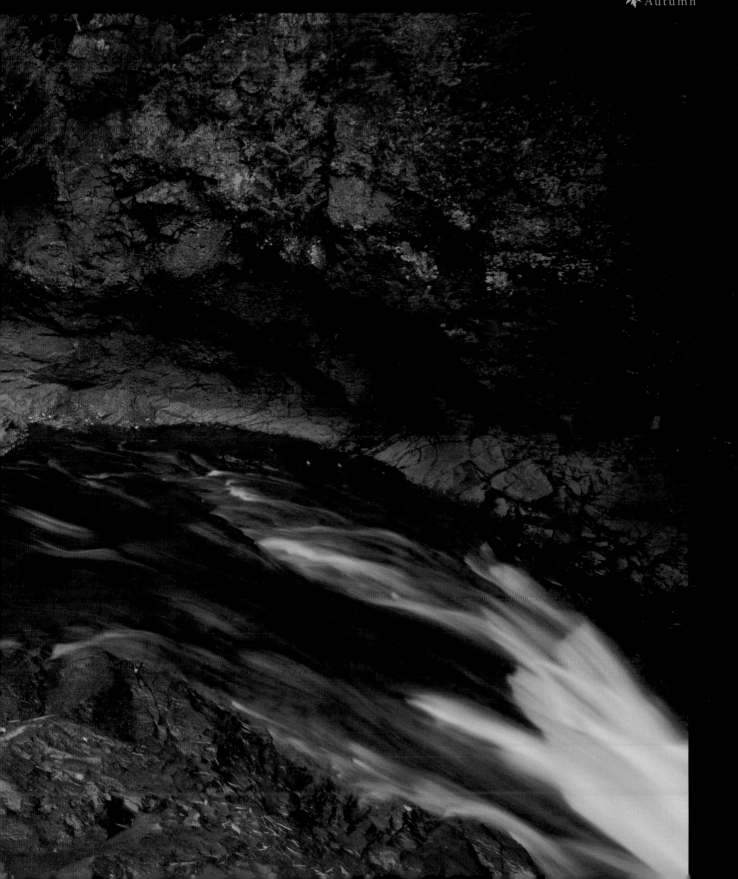

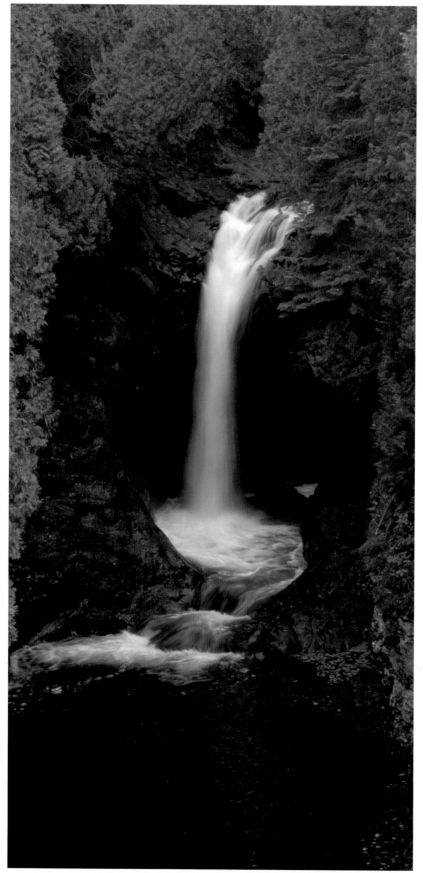

◄ Cascade Falls. *Canon 1ds Mark II Camera, 16 - 35mm f/2.8 lens, 35mm, ISO 100, 1/6 second at f/22.*

Minnesota Geology

The spectacular and rugged northern Minnesota landscapes are even more amazing with the arrival of vivid fall colors in autumn.

Dropping 900 feet over three miles of rugged landscapes, the Cascade River twists and turns through a series of impressive waterfalls before emptying into Lake Superior.

Against a backdrop of 1.1 billion year old late-Precambrian volcanic outcroppings, the Boreal Forest of conifers, aspen, birch, spruce, and cedar comes alive with color along the North Shore.

Despite the rather predictable weather and landscape of today, that's not always been the case. From slowly advancing and receding seas, volcanic and extreme glacial periods, Minnesota has had a very diverse geologic history. Some of the oldest rock formations extend back to Pre-cambrian periods. Formed 4.5 billions years ago, these formations are part of the Canadian Shield and are found in northern Minnesota.

► The Cascades. *Canon 1ds Mark II Camera, 16 - 35mm f/2.8 lens, 35mm, ISO 100, 0.8 second at f/22.*

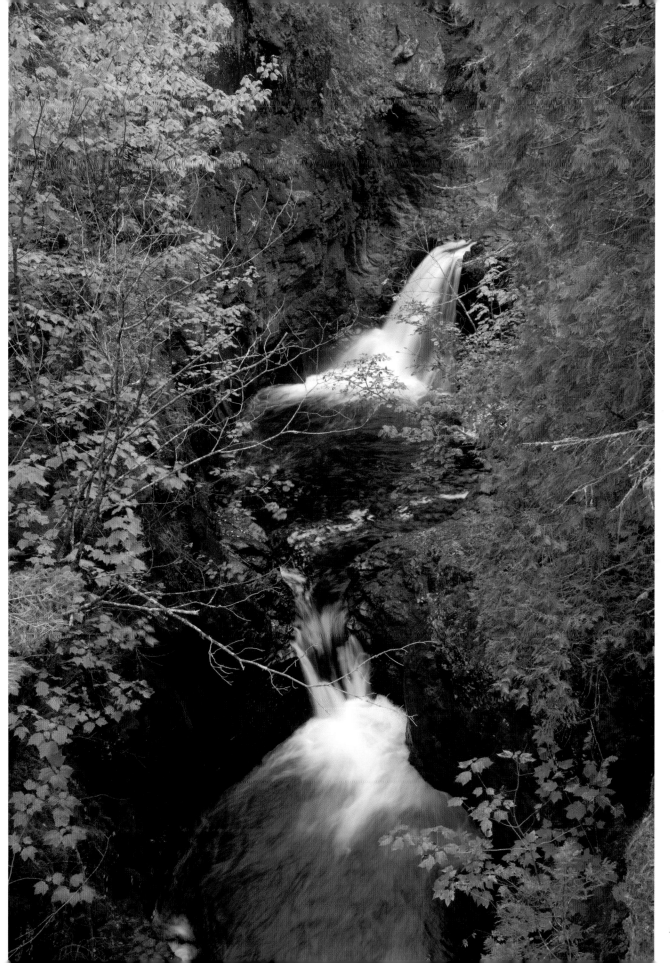

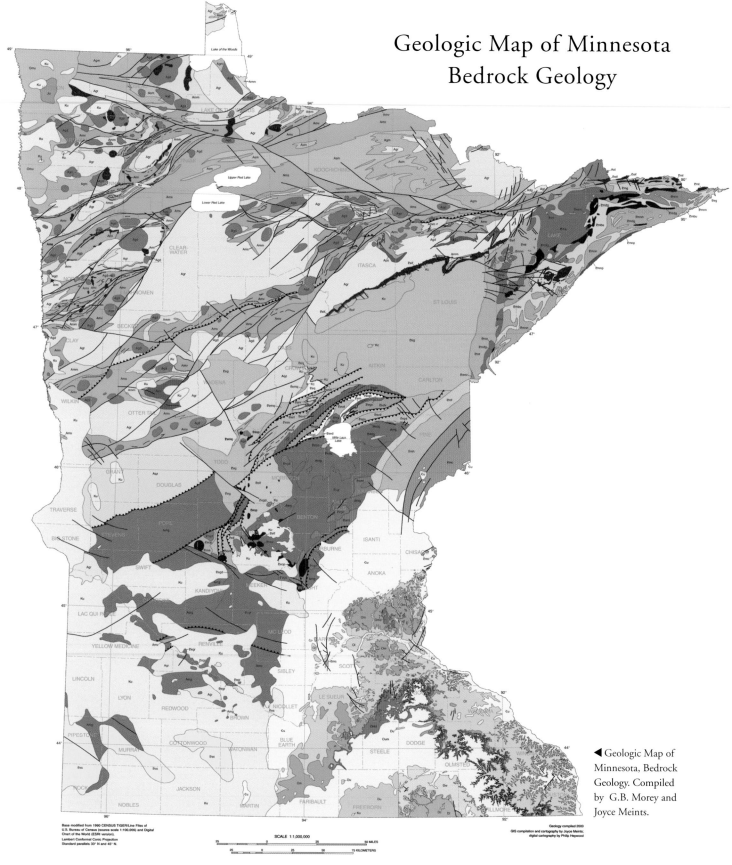

Geologic Map of Minnesota
Bedrock Geology

◀ Geologic Map of
Minnesota, Bedrock
Geology. Compiled
by G.B. Morey and
Joyce Meints.

Base modified from 1990 CENSUS TIGER/Line Files of
U.S. Bureau of Census (source scale 1:100,000) and Digital
Chart of the World (ESRI version).
Lambert Conformal Conic Projection
Standard parallels 33° N and 45° N.

SCALE 1:1,000,000

Geology compiled 2000
GIS compilation and cartography by Joyce Meints;
digital cartography by Philip Heywood

The geologic features within the state show a varied grouping of stratified, metamorphic, and igneous rocks spanning an incredible 4.5 billion years.

Developed by G.B. Morey and Joyce Meints of the University of Minnesota, the Geologic Map of Minnesota shows a state littered with faults, iron-formations, and diverse geologic structures.

Along the North Shore and throughout the arrowhead of Minnesota, significant areas have evidence of volcanic rock such as basalt and rhyolite. Moving inland, granites, sandstones, shales, siltstone, and associated volcaniclastic rocks occupy large areas of the state. Large prairie sections of the southwest are home to Cretaceous rocks giving supporting evidence of ancient seas in the state.

▲ *Canon 1d Mark II Camera, 500mm f/4 lens, 1.4x teleconverter (effectively 910mm) ISO 100, 1/400 second at f/9.*

Late Autumn

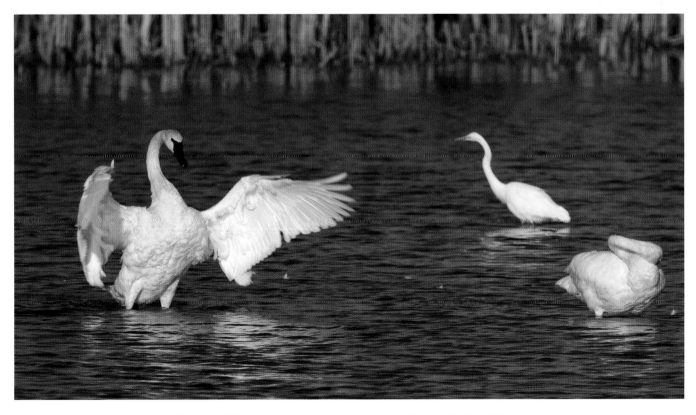

▲ Trumpeter Swans. *Canon 1d Mark II Camera, 500mm f/4 lens, 1.4x teleconverter (effectively 910mm) ISO 100, 1/500 second at f/9.*

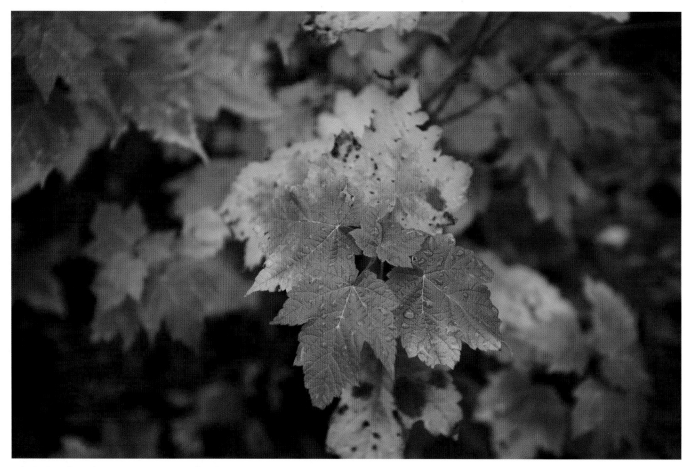

▲ *Canon 1ds Mark II Camera, 16 - 35mm f/2.8 lens, 35mm, ISO 100, 1/100 second at f/2.8.*

Fall Colors

The timing and intensity of fall colors along the North Shore can change dramatically based on a number of factors. Tree type, elevation, proximity to Lake Superior, soil conditions, and the climate leading up to fall can significantly affect color intensity.

The Highlands Moraine parallels the Lake Superior shoreline 25 miles inland. Here, intense colors arrive first in mid-September with Sugar Maples at the higher elevations, and in a line of "fire" work downward into areas such as Cascade River State Park in late September. By October intense colors have finally burned out reaching the Lake Superior shoreline in a final farewell to autumn in the north country.

Digital Equipment
• *Wide-angle zoom.* The hiking trails, deep canyons, and waterfalls are ideal for ultra-wide angle zooms.
• *Tilt-shift.* Using perspective control lenses offer the opportunity to create wide angle panoramic images without distortion.
• *Fast lenses.* Photographing in these areas often has reduced lighting due to a dense tree canopy. Using a tilt/shift or f/2.8 wide angle lens allows for sharp images in low light conditions.

▶ Cascade River. *Canon 1ds Mark II Camera, 16 - 35mm f/2.8 lens, 27mm, ISO 100, 1/80 second at f/3.5.*

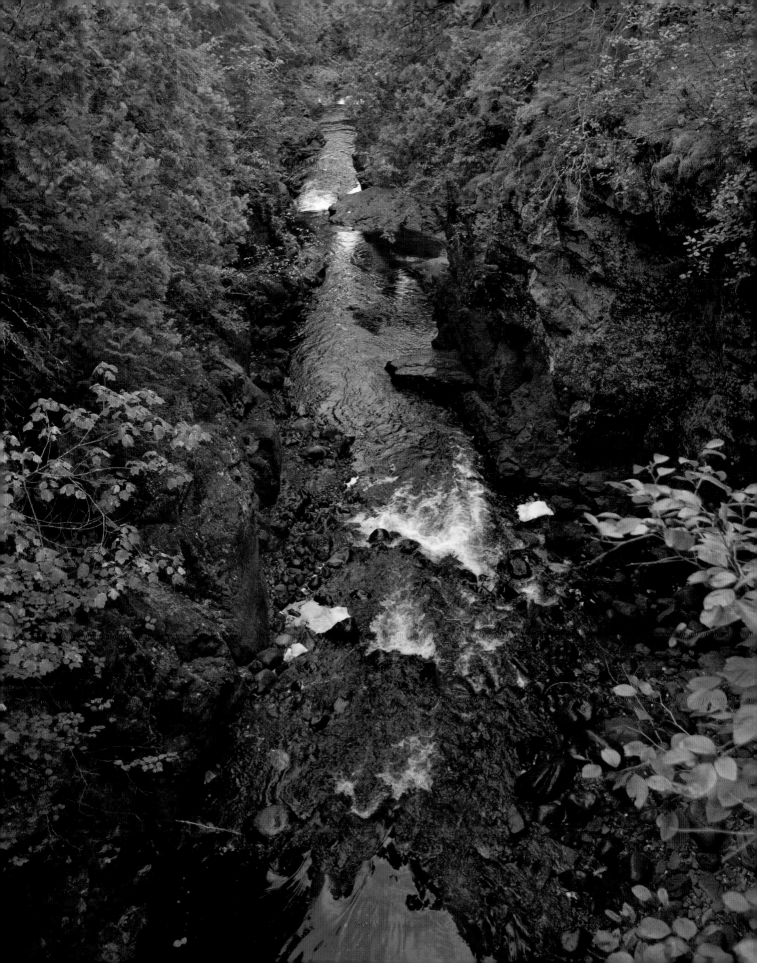

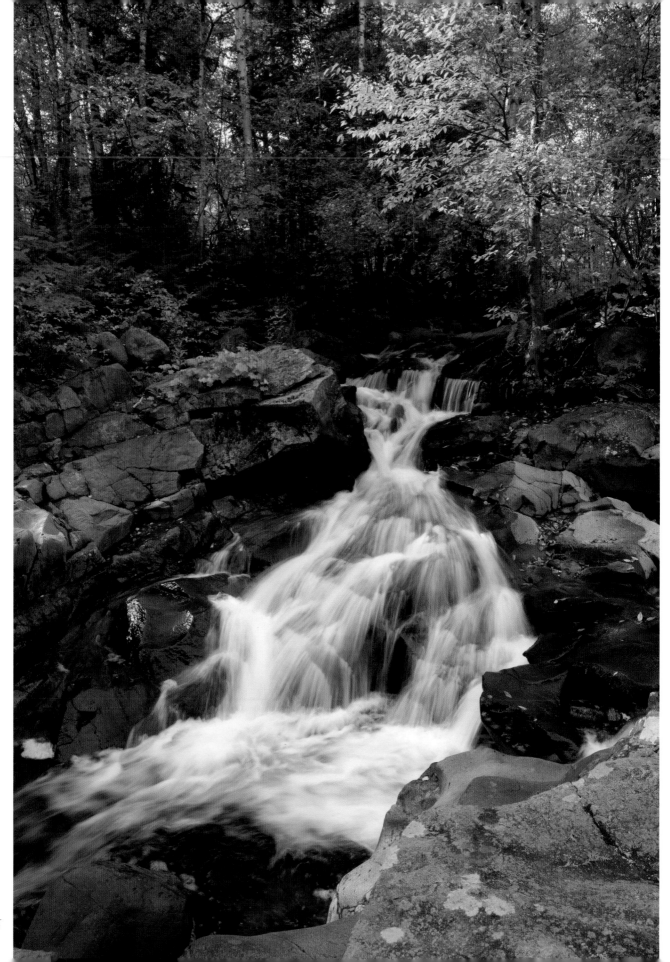

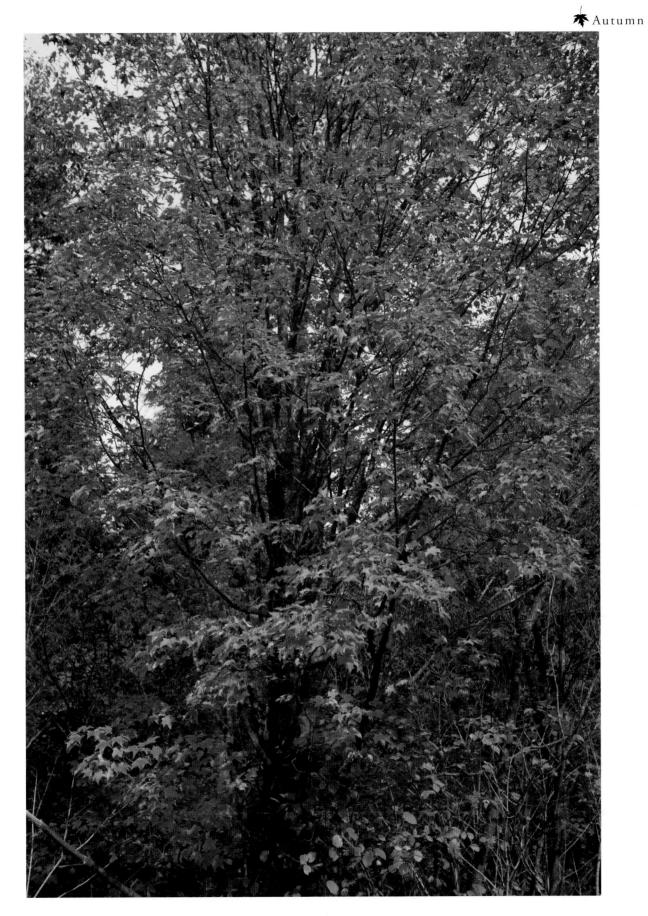

▲ Sugar Maples along the North Shore. *Canon 1d Mark II Camera, 100-400mm f/4 lens, 330mm, ISO 200, 1/320 second at f/5.6.*

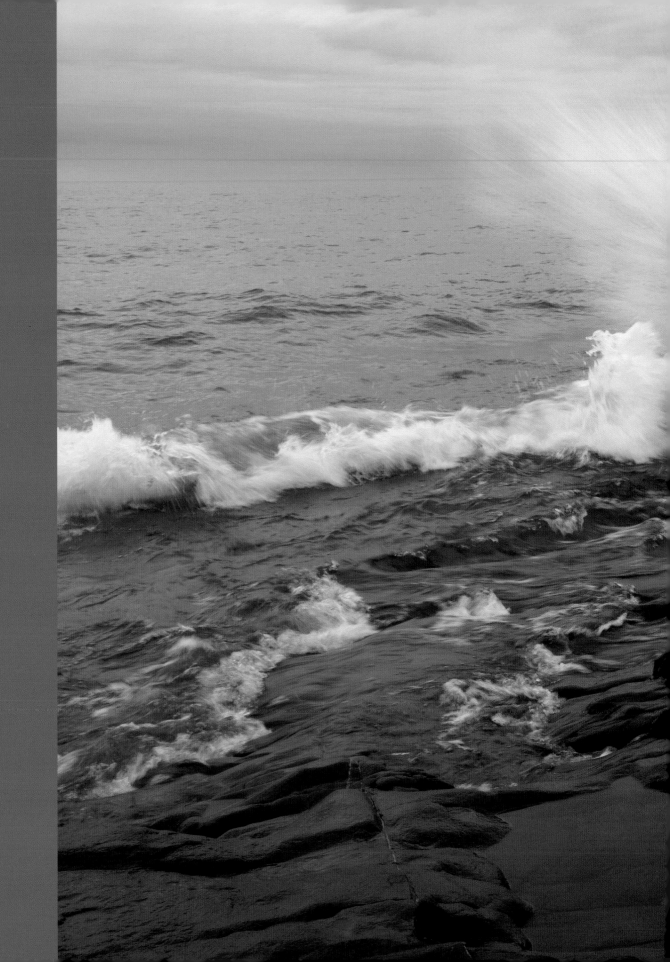

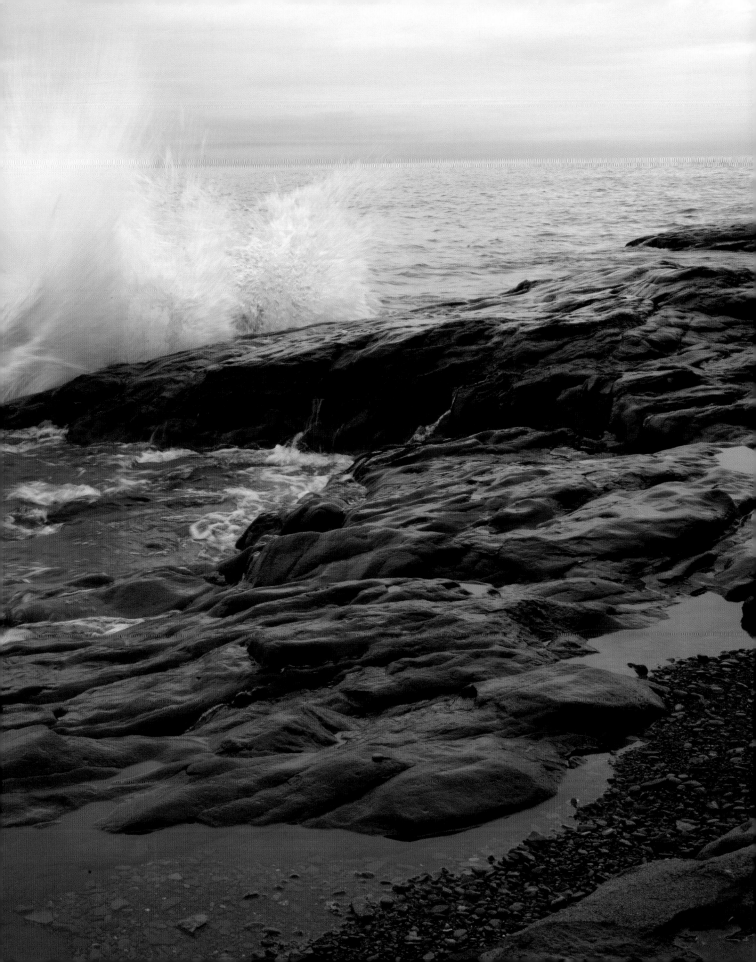

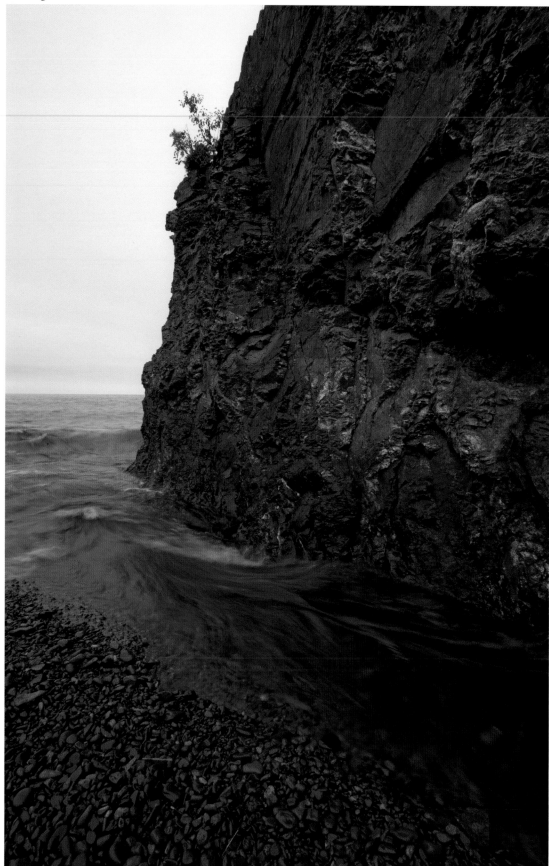

◀ By late fall the Baptism River has shrunk to just a few feet across to empty into Lake Superior. *Canon 1ds Mark II Camera, 16 - 35mm f/2.8 lens, 16mm, ISO 100, 1/4 second at f/22.*

▶ Lake Superior. *Canon 1ds Mark II Camera, 16 - 35mm f/2.8 lens, 31mm, ISO 100, 1/6 second at f/22.*

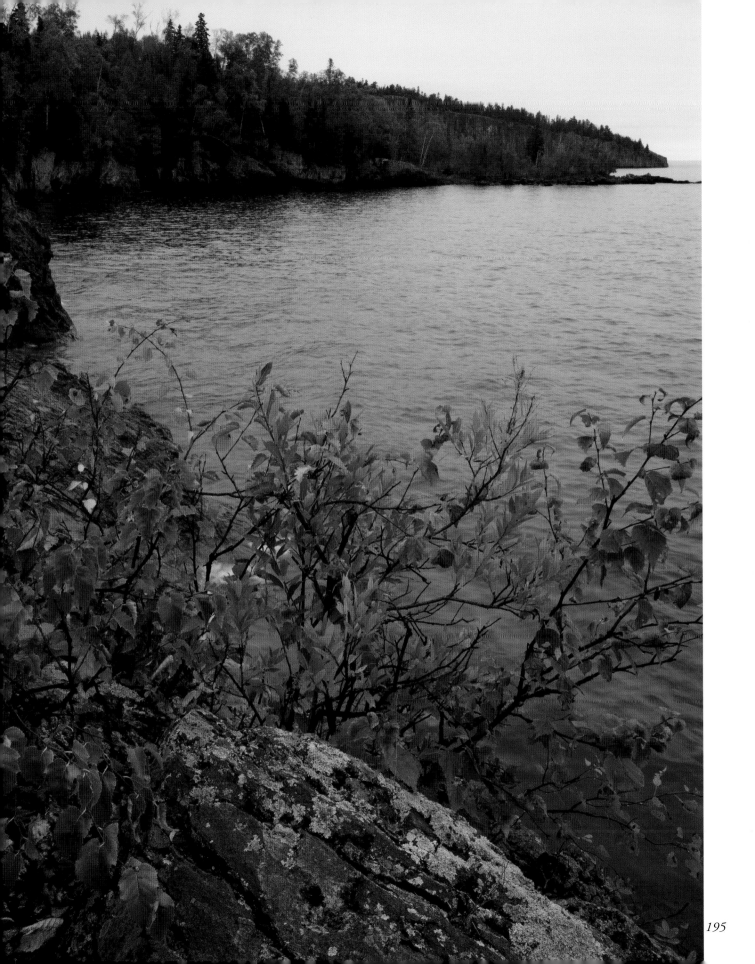

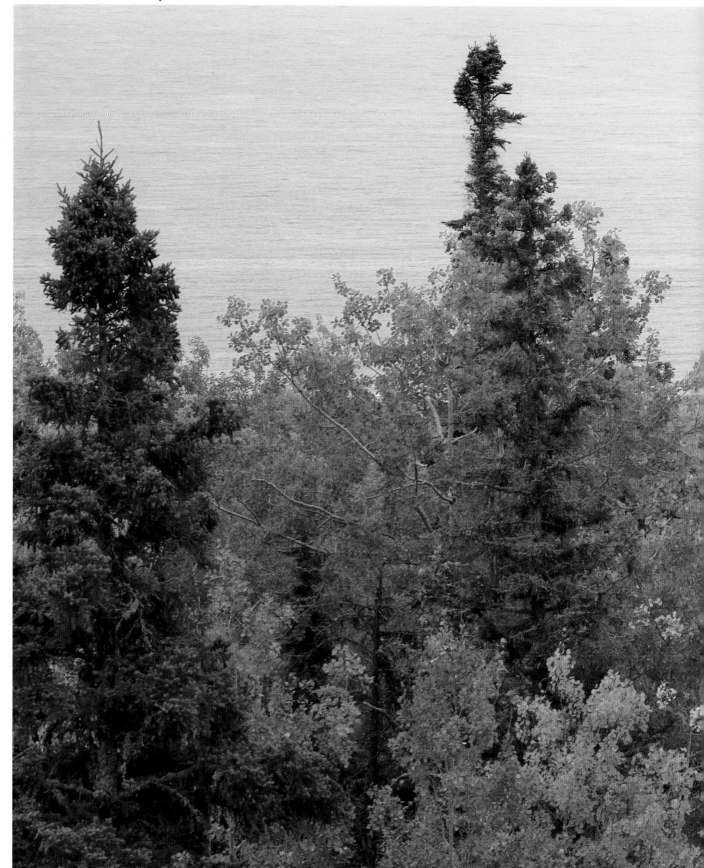

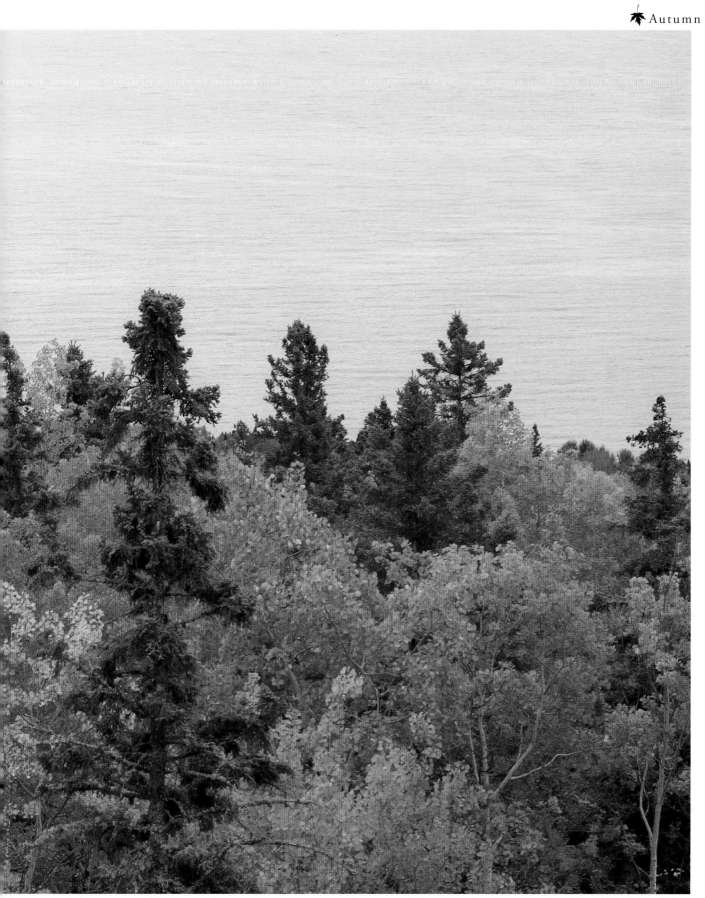

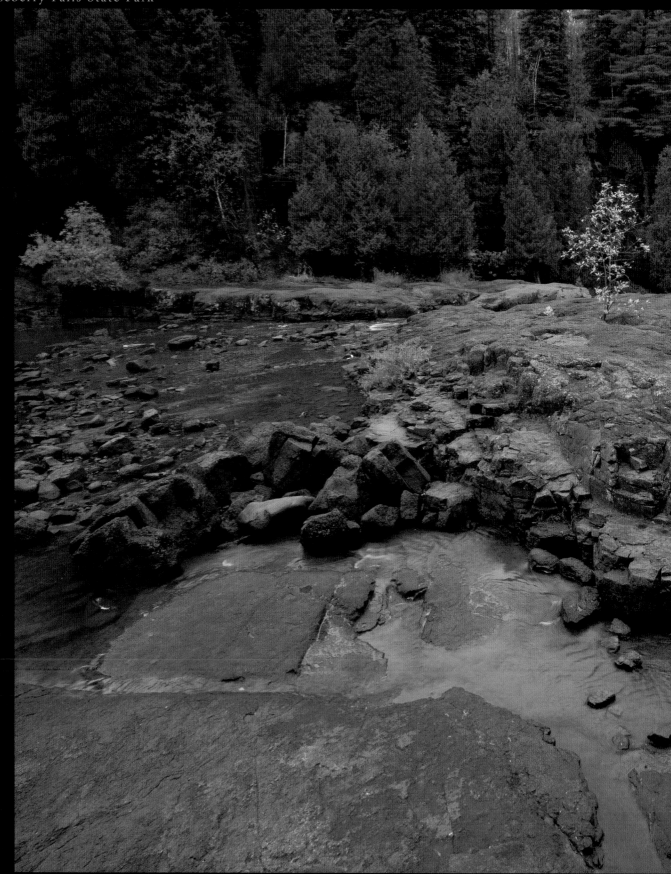

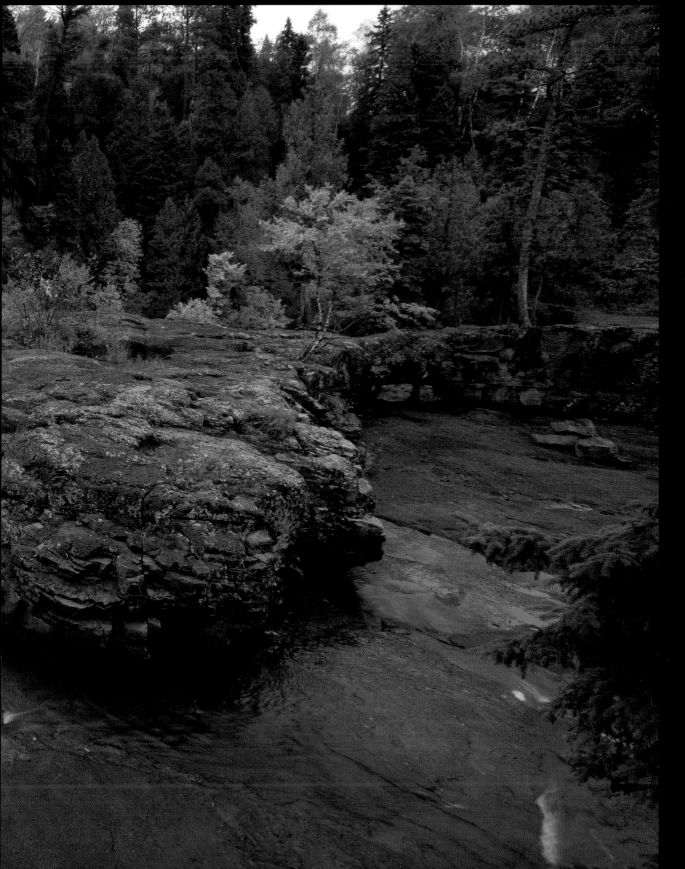

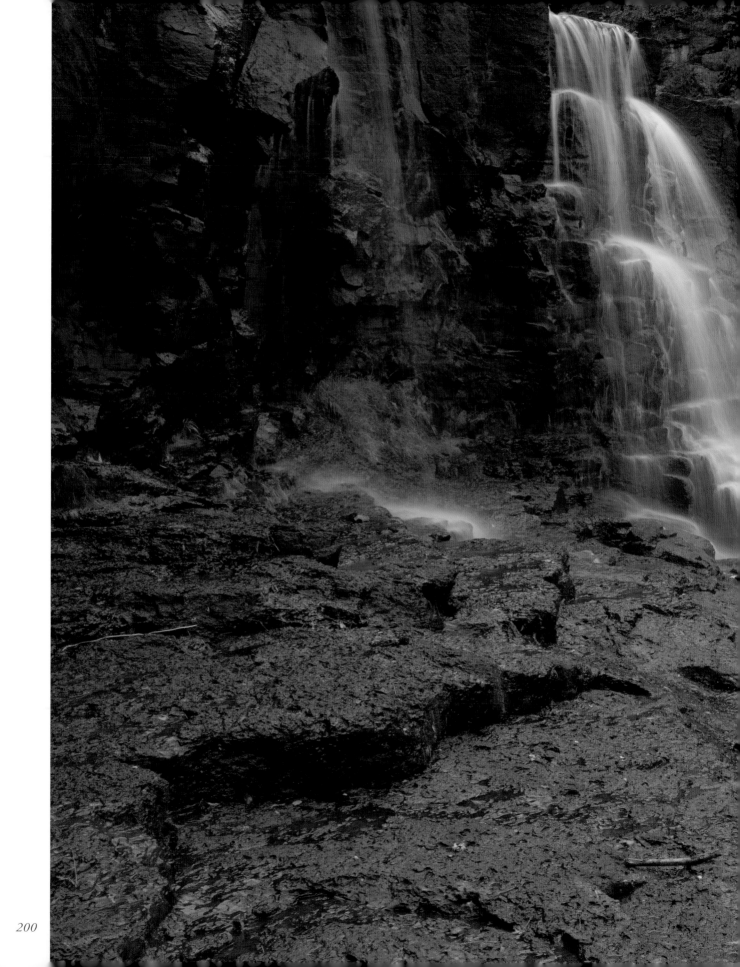

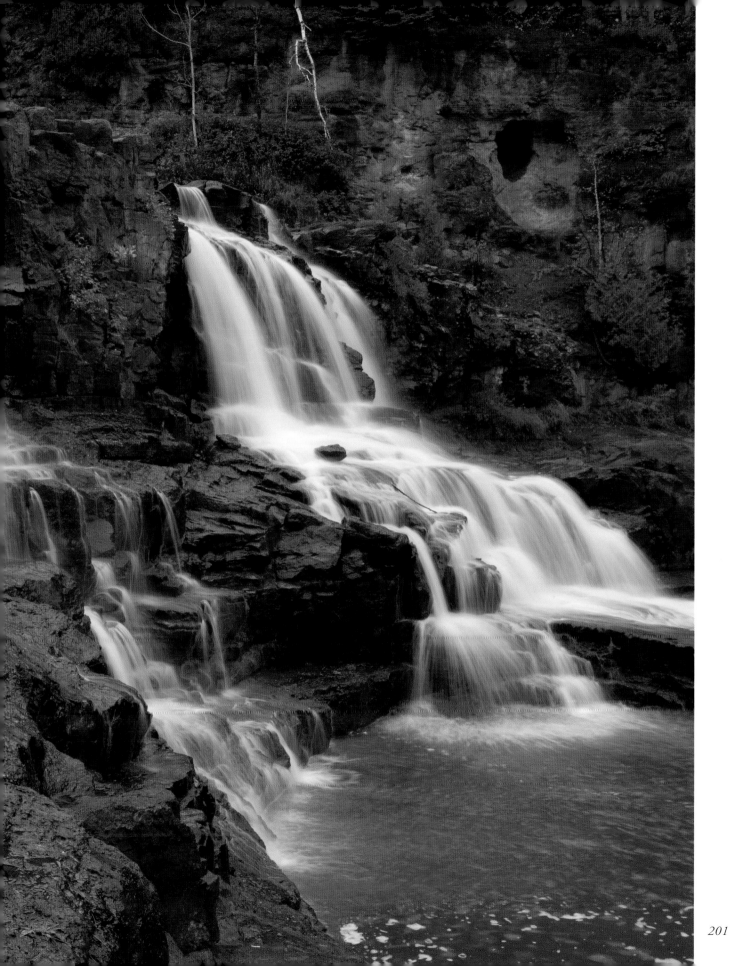

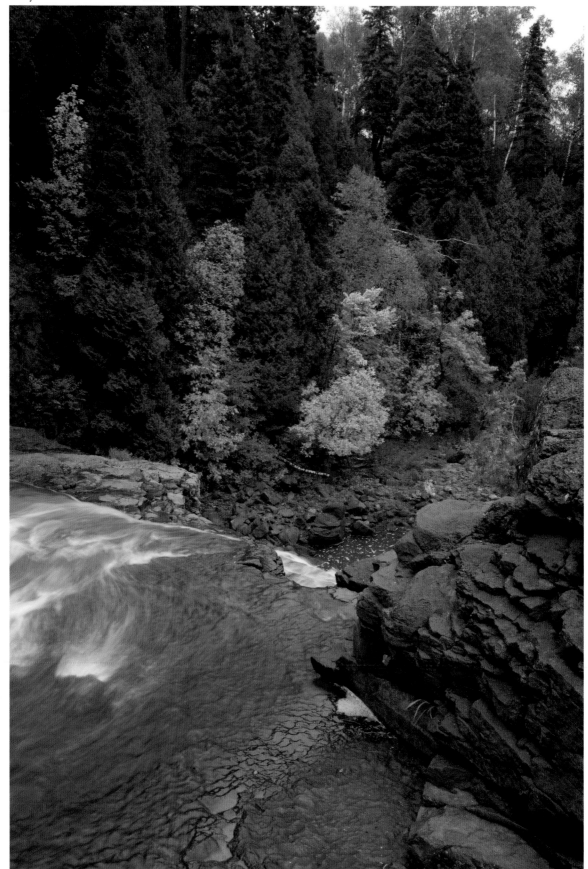

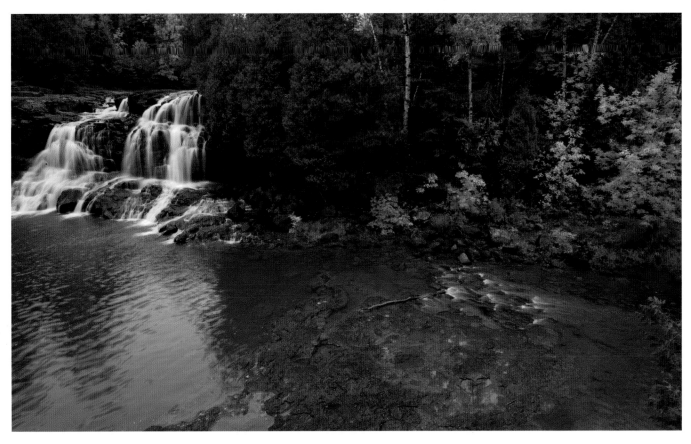

▲ Upper Falls. *Canon 1ds Mark II Camera, 16 - 35mm f/2.8 lens, 24mm, ISO 100, 0.3 second at f/22.*

Going Wide

An ultra-wide angle zoom in the 16 to 35mm range can be an ideal choice in photographing the tight waterfall areas of Gooseberry Falls State Park. The sweeping views and intense colors can be collected into highly dynamic images pulling the viewer into an almost three-dimensional image. Relatively lightweight and fast for low-light conditions, Canon's 16-35mm offers excellent mobility over the rugged trails of the North Shore. Coupling this lens with Canon's 16 mega-pixel 1Ds Mark II body allows high resolution in a full-frame imaging system capable of taking advantage of the 16mm ultra-wide angle.

Digital Equipment

• *Always use a tripod.* With a fast f/2.8 lens, it's tempting to simply hand-hold your camera for a landscape shot. Beyond the reduced stability and decreased sharpness, shooting without a tripod unnecessarily quickens taking an image and consideration of the graphic elements critical for a high quality image.

• *Go wide.* Wide angle zooms offer exceptional sharpness and sweeping views pulling the viewer into a 3-dimensional image.

◀ Middle Falls. *Canon 1ds Mark II Camera, 16 - 35mm f/2.8 lens, 35mm, ISO 100, 0.4 second at f/22.*

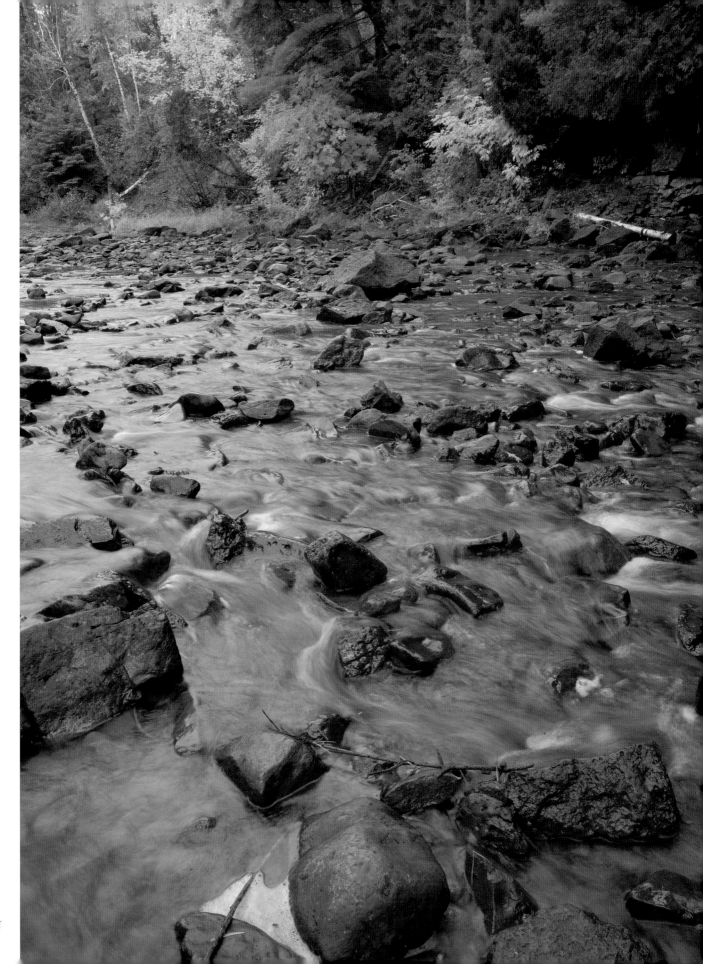

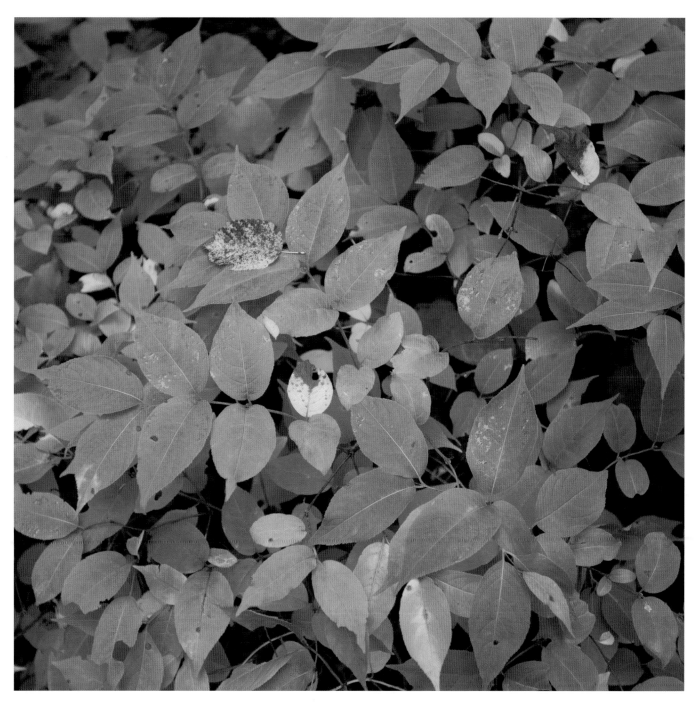

▲ *Canon 1ds Mark II Camera, 16 - 35mm f/2.8 lens, 35mm, ISO 100, 1/100 second at f/2.8.*

◄ Along the Superior Hiking Trail at Gooseberry Falls State Park. *Canon 1ds Mark II Camera, 16 - 35mm f/2.8 lens, 29mm, ISO 100, 0.3 second at f/22.*

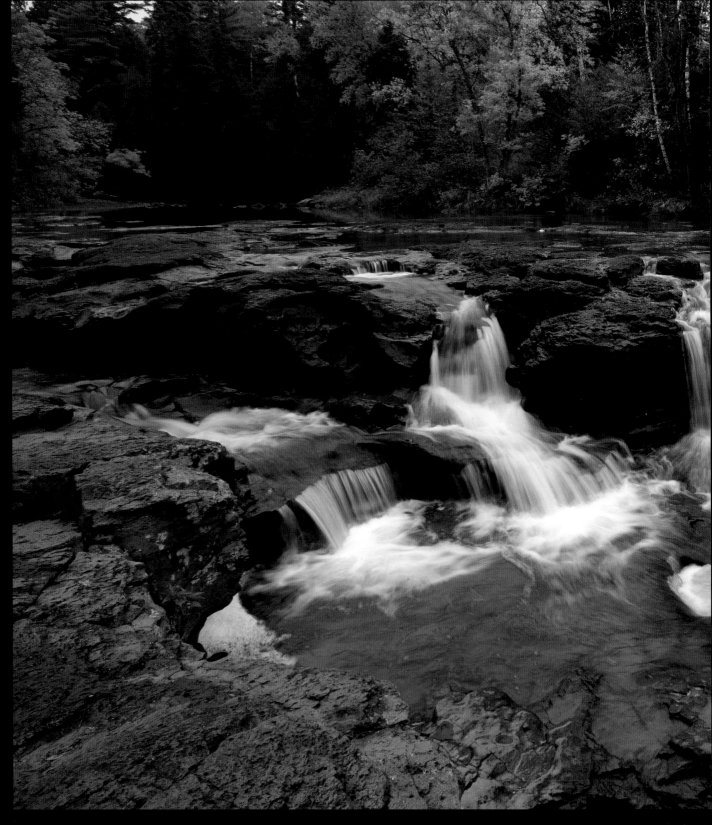

▲ Upper Falls. *Canon 1ds Mark II Camera, 16 - 35mm f/2.8 lens, 16mm, ISO 100, 1/5 second at f/22.*

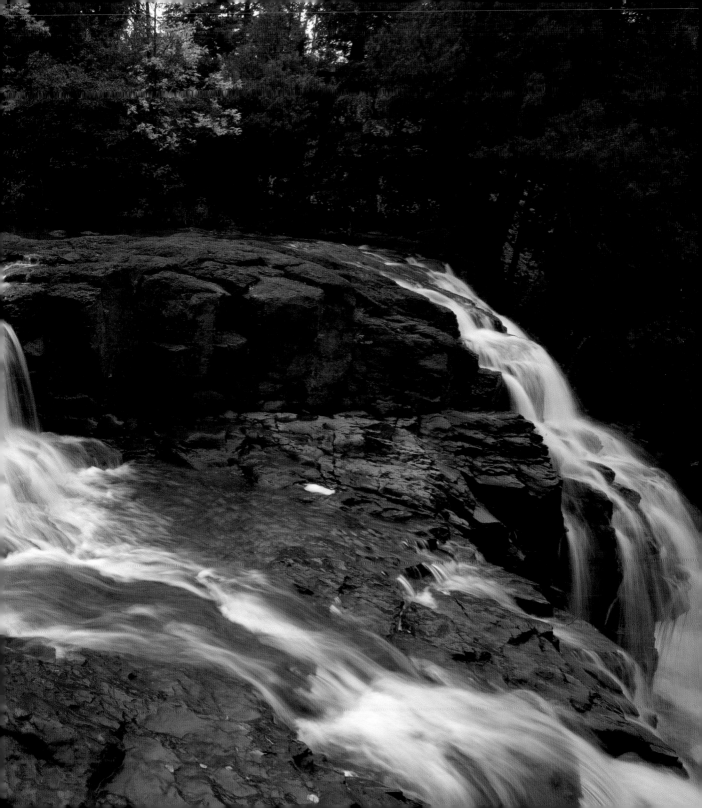

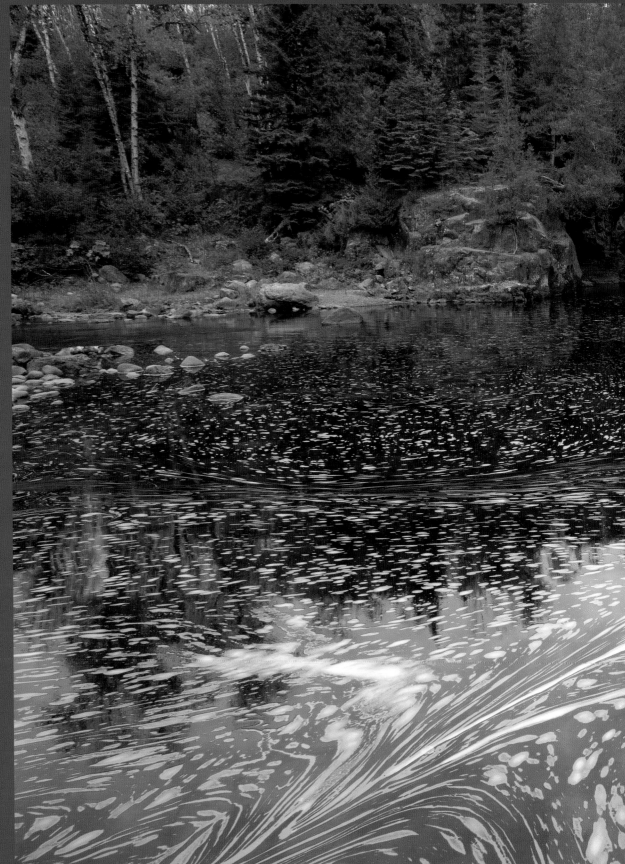

▶ Outlet of Hidden Falls. *Canon 1ds Mark II Camera, 16 - 35mm f/2.8 lens, 20mm, ISO 100, 1/5 second at f/22.*

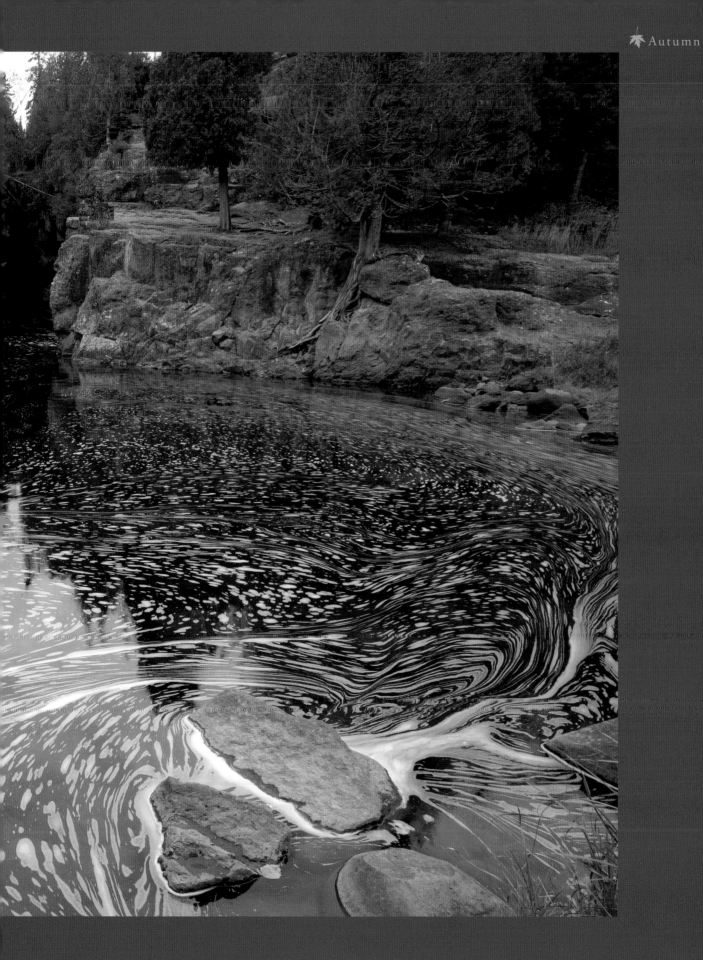

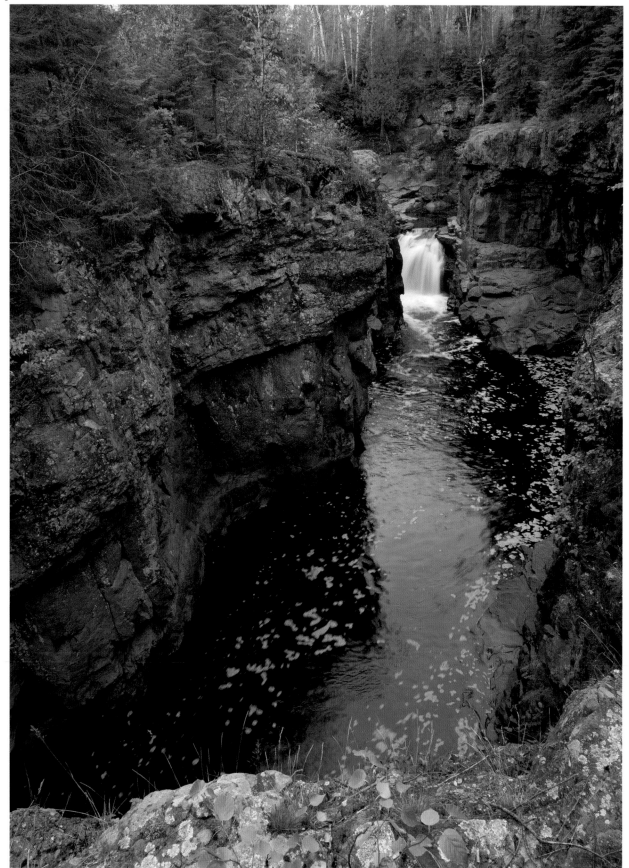

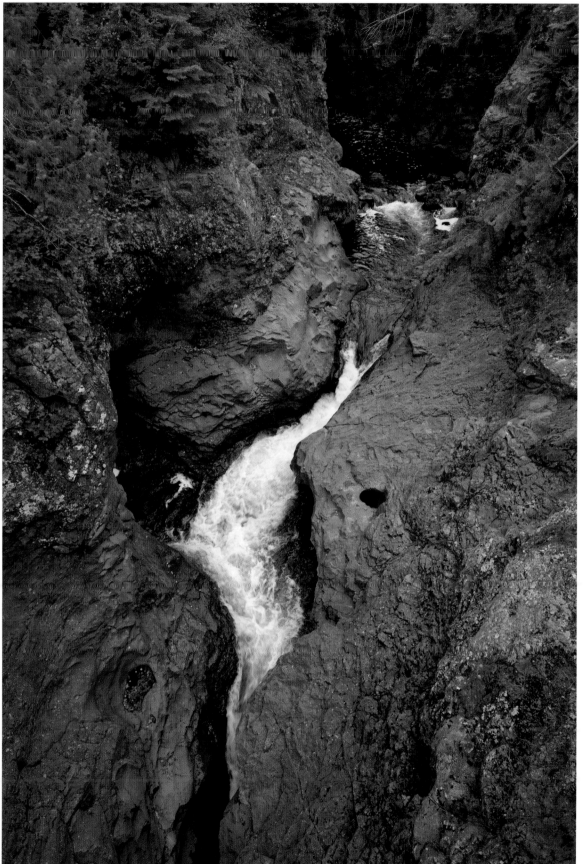

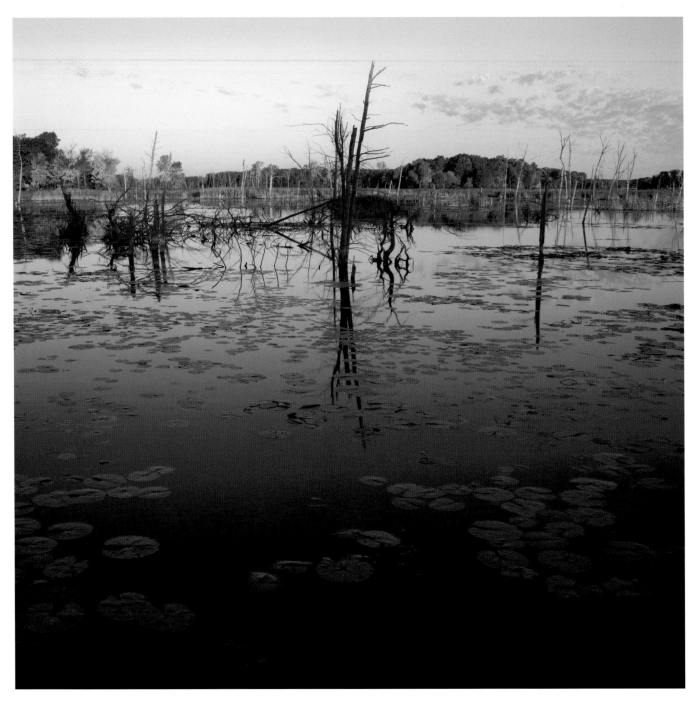

▲ Fall has finally reached Sherburne National Wildlife Refuge by mid-October, a full month later than the North Shore. *Canon 1d Mark II Camera, two images stitched together, 45mm f/2.8 TS-E lens, ISO 100, 1/13 second at f/22.*

▶ *Canon 1d Mark II Camera, 500mm f/4 lens, ISO 100, 1/20 second at f/7.1.*

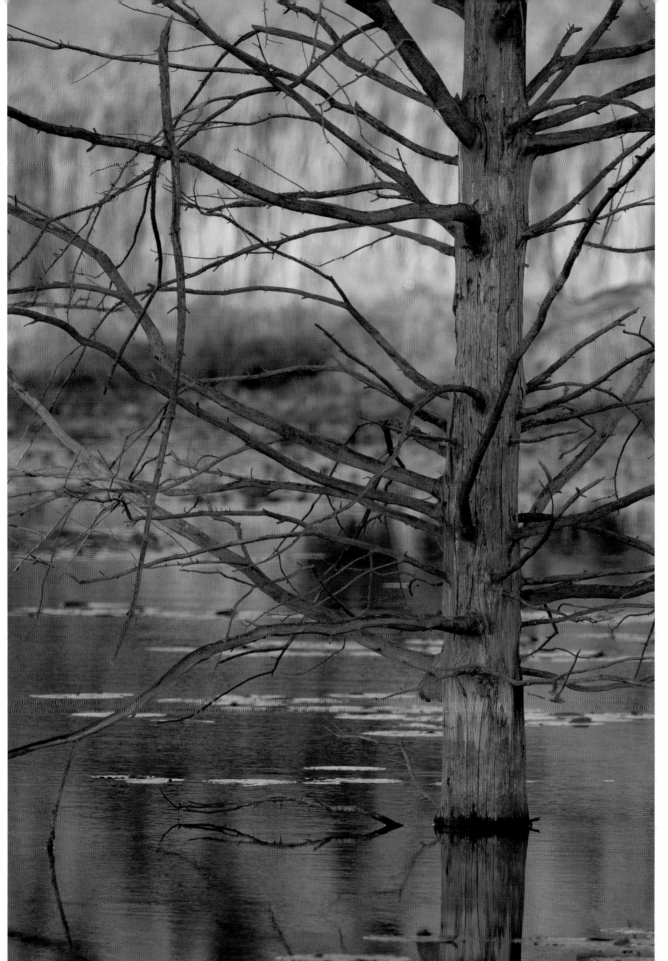

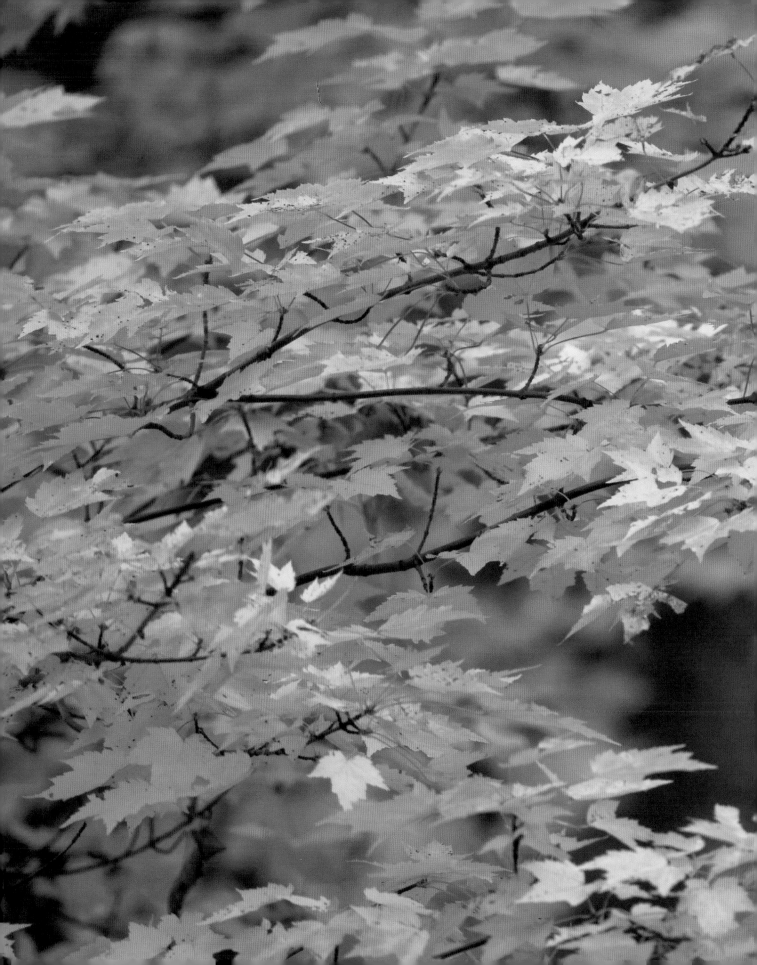

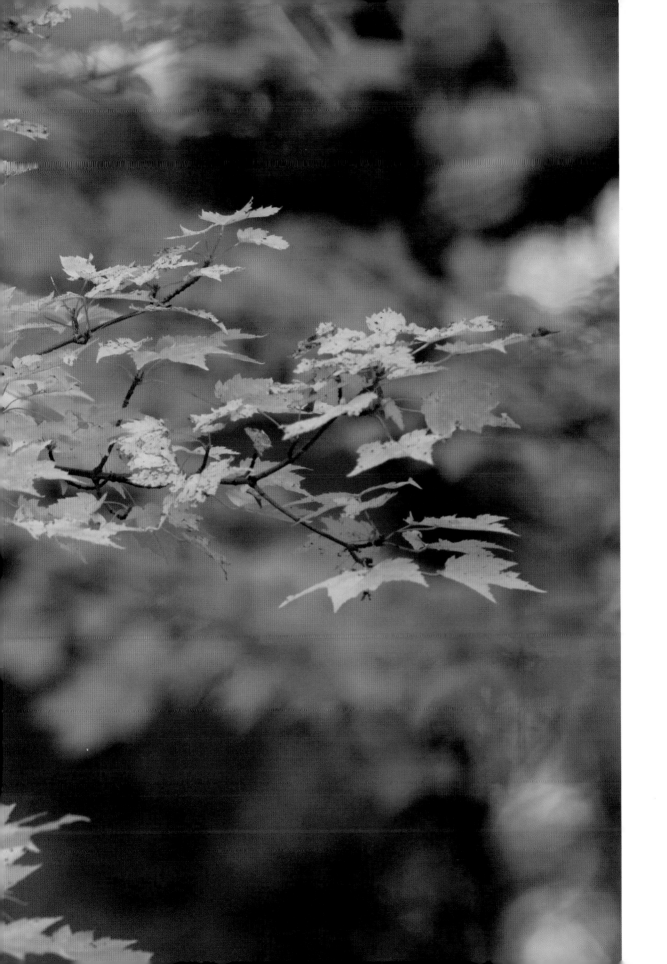

▲ Sunrise, Sherburne NWR. *Canon 1d Mark II Camera, 500mm f/4 lens, ISO 320, 1/10 second at f/9.*

Return to Winter

From the rugged volcanic outcroppings of the North Shore to the inland prairies, deciduous forests and bluffs of central and southern Minnesota, the state offers a critical ecosystem of vast and plentiful resources. Crossing this edge of the Boreal Forest, the area is an important ecosystem and gateway to the earth's largest forest with amazing diversity, wildlife and complexity.

In the span of just a year, hundreds of thousands of Common Loons, rare Trumpeter Swans, Bald Eagles, Egrets, and many others species invaded the state, raised new generations, and wintered to be observed and photographed for many seasons to come throughout North America. Through the arteries of rivers and pristine lakes, the cycle of life continues with certainty. Sometimes with deep and difficult challenges, other times with amazing recovery, the Minnesota ecosystem is unlike any other in North America.

As this delicate cycle of life ebbs and flows within the context of much slower and dramatic ecological and climatic changes, we know today that our environment was very different millions of years ago and continues to undergo change. Against this backdrop of advancing and receding oceans, volcanism, glaciation, and erosion, the rhythm of life has adjusted and continues to adapt into the trails, lakes, and wildlife that were photographed over the past year.

Soon the last leaves of autumn have parted ways once again, most birds and wildlife have moved on, and a crisp arctic breeze is again in the air. By late October, cold rains and occasional heavy snows move in with regular occurrence. As autumn comes to a close, with conservation and preservation of our great Minnesota environment, the cycle will be repeated again and again for generations to come.

▶ Sherburne NWR. *Canon 1d Mark II Camera, 500mm f/4 lens, ISO 320, 1/6 second at f/9.*

During my career as an engineer I was awarded numerous US and international Patents and participated in a number of design efforts for some of the world's most advanced systems and programs. With all of that focus on the technical, I've still held close an interest in developing and using my artistic skills. First as a hobby and then professionally, photography has consumed my thoughts. I have had numerous personal and corporate clients over the years and have had my work featured in a number of photographic contests, magazines, newspapers, and awards.

In 2003, I produced my first book featuring my photography, *Bosque del Apache National Wildlife Refuge, 48 Hours of Flight*. The book was devoted exclusively to this New Mexico refuge and documents my first experiences over a 48 hour period. It has been recognized in a number of magazine and newspaper reviews, and by the Midwest Independent Publishers Association. It was shot entirely with a 35mm film camera.

A year later I published a second book *Our National Parks and Wildlife Refuges, Capturing the Rhythms of Light and Land*. This book unravels the natural rhythms of the land through photographic techniques and conservation / preservation issues. Using a mix of 35mm and medium format films, some of our most cherished national parks and refuges are explored. The book was recognized by the 2004 International Photographer of the Year Awards, and numerous other awards and reviews.

In 2005, I published *The Flight Deck, Digital Rhythms of Our National Wildlife Refuges*. This book focuses on four key national wildlife refuges, the role they play in migration, and the advancements offered by digital photography. The book was also recognized by the 2006 International Photographer of the Year Awards, and numerous other awards and reviews.

All of my books have been published by ImageStream Press, a company I founded in 2003 to capture the rhythms of our great national parks and wildlife refuges on film and digital imagery. Our only focus is to bring light to the benefits of conservation and preservation of natural resources through

nature and wildlife photography.

Publishing a book can be a daunting task but absolutely enjoyable. Conducting the research, visiting wonderful locations, photographing unbelievable views, and putting together the concept is the ultimate in creative freedom. Make no mistake however, publishing is a tough business. However for those who succeed, the rewards can be much more than just monetary.

Photography has allowed me the opportunity to blend my creative, technical, and environmental interests to further conservation. I look forward to many more years of capturing the wonders of our national parks and wildlife refuges for generations to enjoy.

See you on the water - or behind the camera.

References

The Journey of Man, A Genetic Odyssey, Spencer Wells, Princeton University Press, 2002

Minnesota-Orthorectified Image. Image derived from Landsat 7 Enhanced Thematic Mapper Plus data and the National Elevation Dataset. Period of Acquisition: July, 1999 - September 2002 Courtesy of U.S. Department of Interior and U.S. Geological Survey.

Earth at Night Image. Marc Imhoff of NASA GSFC and Christopher Elvidge of NOAA NGDC. Image by Craig Mayhew and Robert Simmon, NASA GSFC, Visible Earth http://visibleearth.nasa.gov/

Earth image. NASA Goddard Space Flight Center Image, Visible Earth http://visibleearth.nasa.gov/

North American Tree Cover. Image by Robert Simmon, based on data provided by Matt Hansen, University of Maryland Global Land Cover Facility , NASA GSFC, Visible Earth http://visibleearth.nasa.gov/

Interstate State Park, Facilities and Features, Minnesota DNR 2006.

NOAA NWS, Storm Prediction Center, Skew-T/Log-P Web Site (online). Accessed 2006-12-1 at http://www.spc.nssl.noaa.gov/exper/archive/events/060102/index.html

Boreal Forest. Lakehead University Web Site (online). Accessed 2006-12-3 at http://www.borealforest.org.

Guidebook for Lake Associations. Minnesota Lakes Association.

DNR's Old-growth Forest Guideline, Implementation Results 2002, Interim Summary Report 2002, The DNR Old-growth Forrest Committee.

Ecological Provinces. Courtesy of the State of Minnesota, Department of Natural Resources. Minnesota, Landsat 7 and National Elevation Dataset. U.S. Geological Survey Department of the Interior / U.S. Geological Survey, http://eros.usgs.gov/

Citizen Lake-Monitoring Program, 2005 Report on the Transparency of Minnesota Lakes, Minnesota Pollution Control Agency, Environmental Analysis and Outcomes Division, March 2006, Pam Anderson.

Minnesota Department of Natural Resources. 2007. The Minnesota Department of Natural Resources Web Site (online). Accessed 2007-2-3 at http://www.dnr.state.mn.us/sitetools/copyright.html

Sherburne National Wildlife Refuge. US Fish and Wildlife Web Site (online). Accessed 2007-1-3 at http://www.fws.gov/midwest/sherburne

Geologic Map of Minnesota, University of Minnesota, Minnesota Geologic Survey, G.B. Morey, J. Meints, 2000.